Artur Landt/Peter K. Burian
Nikon F100

Magic Lantern Guides

Nikon
F100

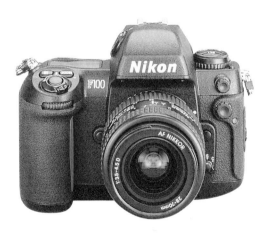

Artur Landt/Peter K. Burian

Magic Lantern Guide to
Nikon F100

Third Printing 2001
Published in the United States of America by

Silver Pixel Press®
A Tiffen® Company
21 Jet View Drive
Rochester, NY 14624
Fax: (716) 328-5078
www.silverpixelpress.com

ISBN 1-883403-61-8

From the German edition by Artur Landt
Edited by Peter K. Burian
Translated by Phyllis M. Riefler-Bonham
Printed in Germany by Kösel, Kempten
www.Koeselbuch.de

©1999 Verlag Georg D. W. Callwey GmbH & Co., Munich, Germany

©2000 English language edition, Silver Pixel Press

Library of Congress Cataloging-in-Publication Data
Landt, Artur, 1958-
 [Nikon F100. English]
 Nikon F100 / Artur Landt.
 p. cm. — (Magic lantern guides)
 ISBN 1-883403-61-8 (pbk.)
 1. Nikon camera Handbooks, manuals, etc. I. Title. II. Series.
TR263.N5L36413 1999
771.3'2—dc21 99-39067
 CIP

Contents

Foreword:
The Camera and This Guide

The Nikon F100 is a high-performance, professional camera designed for the most demanding users. This model is a "slimmed-down" version of the top-of-the-line Nikon F5; therefore, the questions most frequently asked by Nikon owners relate to the differences between the two models. Most noticeable is the weight/size reduction. The F100 is 37% smaller and 34% lighter (a full pound less).

Although both cameras use some similar controls, the F100 is more ergonomic. Its buttons are larger, more clearly labeled as to their use, more prominent, and therefore can be pushed more conveniently. Even the tiny keys for less frequently used functions—which are hidden under a door in the F5—are positioned on the body of the F100 for better accessibility.

Nikon F100 vs. F5

Other differences exist between the two cameras. Considering the much lower price of the F100, a few F5 capabilities have been omitted. These are not as significant as you would guess, given the huge price difference, and the omissions are not the type that would affect a demanding photographer's daily routine. Here are the primary differences, in point form, with an assessment of each:

❏ In the F100, the active AF sensor lights up in bright red, more immediately visible than the F5's gray indicator.

❏ Instead of the F5's 7.4- or 8-frame-per-second (fps) film advance, the F100 is limited to 4.5 fps, or 5 fps when the accessory battery pack MB-15 is used. Frankly, this is more than adequate unless you really want to blast through a roll of 36 exposures in under 5 seconds as in ski-racing photography.

❏ The F100 does not include 3D color matrix metering with 1005 pixels and flexible center-weighted exposure metering;

these are features that helped the F5 establish new standards for exposure metering. While the F5's color matrix metering system is more foolproof in difficult conditions, it also consumes more battery power. And the new ten-zone 3D matrix metering system of the F100 is still one of the most intelligent systems of any camera on the market; it is highly successful in numerous photographic situations. Flexible center-weighted metering is a nicety, but is it something few photographers would ever miss; conventional center-weighted metering in the F100 will suit most users.

❏ The F100 does not have an interchangeable pentaprism feature; in fact, the F5 is the only current autofocus camera of any brand to still include that option. In our experience, this omission does not detract from the use of the F100.

❏ The F100's viewfinder shows "only" 96% instead of 100% (F5) of the image that will be recorded on film. This is just as well, because a slide mount hides some of the image area, and the edges of prints are always cropped in automated printmaking systems.

❏ The F5 has a built-in eyepiece blind to cover the eyepiece when the photographer is not looking through the viewfinder, as in self-timer photography. The F100 offers only an accessory, which is not as quick to operate but does the job as well; attach it to the camera strap so it does not get lost.

❏ The F5 has reflex mirror lock-up (to eliminate internal vibrations from mirror bounce), while the F100 does not. Because mirror action is very well cushioned, most photographers will never notice a difference. Only in high-magnification photography, as with macro lenses in the 1/2 second to 1/15 second range, does the F5 have a meaningful advantage in terms of sharper images. With the F100, try to avoid these few shutter speeds in extreme close-up photography.

❏ The F5 has more metal parts, intended to better withstand "professional-level" abuse. However, the F100 is a very rugged model, too, and it's a lot lighter. The F100 front body

and bottom covers are constructed of an armor-like magnesium alloy with the rigidity and strength required to maintain precise alignment; some stainless steel castings are also used. Strategically placed O-rings provide resistance against moisture and dust, as in the F5.

❑ A few F5 controls are quite conventional ("old-style"), while the F100 uses high-tech controls. The new camera is also quicker to operate, as fewer features require manipulating two buttons to access.

Primary F100 Technology/Capabilities

The good news is that the most important technologies of the Nikon F5 have been maintained. In a nutshell, the following F100 features/technology should be noted, because most are not available with other Nikon cameras except the F5. (All of these will be discussed in greater detail in later chapters.)

❑ The powerful Multi-CAM 1300 autofocus module (from the F5, although that camera's autofocus is slightly faster). It works with five AF sensors; three are crosshatched, capable of detecting most types of patterns for reliable focus acquisition. Two are line sensors, slightly tilted for reliable focus on vertical lines. When none of the sensors are exactly on a subject, the system automatically selects the sensor that is closest and finds focus.

❑ Dynamic autofocus operation. The system automatically switches among the five AF sensors as the subject moves within the frame for off-center subject tracking even at high-speed film advance. AF with "lock-on" continues to track the original subject even if focus detection is momentarily interrupted by some other object.

❑ 22 custom settings (some with multiple options) to add extra functions and to reprogram some camera operations.

❑ Intelligent multi-sensor balanced fill flash, other flash modes as listed in the specifications, wireless off-camera TTL flash

with the optional SU-4 accessory, and High Speed Flash Sync (at any shutter speed!) with the following Speedlights: SB-26, SB-27, or SB-28.

❏ New ten-zone 3D matrix metering with a database of over 30,000 actual scenes to make "intelligent" decisions (with a microcomputer) on exposure when evaluating scene brightness, contrast, selected focus area, and subject distance. (Distance is only considered when a D-type AF Nikkor lens is used.)

❏ Unique exposure bracketing system with numerous options (number of frames, overexposure, or underexposure) selectable in any operating mode, including Manual; both flash exposure and ambient light exposure can be bracketed, simultaneously, if desired.

❏ Electronic depth of field preview (for visually assessing the zone of sharp focus at any aperture) operates in any mode, including Program.

❏ Optional C-2WE Photo Secretary II (for Windows) software and PC-link cord for downloading shooting data to a Windows-based PC. This accessory is beyond the scope of this guide. However, it can be used to link your F100 to a Windows-based PC with connecting cord MC-31 or MC-33. Various F100 functions can be set from a computer, and data about photos (from up to 70 rolls of film) stored in the F100 can be downloaded.

This information should whet your appetite for the technical smorgasbord offered by your new camera. After reading this guide—with camera in hand—you will have completely mastered all of the functions of the F100 and its primary accessories. You will read about both theoretical and technical considerations, as well as hands-on suggestions for sophisticated picture-taking with your new camera in real-life situations. Instead of "information overload," here is information you can use.

Topics are covered in concise, easy-to-understand sections. As a result, all photographic information and examples relating to a

given topic can be reviewed quickly. Furthermore, practical tips and basics are provided, which may be read first and used for reference later. The second part of the guide contains worthwhile information for system expansion with accessories and an introduction to advanced photography with interchangeable lenses.

Glossary of Photographic Terms

AF: *Autofocus*; motor-driven system to automatically set focus.

Balanced Fill Flash: In bright light, the metering system automatically reduces flash output so flash does not overpower the ambient light.

Bracketing: Taking a series of pictures of the same subject varying the exposure for each frame.

Center-Weighted Metering: TTL (Through-the-Lens) metering; the scene brightness is evaluated with nearly 75% of the meter's sensitivity concentrated at the center of the viewfinder.

Continuous Servo AF (C): AF mode for moving objects with focus tracking and "release-priority": The shutter will release even if perfect focus has not been achieved.

EV: *Exposure Value*; numerical value describing a certain exposure; several combinations of shutter speed and aperture correspond to a defined film sensitivity. For example, the following shutter speed/aperture combinations all produce the same exposure on film: 1/250 second at f/2, 1/125 second at f/2.8, 1/60 second at f/4, 1/30 second at f/5.6, 1/15 second at f/8, and so on. This fact is called reciprocity or equivalent exposure.

Exposure Compensation: A control that allows the user to set a fixed amount of over- or underexposure (from the meter-recommended settings), especially useful in the camera's Automatic modes.

Single Servo AF (S): AF mode for static objects with focus-priority; the shutter will not release until focus is confirmed; if subject

motion is detected, the system will automatically begin tracking (servo) focus.

SLR: *Single-Lens-Reflex* camera; the image captured by the lens is reflected by a mirror to the viewfinder. There is no secondary viewing system as with some cameras; you view the scene through the lens that will take the picture, for greater accuracy in framing of a subject.

Spot Metering: TTL metering where the system reads only the brightness in 1% of the image area; with the F100, the spot metering area corresponds to the user-selected focus sensor for off-center spot metering when desired.

3D Matrix Metering: TTL multi-segment metering with distance data detection; exposure is determined in several metering segments (ten in the case of the F100), and scene evaluation is made by artificial intelligence in a microcomputer. When AF Nikkor lenses that are not D-type are used, conventional matrix metering is provided.

TTL: *Through the Lens*; internal metering; the camera's metering system reads the light entering through the lens; there is no need to compensate for filters or other accessories that reduce light transmission. All F100 metering systems are of the TTL type.

Camera Controls

The Nikon F100's elaborate features are not difficult to manage. Most controls can be manipulated with the camera at eye level; all are well marked (with a symbol or abbreviation) as to their purpose. References to the location of controls apply to the camera held in shooting position. All controls are at or near locations where your fingers naturally rest while holding the camera. A great deal of feedback is provided in the data panel in the viewfinder and on the top right deck of the body.

Before reading ahead to other chapters, you should familiarize yourself with the location of important control elements to allow you to make full use of the Nikon F100's enormous performance

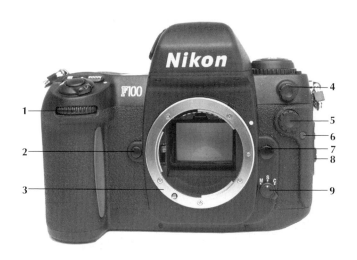

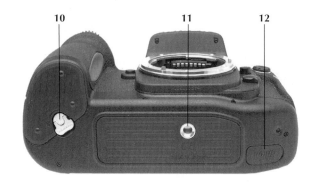

1	Front command dial	13	Film confirmation window
2	Depth-of-field preview button	14	Camera strap eyelet
3	Lens mount	15	Custom settings button/
4	Sync terminal		Camera reset button (1 of 2)
5	10-pin remote terminal	16	Shutter/Aperture lock button
6	Self-timer indicator LED	17	Viewfinder
7	Lens release button	18	Diopter adjustment
8	Camera back release	19	Exposure/Focus lock button
9	Focus mode selector	20	AF start button
10	Battery holder release	21	Rear command dial
11	Tripod socket	22	Focus area selector
12	Contacts for MB-15	23	Focus area selector lock

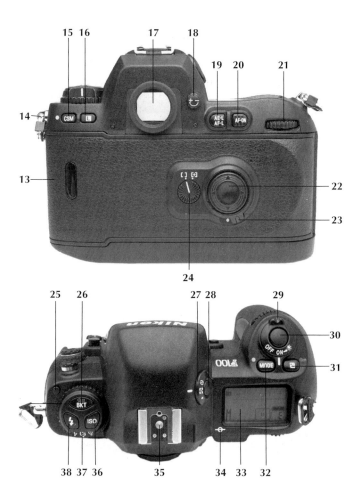

24 Focus area mode selector	32 Exposure mode button/
25 Film advance mode	Camera reset button (2 of 2)
selector release	33 LCD panel
26 Exposure/flash bracket button/	34 Film plane indicator
Film rewind button (1 of 2)	35 Flash accessory shoe
27 Metering mode selector	36 ISO setting button
28 Metering mode selector release	37 Film advance mode selector
29 Power switch	38 Flash mode button
30 Shutter release button	
31 Exposure compensation button/	
Film rewind button (2 of 2)	

potential. You will get to know your camera better and hands-on operation will be easier. The methods used to access functions will be explained again later in detail in sections relating to specific camera operations. Here is a brief overview of the layout and operation of the F100 controls:

Frequently used controls are located on or near the right upper shoulder of the camera, including the buttons for selecting the Operating mode [MODE] and exposure compensation [+/-]. Right near your right thumb are the autofocus activation [AF-ON] and autoexposure/autofocus lock [AE-L/AF-L] buttons. By omitting the manual film rewind crank featured on the F5, the designers created room for important control buttons on the top left shoulder of the camera: automatic exposure bracketing [BKT], flash function selector (flash symbol), and film-sensitivity setting [ISO]. The film advance mode control (S, C, Cs, multiple exposure, self-timer) dial is here as well.

Easily accessible to your left thumb is the button for selecting custom settings [CSM], as well as the button for locking in a preselected aperture or shutter speed [L]. (On the F5, some function buttons are significantly smaller and located under a lid, making their use and rapid access more difficult.) The F100's autofocus area mode selector and the focus area selector keypads are much more ergonomic; the circular keypad is slightly larger and offers better traction than that of the F5. The metering area selector switch is on the side of the pentaprism, as with the F5.

The F100's most important controls are the front dial, called the sub-command dial by Nikon, and the rear dial, called the main command dial by Nikon (referred to in this book as the front and rear dials). Both offer diverse functions, which will be explained later, depending on the camera operating mode and any custom settings that have been activated. However, the front

This dial, on the left top of the camera, is used to set the film advance mode, auto bracketing, manual ISO speed, and flash sync mode.

dial is most often used to select apertures (f/stops), while the rear dial is most often used to select shutter speeds.

Additional information on all controls is provided later in this chapter in the "Dry Run—Test-Drive" section.

In a Rush?

If you want to take some pictures with your new Nikon F100 before reading the rest of this chapter, try the following:

1. Load four alkaline AA batteries into the holder in the hand grip with the camera's power switch set to OFF. (The switch surrounds the shutter release button.) You can open the battery compartment by turning the small lock release to the left. Remove the holder and insert batteries according to the plus and minus indication inside. Insert the battery holder and lock the chamber.

2. Mount a lens on the body while the camera is OFF, after removing the body cap. Line up the white index line on the lens mount with the white dot near the bayonet mount of the body. Twist the lens counterclockwise until it locks in with an audible click. The aperture ring on the lens must be locked in the "A" position or at the largest number, such as 22.

3. Turn the camera's power switch to ON.

4. Press and hold the [MODE] and the [+/-] buttons simultaneously for more than two seconds. This resets the F100 to its most basic modes, without overrides, etc. The camera is now in the fully Programmed mode where both f/stop and shutter speed are set by a computer.

5. If the aperture ring on the lens is not set to "A" or to the largest number, do so now.

6. To set the camera to autofocus, flip the M, S, C switch on the front of the F100 to "S" for single-shot autofocus or to "M" if you are using a manual focus lens.

7. Turn the metering pattern selector dial on the right side of the pentaprism while pressing the central button to the center option, matrix metering.

8. Open the camera back by depressing and sliding the switch on the left side of the body. Insert the film in the left chamber and pull the film leader out to the red index mark. Close the camera back. Press the shutter release button once, and check to see that the film advances to the first frame.

9. For those who are more advanced: Turning the rear dial allows you to shift among various combinations of shutter speed/aperture without changing the exposure value.

10. Make sure the film advance mode dial is set to "S" for single-frame film advance; if not, press the small button near the [BKT] button and hold it while rotating the dial to the "S" position.

11. Point the lens at the subject. Hold the camera still and press the shutter release button all the way down to take the picture. Autofocus will be active even if you do not press the [AF-ON] button.

12. To rewind the roll of film after it has been exposed, press and hold the [BKT] button and the [+/-] button simultaneously for approximately one second. (Note that both of these controls show a film rewind symbol in red as a reminder of their secondary function.)

To rewind film, press and hold the [BKT] and [+/-] buttons simultaneously for about one second.

Dry Run—Test-Drive

If you prefer to test-drive the F100 without film to become famil-
iar with the controls, proceed with this section.

❏ With the camera in hand, activate all of the controls as fol-
lows, with a lens on the F100. (Refer to the previous section
for some basics, but do not load film.) Don't worry about
making settings you may not want later on; you'll learn how
to reset the F100 to its most basic (factory default) settings at
the end of this exercise.

❏ Set the camera to ON with the power switch. Try illuminating
the external LCD panel (turn the switch to the lightbulb sym-
bol); this feature will be useful when you are shooting in low-
light conditions.

❏ The shutter release button has two positions: By lightly press-
ing the button, autofocus is started and exposure metering
activated. (There is no need to use the [AF-ON] button to acti-
vate autofocus.) Exposure data is now displayed in the view-
finder and on the top deck LCD panel.

❏ The operating mode selector button [MODE] allows the set-
ting of any desired mode: Program, Aperture-Priority, Shutter-
Priority (all Automatic modes), and Manual mode. Press the
button and use the rear dial to select and display the abbrevia-
tion for the desired mode (P, A, S, M) on the top deck LCD
panel and in the viewfinder data panel. Release the [MODE]
button and practice selecting settings within each mode using
the control dials.

❏ The [CSM] button enables you to select the menu for the cus-
tom settings as follows: The desired custom setting (1 through
22) is accessed with the rear dial while pressing the [CSM]
button. Options for each are then selected with the front dial.
For practice, try changing some of these by rotating the
camera's front dial while pressing the [CSM] button.

❏ On the left side of the body is the camera back lock release;
open the camera back by pressing the release lever and slide

it downward. Do not touch the shutter mechanism! Close it again. (You cannot fire the shutter when the back is open unless the F100 is set for a 1/250 second shutter speed.)

❏ The focus mode selector on the front of the F100 (M, S, C) allows you to select Manual Focus, Single Servo, or Continuous Servo autofocus by turning the switch. Try focusing in each of these modes.

❏ The autofocus system can be started either by lightly touching the shutter release button or by pressing the [AF-ON] button. The focus may be locked by partially pressing the shutter release button or by fully pressing the [AE-L/AF-L] button. When you press the latter, note that the exposure settings are locked, too: The f/stop and shutter speed do not change even as you point the lens toward a dark area or a bright light.

❏ The very small circular dial on the camera back is used for selecting the AF Area mode: single sensor (the [] symbol) or Dynamic (the [+] symbol) where the camera can automatically select from all five sensors. In Dynamic AF [+] mode, you can designate the primary sensor—the one that the system should select first; if the subject moves to another area of the frame, other sensors will be automatically activated to maintain focus.

❏ Let's say you do want to select one of the five focus sensor areas; unlock the larger circular keypad (focus area selector) using the small switch at the bottom. Press the camera's shutter release button slightly; press the keypad up/down/right/left until you reach the desired sensor—this is displayed on the top deck LCD panel and on the viewing screen. To lock in your choice, rotate the switch to the locked position.

❏ The depth-of-field preview button is located on the front of the body under the F100 logo. Select an aperture, such as f/16, in any mode of the camera with the front dial. Now press the preview button—the screen is now dark since little light is entering via the very small aperture. (Your eyes will become accustomed to the dimmer view in a few seconds.) Note that

most everything appears sharp: the point of focus and the area in front and behind it. Release the button and select f/5.6. Now note that only the focused subject appears very sharp; the difference is most obvious if you have a 200mm or longer lens on the camera.

❏ Find the selector switch for exposure metering patterns on the right side of the pentaprism. With the central button pushed, turn the switch and stop when you reach the desired metering pattern symbol. Select among spot, matrix, and center-weighted metering patterns. The symbol for the pattern you select will also appear on the left side of the viewfinder data panel as a reminder.

❏ Press the button for exposure compensation [+/-] to the right and below the on/off switch, and turn the rear dial to set a plus compensation factor (to increase exposure from the meter recommended settings) and then set a minus factor (to decrease exposure). Release the button.

❏ The [BKT] button featured on the left top of the camera allows you to select autoexposure/flash exposure bracketing—taking two or three frames of the same subject, with the exposure varied from one frame to the next. Press it and rotate the rear control dial until [BKT] appears in the top deck LCD panel. Rotate the front dial while pressing the [BKT] button. Watch the various options appear in the LCD panel: number of

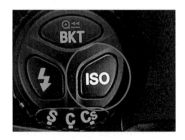 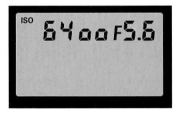

The set film speed appears on the top left side of the LCD panel when you press the ISO button. To change the film speed, hold the ISO button and turn the rear dial until the right ISO is displayed on the LCD panel.

frames, amount of exposure deviation from one frame to the next, etc.

❏ With the Flash Sync mode button (lightning bolt symbol below the BKT button) pressed, rotate the rear dial to switch among the various options. These are shown on the top deck LCD panel. You will see the display change as you select: normal setting, slow sync (for long exposures with flash), slow sync with rear shutter curtain or regular sync, red-eye reduction, red-eye reduction with slow sync flash. Unless you have a flash unit attached to the F100 and activated, this control will not achieve anything, of course.

❏ The film speed button [ISO] to the right is used to manually set the ISO film speed or to activate auto DX, which automatically sets the film speed by reading the DX barcode on the film cassette. To manually set a film speed, press and hold the [ISO] button and turn the rear dial until the right ISO number is displayed on the top deck LCD panel.

The film advance mode selector sets single-frame, continuous, and continuous-silent advance, as well as multiple-exposure and self-timer functions.

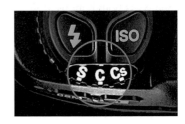

❏ The film advance mode selector (S, C, Cs) dial, below the button above, lets you choose among three film advance modes: single-frame (S), continuous (C), and quiet/slow/continuous (Cs); you can also set the camera for multiple-exposure (overlapping frames of film symbol) or self-timer (clock symbol). Note that this selector dial can be rotated only while the unlock button (near the BKT button) is depressed.

❏ To the right of the [CSM] button on the back, left shoulder of the camera, is the lock button [L], which is used to lock the set aperture or shutter speed; try locking in a setting and then

unlocking it. (This is something you might want to do so when handing the camera to a child who might inadvertently change settings.)

Resetting the F100

Once you are ready to reset the camera to the basic settings, simply press and hold the [MODE] button and the [CSM] button simultaneously for more than two seconds. This returns the F100 to its default settings: central focus sensor, Programmed Auto mode, shutter speed and aperture lock canceled, exposure compensation canceled, AE lock canceled, exposure bracketing canceled, flash mode set to front curtain sync. (Custom settings are not canceled, however.)

Note: If you have custom settings that you want to cancel, the procedure is a bit different. Press and hold the [MODE] button and the [CSM] button simultaneously. Note that [CUSTOM] blinks in the top deck LCD panel. Release one of the two buttons once and then press both buttons again for two seconds.

Changing Lenses

First remove the translucent body cap that comes with the camera and the rear cap on the lens. The lens is attached to the camera so that the index line (white line in the center of Nikkor lenses) is opposite the white dot near the camera's bayonet mount. Once the marks are aligned, turn the lens counterclockwise until it snaps in place. (Do not hold the lens with the focusing ring or the zoom ring but by the back end of the barrel.) The click must be heard and felt when the lens engages. It is also a good idea to try a gentle clockwise turn to confirm that the lens is properly seated in place.

Unless the aperture ring of the Nikkor lens is set to the largest f-number or to "A," you'll get a blinking **FEE** warning in the viewfinder and on the top deck LCD panel. The camera will not fire until this is corrected. If the lens is not properly mounted, **F- -**

(instead of **FEE**) will be displayed in the viewfinder and on the LCD panel. When this happens, the lens must be removed and mounted properly. In order to remove the lens, press the release button (on the front of the camera above the M, S, C switch) and turn the barrel in a clockwise direction.

Note: The display *F- -* also appears when you mount a lens without a CPU (such as an AI Nikkor lens without electronic contact points) or when no lens is attached to the camera. To see if you are using a non-autofocus Nikkor lens (without CPU), simply check on the aperture ring of the lens.

Custom Setting: If you prefer to set apertures using the ring on the lens instead of the camera's command dial, set CSM 22-1.

Preventing Electronic Faults

Whenever you are changing lenses, Nikon recommends switching the F100 to OFF to prevent any possible electronic fault. However, the authors must confess that we usually forget to do so, and the F100 has never malfunctioned as a result of this omission. You should follow recommended procedure, however. To be safe, you should also turn the camera OFF when changing batteries. Should you forget to switch off the camera during a battery change, this should not cause a major problem. Should the LCD display indicate an error, turn the F100 OFF and remove the batteries. Then reinsert the batteries. If an *err* warning appears frequently, consult a Nikon dealer or service center.

Replacing Batteries

A high-tech camera with many features and a multitude of computerized capabilities requires an appropriate power supply. In the case of the F100, this is four 1.5V AA-type alkaline-manganese or lithium batteries.

The standard battery holder can be exchanged with the 3V lithium battery holder MS-13, which is configured to hold two 3V CR-123A or DL-123A lithium batteries. However, the 123A

The battery holder release is on the bottom of the camera, and the battery chamber is in the camera's grip.

batteries are far more expensive than alkaline AA batteries and are difficult to find outside major cities. In most countries, lithium AA batteries are available. Though expensive, four lithium AA batteries can last up to twice as long as two of the small 123A types and do not require an MS-13 holder.

The F100's battery chamber is in the camera grip. To open the chamber, fold out the metal wing screw and turn it counterclockwise until it comes to a stop. Then pull the battery holder out in a downward direction and remove it completely. The four batteries are inserted as shown by self-explanatory markings. Use only batteries of the same brand. Do not combine old and new batteries.

The camera grip is reattached to the camera by pushing it back in until it comes to a stop. Then tighten the wing screw in a clockwise direction.

Note: The polarity of the batteries must be correct or the camera's electronics could be damaged. If the LCD panel does not display any data after you load batteries, remove the batteries immediately. Check the + and - markings on the holder and on the side of the batteries and reload the batteries correctly.

Practical Tip: The battery and camera contacts should be clean, dry, and free of grease. The most effective way to clean battery terminals and contact points inside the battery holder is to use the

eraser on a lead pencil. However, be sure to blow away any small rubber particles before reinserting the holder into the F100.

Power Options

For extra power, you may want the optional Multi-Power High Speed Battery Pack MB-15, which features a vertical grip and controls: shutter release, AF start button, and command dials. These make the F100 easier and more comfortable to use in a vertical orientation. The MB-15 can be loaded with six 1.5V AA-type alkaline-manganese or lithium AA batteries.

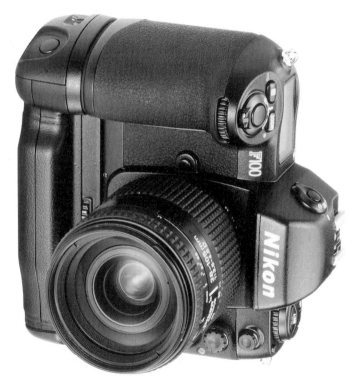

In addition to more battery power, the Battery Pack MB-15 provides an ergonomic grip with an alternate shutter release, AF start button, and command dials positioned for shooting vertical-format pictures.

You may prefer to use the optional rechargeable NiMH battery MN-15 pack, which has been designed specifically for the MB-15. The Quick Charger MH-15 allows approximately 500 charges and provides maximum power supply for your Nikon F100. Regardless of the type of battery used, the top film advance rate increases from 4.5 to 5 frames per second when the MB-15 is used.

Automatic Battery Check

When you turn the camera's power switch from OFF to ON, a battery symbol appears on the top deck LCD panel, regardless of the activated operating mode of the camera. With the camera switched ON, battery power status will be displayed at all times; check it frequently, especially in cold weather.

The battery symbol indicates three stages. A black symbol indicates that the batteries have sufficient power. As voltage decreases, half of the battery symbol appears white. At this point the batteries do not have to be changed, but a new set should be kept handy. After a rest (or after a cold camera warms up), the batteries may recover, and the symbol will indicate full power after the camera is switched ON again. This is due to charge fluctuations and how the automatic battery check feature is programmed, which causes the "half power" symbol to appear well ahead of time.

Batteries must be changed only when the "half empty" symbol starts blinking. If there is no battery power indication on the LCD panel at all, the batteries are dead. If there is still no indication after a battery replacement, it is possible that they have been inserted improperly. Check this by reopening the battery chamber.

Changing the Focusing Screen

The BriteView B focusing screen, which is standard on the F100, can be exchanged with clear/matte E-type Fresnel screen that is etched with a grid pattern. Special tweezers are supplied with the replacement screen. With the lens removed, pull the focusing screen release latch outward using the supplied tweezers. Grab the small tab on the screen with the tweezers and remove it completely from the camera. Now insert the new focusing screen in

the holder. Then use the tweezers to push the front edge of the holder upward and listen for it to click into place.

The grid screen, with its vertical and horizontal lines, is useful for architectural photography and for copy work with the F100 mounted on a copy stand. It is a valuable aid in the accurate alignment of the camera. The grid pattern also makes it easy to follow the Rule of Thirds when composing an image; place the primary subject at an intersecting point of the grid.

The Type E focusing screen

Viewfinder Information

Sophisticated photography requires that exposure-relevant information be available without taking the camera away from your eye. To achieve this, the viewfinder of the F100 offers a full information data panel below the image area. As well, the location of the five focus detection sensors is clearly marked on the viewing screen. When you use the F100, the AF sensor that is active lights up in red under certain circumstances, as will be discussed. (Its brightness level adjusts for lighting conditions, so it is easy to see at all times.)

The central 12 mm diameter circle on the screen indicates the area of primary sensitivity when the F100 is set to center-weighted metering. There is no indicator for the spot metering area, because its location varies depending on which of the five focus areas you select. The spot metering segment has a diameter of 4 mm and corresponds approximately to the size of the individual focus detection sensor rectangles etched into the viewing screen.

Up to 12 items of information are available at a glance in the data panel below the viewing screen. This status bar provides clear displays of all exposure-relevant information. In the diagram below, all viewfinder information is displayed at the same time. In reality, only currently active functions are displayed so that

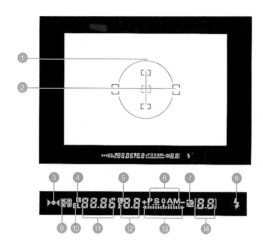

Viewfinder information

1 Reference circle for center-weighted metering area
2 Focus brackets (focus area)/spot metering area
3 Focus indicators
4 Shutter speed lock indicator
5 Aperture lock indicator
6 Exposure mode
7 Exposure compensation
8 Flash ready light
9 Metering system
10 AE-L (autoexposure lock)
11 Shutter speed
12 Aperture
13 Electronic analog exposure display
14 Frame counter/exposure compensation value

you have continuous and complete awareness over essential camera settings.

The Top Deck LCD Panel

The top deck LCD panel is the Nikon F100's most comprehensive control and information center. It informs you of all essential camera settings and provides data regarding remaining battery power, the film ISO setting, and activated custom settings; some of these require you to press the pertinent button for the information to appear. In the diagram below, all possible information is

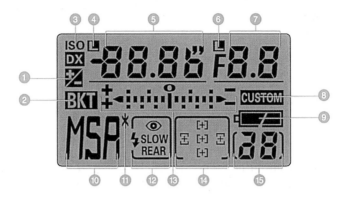

The top deck LCD panel

1 Exposure compensation
2 Autoexposure/flash exposure bracketing
3 Film speed/DX indication
4 Shutter speed lock
5 Shutter speed
6 Aperture lock
7 Aperture
8 Custom setting
9 Battery power
10 Exposure mode
11 Flexible program
12 Flash sync mode
13 Electronic analog exposure display
14 Focus area
15 Frame counter

displayed at the same time. However, when pictures are taken, only the currently active data and functions are displayed so the data does not become confusing. It can be read easily at all times—even in darkness, because the panel can be illuminated.

To activate the top deck LCD panel illumination, turn the ON/OFF power switch to the position with the lightbulb symbol. The panel is now illuminated in green. The light stays on as long as the camera's exposure meter is on; there is no need to hold the switch.

Custom Settings: By using the custom setting CSM 17-1, the camera can be programmed to switch on the LCD panel illumination

whenever any button is pressed on the F100. To save battery power however, this custom setting should be used only when you are planning to shoot in dark conditions for quite some time. Afterwards, return it to the 17-0 setting to cancel the custom setting.

The LCD (Liquid Crystal Display) indicates data on the panel. At temperatures around 140°F (60°C), which can easily be reached during summer inside a car, the LCD panel will turn black. At very low temperatures (below the freezing point), the reaction of liquid crystals is somewhat slow. However, liquid crystals recover as normal temperatures around 68°F (20°C) are reached again. In time (perhaps five or more years), the liquid crystal displays will fade and become difficult to read. (This is something that occurs with any camera and not just the F100.) At that time, a Nikon Service Center can replace the module; a charge for this service will apply, of course.

Adjusting the Viewfinder Eyepiece

A clear and sharp viewfinder image is necessary for composing photographs, checking automatic focus and depth-of-field, and for manually setting focus when desired. In order for all photographers (even those who are near- or farsighted) to see a sharp viewfinder image, the Nikon F100 features diopter adjustment. It is very simple to adjust the viewfinder to your eyes.

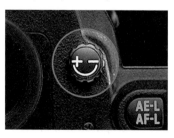
The diopter control knob

Remove the lens and look through the viewfinder at a uniformly light surface, such as a white wall or the sky. Then pull out the adjustment knob next to the viewfinder eyepiece and rotate it until the brackets and the circle etched into the viewing screen

appear sharp and with distinct contrast. Then press the knob in again, without turning it.

The built-in correction range is –3 to +1 diopters (DP). If your eyesight requires more correction, ask a Nikon dealer to order one of the nine optional corrective lenses with values between –5 and +3 DP. (Your optometrist can tell you which corrective lens to order.)

Note: Of course, you can also wear your eyeglasses when using the F100. Thanks to the high-eyepoint design, you can see the entire viewing screen and data panel even if your eye is up to 21 mm from the eyepiece. However, in very sunny conditions, the bright light can make it difficult to see everything clearly, and stray light entering around your glasses may affect the overall exposure.

Depth-of-Field Preview Button

The depth-of-field preview button is located on the right side of the housing between the bayonet mount and the handgrip. It can be pressed easily with the middle finger of the right hand. When you do so, the diaphragm mechanism of the lens stops down to the actual aperture you have selected. Instead of viewing the scene at the widest lens aperture, you can do so at f/8, f/11, or f/16, etc. This enables you to visually assess the actual zone of apparent sharpness that will appear in a photograph.

This lets you check through the viewfinder, before making an exposure, whether the working aperture is appropriate for the depth of field considering the subject and the background. Is background clutter quite noticeable at f/11? If so, switch to f/8 and preview depth of field again. If it is still excessive, switch to f/5.6 and so on. In other situations, you may wish to render an entire scene sharply—from a foreground tree, to a mid-ground river, to the mountain in the distance. Check the depth of field at several apertures until you find an f/stop that depicts the right zone of apparent sharpness.

Note: When you press the depth of field preview button, the viewing screen will darken, especially at smaller apertures such

as f/16 or f/22. This occurs because you are viewing the scene through a small opening, so not much light is reaching the viewfinder. In most circumstances, your eye will adapt to the dimmer view in a few seconds. You can still see well enough to manually change the point of focus.

In very low light, however, it may take your eye much longer to adapt. In some situations, such as in the late evening, you may not be able to visually assess the zone of apparent sharpness, because the viewing screen will seem nearly black. In that case, you may have to guess at the depth of field.

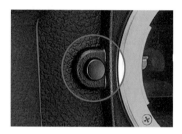

The depth-of-field preview button

Other Camera Functions

In addition to the primary capabilities, the Nikon F100 offers other functions which are useful and well worth considering. Following is a summary as well as some commentary on functions not reviewed in detail elsewhere in the book.

Self-Timer
The self-timer automatically fires the camera after a period of time determined by the photographer. This delay allows the photographer to get in front of the tripod-mounted camera to be

This red LED flashes during the self-timer countdown.

included in the picture. When the photographer is not looking through the viewfinder while the picture is being taken, it's important to use the Eyepiece Cover DK-8 if shooting in any automatic mode. After focusing and composing, with the camera mounted on a tripod, slip this accessory onto the eyepiece to prevent light from entering the camera and affecting the exposure.

Press the small lock button near the [BKT] button to unlock the control and rotate the film advance mode selector past S and C until you reach the clock, which is the self-timer symbol. Press the shutter release button, and the shutter will open ten seconds later to take the picture.

There is a more significant use for the self-timer: It can be used instead of a cable release to ensure a sharp picture, without the risk of blur from vibration. During the delay, all vibration quiets down; this is important especially with long telephoto and micro lenses, because any vibration would be amplified under high magnification. Nikon offers remote-control accessories that can be used to achieve the same purpose, but the self-timer does not require you to buy and carry extra gear. Granted, the delay is not ideal with subjects such as birds or flowers moved by the wind. In such situations, you need to trip the shutter at exactly the right time—when the subject strikes the right pose or during a brief lull in the wind.

Of course, the self-timer can be used in any operating mode and with system-compatible flash units; all camera and flash capabilities are maintained. It is best to use a stable tripod for self-timer shots. If you do not have a tripod handy, you can improvise and set the camera on a table, a windowsill, or a wall. Autofocus can be used, but generally manual focus is more convenient for the situations in which self-timer is used.

Custom Settings: Depending on the intended use of the self-timer, you may want to change the delay time (the time between pressing the shutter release and the instant when the actual exposure is made) with custom setting 16. CSM 16-2 offers a brief two-second delay, preferable when using the self-timer to trip the shutter without vibration. CSM 16-5 offers a five-second delay, and CSM 16-20 offers a 20-second delay (enough time to get into a picture and pose). The default setting is CSM 16-10, offering a ten-second delay.

The actual countdown is activated by pressing the shutter release button. The self-timer countdown is indicated by a blinking LED located on the front of the camera body. With a delay time of five, ten, or 20 seconds, the indicator LED blinks and then remains lit for the last two seconds. With a delay time of two seconds, the indicator LED remains lit constantly. This visual indicator for the countdown is important for the subjects, because it is easier for them to judge when the picture will actually be taken. This countdown can be canceled by switching off the camera (front dial on OFF). The self-timer function remains activated, however, even after the camera is switched off. In order to deactivate it entirely, you must turn the film advance mode selector into another position.

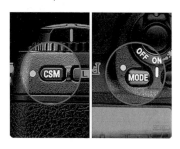

Simultaneously pressing these two buttons for two seconds will automatically reset the F100 to its default settings.

Two-Button Reset
One highly useful feature of the Nikon F100 is the two-button reset, because it lets you return to the camera's default settings in a quick and easy manner. It allows you to cancel inadvertent settings or intentionally selected overrides, such as AE bracketing, exposure compensation, etc. This reset feature is not specifically marked on the camera, apart from two green dots, but it is easy to activate.

Simultaneously press the [CSM] and the [MODE] buttons, and hold them for more than two seconds. Camera functions are now returned to the default settings. This does not reset custom settings. If you wish to return them all to the default setting, note that the indication CUSTOM blinks for two seconds on the top deck LCD panel during the two-button reset process. To cancel custom settings, release one of the two buttons when you see the CUSTOM indicator blinking. Then press both buttons again.

After two-button reset, the camera functions return the following default settings:

- ❏ Programmed AE is switched on
- ❏ Program shift is deactivated
- ❏ Central focus detection sensor for AF is activated
- ❏ Exposure compensation is set to zero
- ❏ AE bracketing is set to zero
- ❏ Flash sync is set to front curtain
- ❏ Aperture/shutter speed lock is deactivated
- ❏ Any metered value locked in by AE lock is canceled

Data Back MF-29
To install the optional MF-29 back, remove the original camera back by tilting it to the right while pressing the back release pin on the top left corner of the back. Do not touch any of the internal components of the camera, such as the shutter, while doing so. To attach the MF-29 back, press the release pin and pop the accessory into place.

The optional Data Back MF-29 lets you imprint date and time information in the sequence of year/month/day, day/hour/minute, month/day/year, or day/month/year. The imprint appears in the lower right corner of the frame (horizontal format). Against a light or reddish background, it may be difficult to read the data, but the numerals are usually quite visible in the finished slide or print. They remind you of the shooting date, important at times, like for a family event or in travel photography. Imprinting data is suitable for documentary photography and technical applications. However, at times, the numerals can also ruin the aesthetics of a photograph. The solution is simple: Imprint only on the first frame of a roll.

Custom Setting: With custom setting CSM 18-1, the Nikon F100 can be programmed so that the data will be imprinted at the beginning of the roll of film, on frame "0."

Three small buttons labeled [MODE], [SELECT], and [ADJUST] are located below the small LCD panel of this camera back. The [MODE] button activates the type of data combination. The [SELECT] button is used to select the sequence. The

[ADJUST] button is used to set the correct data. By pressing the [SELECT] button again, the setting is confirmed or stored.

Once the data have been entered correctly, the desired combination is retrieved by pressing the [MODE] button. If data are not to be imprinted, the display on the LCD panel on the camera back must show "— ——." Practice setting the data, revising it, printing, and canceling the print function.

Optional F100 Accessories

Nikon offers numerous accessories for the F100; following is a brief discussion of the most essential. Several neck straps are available plus two soft cases.

Remote release accessories include the Remote Cord MC-20; it is 2.6 feet (80 cm) long and plugs into the ten-pin terminal on the front of the F100. Various extension cords, cords for connecting two F100 cameras, adapters, etc. are also available. Nikon offers two Modulite Remote Control Sets: ML-2 for triggering the camera from distances up to 328 feet (100 m) and ML-3 for remote control to distances up to 26.2 feet (8 m). The camera is triggered by an infrared pulse that is activated when you press a button on the remote control unit.

Remote Cord MC-20

Remote Control Set ML-3

Power accessories are discussed in the pertinent sections as are the eyepiece correction lenses. Several others are discussed in the chapter on flash. For specifics on any accessories, you should visit a Nikon Advanced Systems Dealer and ask the staff to consult their catalog; a brochure on some may also be available.

Nikon F100 Custom Settings

To select a custom setting, rotate the rear dial while pressing the CSM button. To view the last-used custom setting on the LCD panel, press the CSM button.

The Nikon F100 features 22 custom settings which let you reprogram certain camera functions to your specifications and needs. Because the use of each of these options is discussed in appropriate sections of this guide, the following is only a brief summary of the available options. You may wish to photocopy this section and carry it with you for quick reference.

Rotate the rear dial while pressing the [CSM] Custom Setting Mode button to access the desired function from 1 to 22. If you merely press the [CSM] button, the last-used custom setting will be indicated on the LCD panel. While holding the [CSM] button, rotate the front dial if you want to change a setting—CSM 7, perhaps, from 7-0 to 7-1. To cancel the change of a custom setting, you have to retrieve the respective custom setting and enter the default setting—7-0 in this example.

The two-button reset allows you to cancel all custom settings and return to the default settings as detailed earlier in this chapter. Following is a list of all available custom settings:

#1: Auto film rewind at end of film roll
 0: Disabled (default); film rewind starts only when two buttons are pressed
 1: Activated, with automatic start of rewind at the end of the roll

#2: EV steps for exposure control (aperture, shutter speed, and exposure compensation)
 3: Increments of 1/3 EV steps (default) are used and displayed in the data panels
 2: 1/2 EV step increments
 1: 1 EV step increments

#3: Bracketing order
 0: First frame is taken at the metered value, the second underexposed, and the third overexposed (default)
 1: Sequence changes to: underexposed; at metered value, overexposed

#4: Autofocus activated when shutter release button is lightly pressed
 0: AF is activated (default)
 1: AF is not activated when the button is pressed; the AF start button must be pressed to do so

#5: Warning of non-DX-coded film, when ISO is set to DX
 0: After film is advanced to the first frame (default)
 1: Warning occurs whenever the power switch is ON

#6: Focus area selection
 0: Normal selection (default); a focus detection sensor is selected when the appropriate part of the thumb pad is pressed
 1: Press and hold any section of the thumb pad, and the selected focus area continues to change until the pad is released

#7: AE lock when shutter release button is lightly pressed
 0: Disabled (default); the [AE-L/AF-L] button is required
 for AE lock
 1: Activated; autoexposure value is locked while light
 pressure on the shutter release button is maintained

#8: Auto film loading when camera back is closed
 0: Disabled (default); a new roll of film advances to
 frame #1 only after shutter release button is pressed
 1: Enabled; as soon as the camera back is closed, film
 automatically winds to frame #1

#9: Dynamic AF mode in AF-S with Closest-Subject Priority
 0: Camera sets focus for an object closest to one of the
 focus detection areas when Dynamic AF is selected
 in Single Servo AF (default)
 1: Disables Closest-Subject Priority

#10: Dynamic AF mode with Closest-Subject Priority in AF-C
 0: Disables Closest-Subject Priority when Dynamic AF
 is selected in Continuous Servo AF (default)
 1: Activates Closest-Subject Priority

#11: Autoexposure/flash exposure bracketing
 AS: Both exposure value and flash output are shifted
 (default) for each frame of a series of images
 AE: Only exposure value is shifted; if flash is used, output
 remains constant for each frame
 Sb: Only flash output is shifted; exposure for ambient
 light remains constant for each frame

#12: Command dial functions
 0: Main command dial (rear dial) controls shutter
 speed; sub-command dial (front dial) controls f/stops
 (default)
 1: Main command dial (rear dial) now controls f/stops
 while sub-command dial (front dial) controls the
 shutter speed

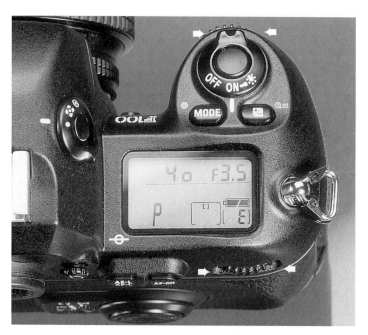

With custom setting CSM 12-0, the rear dial controls the shutter speed and the front dial controls the aperture setting; with CSM 12-1, the rear dial controls the aperture setting and the front dial controls the shutter speed.

#13: Use either dial for exposure compensation settings (depending on CSM-12)

 0: Disabled; must press and hold [+/-] button to set exposure compensation (default)

 1: Activated; exposure compensation can be performed without pressing the [+/-] button by simply rotating the front dial in P or S mode and the rear dial in A or M mode

#14: Multiple exposure, film advance

 0: Single-frame firing (default) when multiple exposure function is set

 1: Continuous shutter release operation; exposures continue to be made on the same frame of film as long as the shutter release button is depressed

#15: Time delay for auto meter switch-off (exposure metering)
- 4: Exposure meter automatically shuts down four seconds after camera is turned ON or after light pressure on shutter release button is removed
- 6: Six seconds (default)
- 8: Eight seconds
- 16: 16 seconds

#16: Self-timer duration
- 2: Shutter is released two seconds after shutter release button is pressed
- 5: Five seconds
- 10: Ten seconds (default)
- 20: 20 seconds

#17: LCD illumination control with any button
- 0: Disabled (default); illuminator is active only when power switch is turned to the lightbulb symbol
- 1: Activated when any button on the camera is pressed

#18: Data imprint on frame #0 (with MF-29 back)
- 0: Canceled (default)
- 1: Activated; when data imprint is on, data will be imprinted on the film frame before frame #1

#19: Aperture setting with certain lenses
- 0: When a Micro Nikkor lens is used, or a zoom whose maximum aperture varies depending on focal length, the f/stop selected with the camera's command dial remains constant as focus is changed or the lens is zoomed (default). This assumes that an aperture smaller than maximum aperture has been selected, e.g., f/8 remains f/8 at any focusing distance and at any zoom position.
- 1: When a Micro Nikkor lens is focused, or a variable aperture zoom lens is zoomed, the actual aperture size will vary, e.g., f/8 may change to f/11 in extreme close-focus or when shifting to a longer focal length

#20: Shutter release indication via LED
 0: Disabled (default); red LED on the front of the camera only lights in self-timer operation
 1: LED lights up just before shutter release whenever camera is used

#21: [AE-L/AF-L] button options
 0: Both focus and exposure are locked simultaneously when [AE-L/AF-L] button is depressed (default)
 1: Only AE lock operation is provided
 2: Only AF lock operation is provided
 3: Both focus and exposure value remain locked after removing finger from the [AE-L/AF-L] button; both remain locked until the [AE-L/AF-L] button is depressed again

#22: Aperture selection via lens' aperture ring
 0: Must select f/stops via sub-command dial (front dial) in A or M mode (default)
 1: Can now select f/stops via the lens' aperture ring

Picture-taking With the F100

Getting Started

Let's take a more detailed look at getting perfect pictures with your F100 from the start, as well as correct film-loading procedures and the right camera-holding posture to ensure sharp photographs.

When taking pictures with an entirely new camera, even experienced photographers will likely make mistakes. Photo dealers know this problem well. Many customers complain about an apparently defective camera because the first roll of film is entirely black or exhibits some other serious problem. In the vast majority of cases, however, the problem was caused by improperly loaded film or an override (such as exposure compensation) that was set inadvertently. Or the film is exposed more or less properly, but some of the pictures are out of focus or blurred. When using a new camera, it is helpful to review shooting posture and shutter release technique.

Loading Film

Always change the film in shade, at least shade created by your body on a sunny day. As you load the film, never touch the shutter blades, which are visible through the film gate—neither with the looped film nor with your fingers. Even the slightest contact can damage the shutter.

To open the camera back, press the camera back lock release button on the left side of the body and slide the lock release lever down. The back pops open automatically. Insert the film cassette into the empty chamber on the left side at an angle from the bottom to the top; if necessary, press it down with your finger. Pull the film leader out to the red index mark on the right side. The film leader must lie as flat as possible, without slack. If you have pulled out too much film, remove the roll from the camera. Turn the knob on top of the cassette until the excess

length is wound back in. Close the camera back—you should hear and feel it lock.

When you press the shutter release button (with the camera switched ON), the film automatically advances to the first frame. The number "1" appears on the top deck LCD panel and the viewfinder data panel indicating that the film has been loaded correctly, and you may begin shooting. The frame counter (indicating the number of frames) remains visible on the LCD panel even when the camera is switched off. You can check the film confirmation window on the camera back to see whether film is loaded as well as the type.

If *err* and *E* are blinking on the LCD panel and in the viewfinder panel, the film has not loaded properly. In this case, open the camera back and try loading the film again.

Custom Setting: By using CSM 8-1, you can program the camera to advance the film to frame #1 automatically as soon as the camera back is closed. This custom setting is one that should be standard with most F100 owners.

Setting Film Speed

The Nikon F100 sets the film speed automatically with DX-coded film. It also allows you to set the film manually if necessary. With the [ISO] button pressed, rotate the rear command dial and watch the display change on the top LCD panel.

If you stop at "DX," the camera will automatically set the ISO film speed as long as the film has the DX barcode and its speed is in the ISO 25 to 5000 range. For normal camera operation, this should be the standard film speed setting mode. Because the DX bar code can occasionally produce errors, as when it is slightly scratched, check that the system has set the correct film speed by pressing the [ISO] button. Double-check the film speed every time you load film, even if you generally leave the F100 set for DX. This will help to prevent any unpleasant surprises.

If you have loaded a roll of film without the DX bar code (or with a badly scratched bar code) and you set the camera's ISO to "DX," an error message—*"ISO, DX, Err"*—will blink in the data panel. If this occurs, you must set the desired ISO number on the camera manually.

A film with an ISO film-speed rating of 100-200 is a good choice when photographing slow-moving subjects, such as these zoo elephants. ©Peter K. Burian

You may wish to manually set ISO, either because the film you are using is not barcoded or you intend to expose the film at an ISO other than the standard rating. Press the [ISO] button and rotate the rear dial until the desired ISO number—within a range of ISO 6 and 6400—appears on the top deck LCD panel. Be careful! This setting is maintained even when you change film. Unless you reset the ISO control to the DX setting or to another film speed, every roll of film you shoot will be exposed at the ISO you have set. This can produce incorrect exposures, if you change from ISO 50 to ISO 800 film, for example.

Note: Today, virtually every roll of 35mm film that is commercially available has DX barcoding. However, photographers who buy large bulk rolls and load their own cassettes will find that the cassettes sold for this purpose do not have the DX coding. However, many photo retailers sell DX-barcode stickers that can be attached to such cassettes.

Modifying the Film Speed

DX coding is certainly the easiest and most convenient way to set the film speed, but there are several reasons why you might set an ISO that is different than the manufacturer's film-speed rating.

Photographers will often "push" film to get a faster effective film speed. If you are shooting in dim lighting and find you have only brought along a low-speed film, such as ISO 100, you can manually set a higher speed. Each time you double the ISO, it represents a change in exposure of 1 stop. For example, setting a 100-speed film to 400 is a 2-stop adjustment. Every exposure on the pushed roll must be made at the same film speed. When you push film, essentially what you are doing is underexposing the film. You must then compensate for the underexposure by over-developing the film when it is processed. When dropping the film off at the lab, indicate that the film needs to be push-processed and by how much.

Some photographers prefer the more saturated colors and finer grain that are produced by overexposing color negative film slightly. Typically, an exposure increase of 1/3 to 1/2 stop, for example rating an ISO 100 film at 64, will yield the desired results with no need to adjust the processing.

Film Sensitivity

The sensitivity of any film to light, or film speed, is denoted using ISO numbers. (ISO is an abbreviation for International Organization for Standardization).

These ISO values follow a sequence whereby a doubling of the number represents a doubling of sensitivity; halving of the number represents halving of the sensitivity, as in the following examples:

❏ An ISO 200 film is twice as sensitive to light as an ISO 100 film is.

❏ An ISO 400 film is twice as sensitive to light as an ISO 200 film is.

❏ Conversely, an ISO 100 film is half as sensitive to light as an ISO 200 film.

❏ An ISO 200 film is half as sensitive to light as an ISO 400 film, and so on.

Note: An older term for film speed numbers was ASA, but this term is obsolete, even though it is still used by some photographers. In any event, if someone says "100 ASA film," simply think of it as "ISO 100 film." There is another series of numbers that has been used to indicate film sensitivity, the DIN series. You may still see film marked with both the ISO and DIN numbers: 100/21°, for example. In most countries ISO numbers are commonly used today.

Commercially available film speeds run in the following series: 25, 50, 64 (an intermediate speed becoming less common), 100, 125 (common only in black-and-white film), 160 (common only in films for portraiture), 200, 400, 800, 1000 (an intermediate speed, much less common), 1600, and 3200. The last two are not common, but you will find a few films of ISO 1600 and 3200. Some highly specialized films may be available in other ISO numbers as well.

Film Selection Criteria

Let's begin with generalities when considering other criteria. The most important consideration is the sensitivity to light (designated with an ISO number), on which grain and sharpness are generally dependent. The photographer has to decide which characteristics are most important and pick the corresponding film. If an extremely sharp, superfine-grained image is critical, a slow film around ISO 25 to 64 should be selected and a tripod used if the shutter speeds are too long for a handheld camera.

However, if you want to handhold the F100 in low to moderate light or you plan to freeze motion, a higher film speed from about ISO 400 to 800 will help you to achieve the faster shutter speeds that will be necessary. The more prominent grain of this type of film is a fact of life with slide film, but today's color and black-and-white ISO 400 negative films are very fine-grained and should produce excellent prints up to 11 x 14". The best ISO 800 color negative films produce fine 8 x 12" prints.

Practical Tip: ISO 200 color print film is becoming a popular film choice. The best of today's ISO 200 films are very similar to the slower ISO 100 films. Read film test reports in photo magazines, or ask a photo retailer who stocks various brands. In slide film, the best ISO 200 films produce good, if not exceptional, results.

The Well-Stocked Photographer

Make sure to keep a variety of films on hand. The latest high-speed films yield fast shutter speeds for a night sporting event or for interiors where flash and tripod are prohibited. With a good supply of different films you can shoot a broad variety of subjects in diverse conditions and get high-quality images. If extreme sharpness and resolution (with minimal graininess) are your primary concerns, select one of the slow films up to ISO 100.

When considering the various brands of color print films, remember this: A good lab is even more important than the choice of film brands. All popular brands will produce prints that range from very good to exceptional. With shoddy printing, however, even the finest film will produce only mediocre prints. Slide films, on the other hand, show significant differences between brands, especially in color balance and saturation. Here you will need to experiment (or at least read test reports in photo magazines) in order to narrow down the choices.

Practical Tip: Film should be stored in cool surroundings for best results. In summer, a refrigerator is a good choice. But if the film is fast approaching its expiration date, the freezer is better for long-term storage to reduce further aging. (Fast film of ISO 800 and higher should not be used after the expiration date even if it has been frozen.) Before use, however, film needs time to warm to room temperature to prevent condensation from forming on the cold emulsion.

Slide vs. Print Film

Two principal questions need to be asked when deciding on a film. Do you want prints or slides? Do you want to shoot in color or in black and white?

If exposure is the only factor, the choice is clear: Color negative film has a broad exposure latitude, unlike positive film. Exposure metering is not as critical as with slides, since corrections can be made at the time of printing. But the very best results are still obtained with optimal exposure. When in doubt, it is better to overexpose color negative films by 1/3 to 1/2 stop. For example, set the ISO to 320 on the F100 if you load an ISO 400 print film to reduce grain, increase color saturation, and provide superior detail in the negative.

Modern print films have such a wide exposure latitude. Also exposure errors can be corrected in printing—typically 1.5 stops under and 2 stops overexposure will still produce printable negatives. However, the sophisticated matrix metering system of the Nikon F100 will just about guarantee perfect negatives in a broad range of lighting conditions.

Slide films, on the other hand, demand very accurate exposure metering since they have a very narrow tolerance for error. As you'll see in a later chapter, this is where matrix metering or the many overrides (such as automatic exposure bracketing) available with the F100 will be especially appreciated.

Some photographers like to shoot two types of film on any outing or trip, perhaps color prints and color slides. Today, black-and-white print film is becoming popular again, and there is at least one black-and-white slide film on the market as well. If you plan to shoot two different types of films, it may be wise to carry two cameras: your F100 and another Nikon body so you can use the same lenses on both. Load one with your favorite film and the other with a new type for experimentation.

Note: Because few labs still process conventional black-and-white negatives, film manufacturers now offer black-and-white films that can be developed in C-41 chemistry intended for color negative film. Any minilab can process the negatives and make proof prints on color paper. They may not be true black and white, although a sepia (brownish) tone can be quite nice, too. Your photofinisher should be able to order true black-and-white prints for you from a lab that uses the traditional paper.

Of course, your film choice may depend on your subject matter. If you like to shoot portraits or nudes, you should choose a

film that provides excellent skin tones and moderate contrast so the images do not appear harsh. You'll find special portrait films (color negative type) with an ISO of 160 or 400. For landscape and architectural shots with exceptional definition of the finest detail, consider films of ISO 50. In the following sections, you'll find additional film selection criteria.

Film Type Pros and Cons

The term "slow" indicates a film that is not very sensitive to light (lower ISO number) and requires slow (long) shutter speeds to make good exposures. Conversely, a "fast" film is more sensitive to light, and consequently, good exposures can be made with faster shutter speeds. Let's briefly review the pros and cons of various film types and speeds:

Slide films feature a limited contrast recording range—dark shadow areas tend to go black while bright highlights may be "burned out," showing no detail. Also, slide films have a narrower exposure latitude than negative films, so they require very exact exposure. If the image is over- or underexposed by even 1/2 stop (0.5 EV), the slide may be unacceptable—excessively bright or dark. Slides are easier to evaluate visually than negatives. Good prints can be made from slides, although the process is far more difficult and higher priced than making prints from negatives. Patronize a film lab that specializes in prints from slides for the best results or labs that scan slides digitally and make prints from a computer file.

Negative films feature a wider contrast recording range—a broader range from shadow to highlight areas can be recorded with detail in both. They also offer a wider exposure latitude. Even negatives that have been exposed improperly by –1.5 EV or +2 EV still produce usable pictures. Color reproduction, print exposure, and frequently even sharpness and brilliance can be affected by the quality of photofinishing. Prints made from negatives (by conventional methods) are generally superior to those made from slides. Even when prints are made from a digital file, those made from negatives will be superior due to the film's wider contrast recording range.

To stop the action when photographing moving subjects, choose a high-speed film with an ISO rating of at least 400. This will allow you to shoot at the required higher shutter speed. ©Peter K. Burian

Very slow films (ISO 25 to 50) generally feature extremely fine grain, ultrahigh sharpness, and brilliant colors with deep color saturation. However, they tend to have a restricted contrast range and narrower exposure latitude. Because slow films need a lot of light, shutter speeds with such films will be longer, increasing the risk of image blur from camera or subject movement.

Slow to medium films (ISO 100 to 200) feature very fine grain and are still very sharp while offering brilliant colors and good color saturation. The chance of image blur is less, because they are more sensitive to light and allow for higher shutter speeds.

Medium to fast films (ISO 400 to 1000) have increasingly more prominent grain and lower sharpness as you move toward the

higher ISO numbers. The best ISO 800 print films can still produce a sharp, colorful 8 x 12″ print. However, slide films above ISO 400 tend to produce flat colors, feature more coarse grain, and create a soft, pointillistic look in ISO 1000 speed films.

Super-speed films (ISO 1600 to 3200) are not common but in general exhibit very noticeable grain, lower sharpness, and even flatter, less brilliant colors. They tend to have a narrower contrast recording range and exposure latitude, even in print film.

Other Film Considerations

Photographers who routinely buy the cheapest film they can find may be disappointed with the results. A brand such as Kodak is highly reliable, although "no-name" brands are cheaper. The old expression "you get what you pay for" applies here. At the very least, a high-quality brand offers constancy: repeatable results with uniform color and image characteristics. Following are a few additional tips on buying film:

❏ When you see a favorable test report (or hear positive comments) about a new film, consider trying it. From time to time, films featuring new emulsion technology should be compared with your familiar films.

❏ Films with the "professional" designation may be essentially the same as the "consumer" films. (Ask your dealer if your favorite professional film has a counterpart in the less expensive consumer line.) However, certain films (e.g., those optimized for portraiture) may be available only as pro films.

❏ Pro films should be refrigerated after purchase so they do not age (deteriorate) quickly. Unlike pro films, consumer films are intended to age gracefully in stores, camera bags, etc.

❏ Buy pro films only from stores that refrigerate them. If you travel, it's preferable to buy films at home where you have a reliable source. In some destinations, film is grossly overpriced or is not properly stored.

❏ On a trip of a lifetime? Do not skimp on film! Consider taking two to five rolls for each day, depending on your destination. You can always bring excess film home, but if you run out, you may not find your favorite type readily available. Take some short rolls of higher speed film in case you end up in a low-light situation where you cannot use flash or where ambient light will result in a more pleasing picture.

Taking Film on the Road
Films must be stored properly, not only at home but also when traveling. For extended car or camping trips in hot weather, consider a cooler with a bag of ice for storing film. If that is not practical, carry it in a white bag to reflect, not absorb, the sun. Covering the bag with a wet towel (refreshed at rest stops) can also be useful to keep the contents from overheating. Exposed films should be processed as soon as possible to prevent latent-image changes; when that is not possible, as on an extended vacation, keep the rolls cool.

Never leave film (or camera equipment) inside a car or truck on very hot days. Temperatures can rise rapidly and increase the risk of damage.

Film and X-ray Concerns
Modern airports are equipped with the latest generation of X-ray equipment, emitting low-dose radiation. Tests conducted in the US and Britain confirm there is little risk of film being fogged by the X-ray systems used for carry-on bags. However, the new CT-scan systems for scanning checked luggage emit harmful radiation, which will damage film. Consider the following tips for safe-guarding film when traveling by air:

❏ Never pack film in luggage that will be checked.

❏ Film with an ISO rating of 100 to 400 that is X-rayed by the systems used for carry-on bags probably will not show visible

On the trip of a lifetime? Don't skimp on film, and if flying, do not pack film in checked baggage. The best rule is to place film in your carry-on bag and request hand inspection whenever possible. ©Peter K. Burian ⟳

damage until it has been scanned at least five times. With film of higher ISO ratings, try to avoid any exposure to X-ray radiation.

❏ To be absolutely safe at all times, request hand inspection of carry-on film at the security counter; this is a right in the US and Canada but not necessarily in other countries.

❏ In third-world countries, be aware that older X-ray equipment may be used; this might damage even low-ISO films, especially if they are scanned several times. Airport personnel in these countries usually refuse to hand inspect film. In this case, pack film inside a lead-lined bag (such as a Domke FilmGuard) and allow it to go through the system used for carry-on bags. An attendant will ask you to open the bag so he/she can determine its contents but will rarely send the film back through the X-ray machine.

❏ X-rays do not affect cameras, processed film (slides, prints, etc.), or digital disks. However, don't forget about the film that is loaded in your F100; protect that as well.

For more information and updates on the use of X-ray machines at airports, check the following Internet Web site: www.pima.org (Photographic & Imaging Manufacturers' Association site).

Film Processing
When you send films to a lab, you give up control of your images and have to trust in the quality control of the photofinisher. The processing of slides and negatives is standardized, so a lab with strict quality control should be able to produce good results. There have been far more problems with slide film processing—poor colors and exposure—than with negative film processing. When it comes to making prints, however, you may find a dramatic difference from one lab to another. Even the same photofinisher may produce different results on different days.

If you have been shooting with the F100, you should expect sharp, clear, and well-exposed prints with a natural color rendition. If your prints are too dark, too bright, or the colors seem "off," ask for reprints to be made. If these are still not acceptable,

start shopping around to find a lab that produces superior results. When you find one that consistently makes excellent prints, stick with that lab even if another lab offers a lower price. For a special print or oversized enlargement, consider a lab that caters to professional photographers. The higher cost will probably be warranted. A lab that is always crowded with satisfied pros picking up their work should be a great choice.

Storing Your Images

Negatives and transparencies should be stored in a dark, cool, and dry place. There are a number of storage options, such as protective sheets for negatives, archiving envelopes, and slide albums. Regardless of the photographer's choice, the important point is that the materials used be "archival": designated as free of materials that might deteriorate your images. It's best to file photographic products in steel cabinets, since those made from wood or veneers may contain glues, paints, varnishes, protective agents, or plastics compounds with fumes that could damage your images.

Film Technology

Simply stated, film is a photosensitive material consisting of a support layer or base and several photosensitive emulsion layers (as in color film). The commonly used term "emulsion" is not quite accurate, because in fact this is not a completely homogeneous suspension of gelatin, silver halide, and other substances (color couplers, sensitizers, and other chemical additives). Due to exposure (when the picture is taken), a so-called latent (hidden) image is formed in the emulsion. This image is rendered visible by development in chemicals, as positive or negative images, depending on film type.

A slide or transparency is a picture viewed by transmitted light with correct tonal and color values. The negative is an intermediate product with tonal and color values complementary to the original, plus an orange tint in color negatives. Paper prints produced from negatives, intended to be viewed by reflected light, exhibit correct tonal and color values.

The Color of Light

The most frequent problems and frustrations in color photography are due to color distortion. A color cast, i.e., a color rendition that is not neutral, can be caused by several different reasons: the color response of the film emulsion, improper film storage, processing or printing errors, using the wrong filter, the warm (orange) color of light at sunset, and so on.

These factors may influence certain dominant colors more or less. However, this is significantly less noticeable than the influence of the color temperature of the light in which the picture is taken. In a nutshell, neutral color rendition is achieved only when the color temperature of the illumination is compatible with the color sensitivity of the photographic material. Most commonly used are "daylight" films, which are sensitive to a color temperature of 5500° on the Kelvin scale. However, there are differently sensitized films for artificial light of type A (3400° K) or B (3200° K).

The white light at about noon on a clear day has a color temperature of 5500° K. On this same scale, warm (amber) light is denoted with low K numbers; sunset light may be around 2000° K. The cool (blue) light of a heavily overcast day may be around 7000° K on this scale. Color temperature is not discussed extensively in this book, but you should be aware of it and may wish to read more about it.

Any color temperature deviating from this results in more or less visible color shifts, depending on the extent of deviation, when pictures are taken with daylight film. This is insidious, because our eyes tend to adjust to changes in the color of light, for example, from afternoon to evening to sunset. Human color perception is subject to physiological as well as psychological factors and can therefore be deceived. Due to our eyes' subconscious adaptation to different colors, we do not recognize the color of light unless it is very obvious, as at sunset.

While we are rarely aware of the changing color of light during the day, photographs will depict the reality, especially slides. When making prints, a lab can correct for the cool light of an overcast day or the warm light at sunset. However, no such changes can be made when a slide is processed; corrections can be made if the image is scanned into a computer, but that is not a simple solution for most photographers. The film documents

every deviation from the color temperature to which it is sensitive with a more or less distinct color bias. When viewing a slide, the human eye is capable of recognizing minor differences in the color of the light and any color cast it has created.

Measuring Color Temperature
Color temperature can be measured only with a color temperature meter, such as Minolta's Color Meter III F or Gossen's Colormaster 3 F. Simply put, measuring the color temperature and the intensity of light can be done at the same time. To achieve this, the plane diffuser of the measuring unit is pointed from the object to the light source. Minolta's Color Meter III F even indicates values for mixed light situations, because its analytical capabilities can separately detect the percentage of flash in mixed light.

Using a color meter is beyond the scope of this guide. However, such accessories allow photographers to determine exactly which filter will produce a neutral effect on film.

Film and Color Filters

In color photography, colored filters are used to modify the color of the light. A pale amber filter used an hour after sunrise can restore some of the earlier warm glow, for example. If you're taking people pictures around sunset, you might use a pale blue filter to produce a more neutral color rendition. Filters are placed in the lens' optical path, generally screwed into the front of the barrel. (When flash is used, a colored filter can be placed in front of the flash tube.)

Even if you do not own a color temperature meter, you can decide which filter might be used in certain types of lighting. To make cool light more neutral, use an amber filter, such as a Tiffen 812 or 81A. To reduce the green effect of fluorescent lighting, use a pale magenta filter, such as an FL-D. To counter excess ultraviolet light and to protect the front element of a lens, you might want to use a UV filter. Many common filters such as these are listed in the brochures available from filter manufacturers, such as Tiffen.

There are also many special effects filters. Some create multiple images of the subject, others render bright points of light as stars, and some produce a soft focus (diffusion) effect, to hide

wrinkles in a portrait, for example. Nikon also offers a limited line of filters (the more traditional types) in the sizes most commonly required for Nikkor lenses.

Practical Tip: One of the most useful filters in outdoor photography is the Tiffen polarizer. Best known for darkening blue skies, this accessory has other uses. It will reduce or eliminate glare from reflective surfaces: glass, water, wet rocks, foliage, painted surfaces, etc. As a result, colors are richer and more subject detail (previously hidden by glare) is revealed. A polarizer also helps cut through atmospheric haze for more contrasty pictures. It is useful for both color and black-and-white film.

For proper operation of the autofocus and light-metering systems, the F100 requires a circular polarizing filter, not the linear type. (The term "circular" does not refer to the shape of the filter; it is a technical term.) Nikon and most filter manufacturers such as Tiffen offer circular polarizers often denoted with the abbreviation "CIR." Although Nikon does not offer one, a Tiffen warm circular polarizer (with a very pale amber tint) can be useful in situations where the light is cool or at high elevations for a more neutral color balance.

Motorized Film Advance

The Nikon F100 professional camera is equipped with a powerful motor for film advance and other film transport functions. Certain basic film advance settings can be changed by using custom settings. In basic mode, film threading and advance to the first frame are achieved after pressing the shutter release button. When you reach the end of a roll of film, shutter release is locked, and the message **End** (blinking for approximately six seconds after lightly pressing the shutter release button) appears on the LCD panel and in the viewfinder. To activate rewinding, press the [BKT] button and the [+/-] buttons simultaneously for over one second.

During the rewinding operation, a film cassette symbol with a bar "moving" from right to left appears on the LCD panel and in the viewfinder indicating that the film is being rewound. At the same time, the frame counter counts backwards. Rewinding is

stopped automatically, and an **E** (for empty) blinks in the frame counter on the LCD panel and in the viewfinder. Now you can open the camera back and remove the exposed film.

Custom Settings: By using custom setting CSM 8-1, the camera can be programmed so the film is automatically advanced to the first frame as soon as the camera back is closed. (Camera must be switched ON at the time.) If you want film rewind to start automatically after the last frame of film, set custom setting CSM 1-1.

You can initiate film rewind at any time before the end of the film roll. (You may wish to switch from ISO 100 to ISO 400 film, for example, when going indoors.) Press the [BKT] and the [+/-] buttons simultaneously. The film leader is always rewound completely into the cassette so you cannot accidentally reload a used roll of film.

Retrieving the Film Leader

When you rewind a roll of film before it is finished, you will need to retrieve the film leader in order to reload the film at a later time. Film leader accessories are available at specialty photo stores. Any film lab can also retrieve the leader for you.

A Nikon Service Center (in most countries) can reprogram your F100 to leave the film leader protruding after film rewind. A fee may apply. Think twice before authorizing this service. Once the camera has been reprogrammed, it will always leave the film leader out. Should you ever forget to manually tuck it into the cassette after finishing a roll, you may inadvertently reload it and ruin two sets of images.

Reloading Partially Exposed Film

Let's assume you have rewound a 36-exposure roll after the 15th frame and now want to reload this partially exposed roll in your F100. You have retrieved the film leader as mentioned previously. Start by loading the film the same as if it were a fresh roll.

Once you are at frame #1, however, do not take any pictures. Set the F100 to Manual operating mode (M), and set the highest

shutter speed, 1/8000 second. Set the smallest aperture (highest f/number, such as f/22). Now switch off autofocus—set the M position on the switch on the front of the camera. Cover the viewfinder eyepiece and cover the front of the lens with a lens cap. Then in dim ambient light, press the shutter release button until frame #16 is reached; monitor this on the top deck LCD panel. To be safe, advance to frame #17. Now you can continue to take pictures normally.

Film Advance/Rewind Options

The film advance is always motorized since the F100 has no mechanical film advance lever (like most cameras today). However, you may select between single-frame and continuous film advance, the latter at either of two speeds. The film advance function is set by means of the film advance mode selector located on the top left side of the housing. With its release button depressed, the film advance mode selector can be rotated to the desired position:

❏ S = Single-frame advance. One frame is taken each time you press the shutter release. This choice is recommended for most shots, except for photos of moving subjects where you want to shoot a series.

❏ C = Continuous advance. The camera fires as long as pressure is maintained on the shutter release button. The maximum speed is 4.5 frames per second, but you must be shooting at a shutter speed of 1/250 second or faster. This higher speed continuous advance mode is more suitable for sports and action photography.

❏ Cs = Continuous but "silent" film advance. This quieter mode offers a maximum speed of 3 frames per second. It is designed for situations where you do not want to create a disturbance such as in candid people photography, in wildlife photography, or at a wedding or other ceremony.

Continuous advance is useful for action sequences, such as these photos of an enjoyable bicycle trek. ©Peter K. Burian

Note: The speed and noise level of film rewind are also affected by the position of the film advance mode selector. In C position, rewinding is fast and somewhat noisy; in Cs ("silent") position, it is quieter but also slower: It takes 19 seconds vs. 9 seconds to rewind a 36-exposure roll. Frankly, neither film advance nor rewind is really silent in Cs mode, but the sound is certainly less audible and less annoying.

Increasing the Speed

The built-in motor drive in the F100 can be further enhanced by attaching the Multi-Power High Speed Battery Pack MB-15. This allows you to take continuous shots in C mode at a maximum frame advance rate of 5 frames per second, assuming that you are shooting at a shutter speed of 1/250 second or faster.

When testing the F100 to determine the highest film advance speed, Nikon technicians did so in the camera's Manual mode with continuous autofocus at a temperature of 68°F (20°C) with fresh alkaline AA batteries. Certain conditions may slow film advance: weak batteries, cold weather, a low-contrast subject that makes autofocus acquisition difficult for the system (in Single Servo AF), and so on.

Note: The NiMH battery MN-15 does not increase film advance rate beyond 5 fps and does not accelerate film rewind. Its primary advantages over alkaline AAs are as follows: It is rechargeable and offers superior cold weather performance, powering five times as many rolls at 14°F (although lithium AAs are even better at low temperatures).

Shooting Posture and Shutter Release Techniques

The Nikon F100's extremely powerful and sophisticated autofocus technology is of little use if your shooting posture and release technique are not right. Start by tucking in your elbows! Place your feet next to each other, spread apart at shoulder width. For low shooting angles, kneel on one knee. Relax your body—try not to be tense. Press the camera against your nose. The ball of your right thumb should rest in the ergonomically molded depression between the AF mode selector and the "spoiler." The thumb itself will rest on the [AF-ON] or [AE-L/AF-L] button; your right forefinger should touch the shutter release button. The other three fingers of your right hand are placed around the ergonomically designed camera grip. Use your middle finger to activate the depth-of-field preview button when desired. The base of the camera rests on your left hand's little finger and the ring finger (both angled), as well as on the ball of the thumb. This is the best posture for horizontal shooting. For vertical shooting, lift your right elbow but do not change the position of your right hand on the camera.

These are the most important adjustments before taking pictures; now you need to be able to reach a few controls, such as the front and rear dials, the MODE, or exposure compensation buttons. This is equally easy, regardless of whether you take pictures in vertical or horizontal camera orientation. The optional Multi-Power High Speed Battery Pack MB-15 is ideal for vertical framing, because its grip has additional shutter release and other controls that are easy to reach.

The suggested shutter release technique is actually quite simple. Breathe steadily, then stop after exhaling. During this quiet and relaxed phase, gently depress the shutter release button completely. If you can find something to lean on, like a door frame, do so, or use it to steady the handheld camera. Bracing both elbows on something solid (a table, a rock, the roof of a car, etc.) often allows you to shoot at longer shutter speeds.

Your reward for taking extra care in handholding the camera will be sharper pictures. If you still end up with unsharp images from camera shake when using the right posture and a shutter speed suitable for the focal length, use a tripod or switch to faster film for higher shutter speeds.

Use a tripod and the locking Remote Cord MC-30 to prevent camera shake when making long exposures, such as this photograph of Hong Kong at night.

Preventing Camera Shake

One rule of thumb suggests that the reciprocal of the focal length of the lens in use, rounded up, should be used as the highest shutter speed for handheld shots. Thus, with a 50mm normal lens, this would be 1/60 second; with a 500mm telephoto lens, 1/500 second. However, this is no guarantee of sharpness. If pictures must be absolutely tripod sharp, your shutter speed should be twice as fast as the rule suggests, especially with 300mm and longer lenses. With a 300mm lens, a suitable shutter speed would be 1/1000 second; with a 500mm lens, it would be 1/2000 second; and so on. In situations where you have difficulty getting the shutter speed high enough and you do not want to use a tripod, try a monopod or other camera brace system.

Long Exposures

The Nikon F100 offers you many possibilities for taking long exposures. In Shutter-Priority AE (S) mode, you can set exposures for up to 30 seconds while the camera automatically selects the

correct aperture. When you select a small aperture, such as f/16, in Aperture-Priority AE (A) mode in dim light, the camera automatically sets a longer shutter speed. In Manual (M) mode, you can set long shutter speeds, but you must also set the corresponding f/stop for correct exposure.

Exposure times longer than 30 seconds are also possible in M mode. Rotate the command dial past the 30 seconds shutter speed option to *bulb*, and the shutter will remain open as long as you press the release button on the camera or a remote-control accessory. Extremely long exposure times—photographing star trails for hours at night, for example—do consume battery power. A fresh set of lithium batteries, however, will last for approximately seven hours, except in cold weather.

The use of Remote Cord MC-30 with trigger lock or MC-20 with timer, or a remote control connected to the ten-pin remote terminal, is highly recommended to decrease the risk of camera shake. Of course, you should use a stable tripod for long-exposure photography. Fireworks, night shots, or multiple flash shots with open shutter are other examples of long exposures.

Reciprocity Failure

As discussed earlier, many combinations of f/stop and shutter speed produce exactly the same exposure on film. Set a wide aperture and a fast shutter speed or a small aperture and long shutter speed, and the same amount of light strikes the film. For example, if f/16 at 1/125 second is a correct exposure, you can get an equivalent exposure at f/11 at 1/250 second, f/8 at 1/500 second, f/5.6 at 1/000 second, f/4 at 1/2000 second, f/2.8 at 1/4000 second, f/2 at 1/8000 second, etc. (There are many other combinations selectable if you control the F100 in 1/3 or 1/2 EV steps.) This concept of equivalent exposure is known as the law of reciprocity.

Unfortunately, reciprocity is not valid in some cases: during extremely short flash exposures (e.g., a 1/30,000 second burst of flash at night) and in the event of extremely long exposures (e.g., 20 seconds). The concept is still correct, but film technology is unable to cope properly with such unusual exposures. The primary problem in general photography occurs with long exposure times, due to a loss of effective film speed.

This long-exposure error is known as "reciprocity failure" and may be noticeable even with exposures of a mere one second with some films. With other films, it may not become a factor until exposure times exceed ten seconds. (Pertinent data on reciprocity is published by film manufacturers. Ask for this data or check for information on their Web sites.) The bottom line is this: During very long exposures, the images will be underexposed. You must increase the exposure beyond the meter-recommended value.

Let's say you are photographing a reconstructed pioneer village at night, using the light of the moon and some lights that are lit in the buildings. The F100 may indicate that f/5.6 at 8 seconds will produce a correct exposure. With the vast majority of films, the images will be underexposed. You may need to leave the shutter open for 30 seconds (in Manual mode) at f/5.6. Or you can stick with a 15-second exposure but open to a wider aperture, f/2.8 in this example, based on a hypothetical film type. The latter is a better choice than extending the exposure time, since it does not aggravate the reciprocity failure effect. Note, too, that a color shift may occur with some films during long exposure times—the images may have a green or yellow cast, for example.

For such applications, shooting color print (not slide) film is recommended, since exposure errors and color casts can generally be corrected in the printing process. If you do shoot slide film, check the manufacturer's data sheet for information about filters that can be used to counteract the color shift (a magenta filter, perhaps, if the shift is toward green). Also, shoot the same scene at various exposures, increasing the exposure time or preferably, opening up to a wider aperture in Manual mode for each subsequent frame. Remember, too, that bright light sources such as incandescent lamps in a dark scene may produce underexposure if you shoot at the metered value; increase exposure for more accurate results.

Multiple Exposures (ME)

The multiple-exposure function is set by rotating the film advance mode selector while pressing the small lock button until the overlapping-frames symbol is opposite the index mark. For correct exposures, you may need to set exposure compensation

The overlapping frames symbol indicates that the camera is set for the multiple-exposure function. Make sure to return to one of the standard advance modes when you no longer wish to make multiple exposures.

in automatic modes; rotate the rear dial while pressing the [+/-] button to do so.

When the F100 is set for multiple exposures, the film will not advance to the next frame after you take a picture. You can make any number of exposures on the same frame of film. The frame may shift slightly while you are shooting; this is a problem especially near the beginning or end of a roll of film, so avoid multiple exposures at those times. After you have made the desired number of exposures on a frame, you must deactivate the ME function and return to conventional film advance C or S to allow the camera to wind the film to the next frame.

Custom Settings: When the ME function is set, one exposure is made each time you press the camera's shutter release button. If you wish to quickly shoot many exposures on the same frame of film, set custom setting CSM 14-1. Now the shutter will keep opening and closing as long as you maintain full pressure on the shutter release button. This is rarely useful unless photographing a model in various poses, for example. Normally, the default setting CSM 14-0 is preferred where an exposure is made each time the shutter release button is pressed.

Multiple exposures, which capture several views of the same subject or various subjects on a single frame of film, can be effective. For example, you may decide to photograph a flower in focus and then out of focus on the same frame for a halo effect. Or you may want to photograph a model against a black background in various poses, perhaps with flash. Multiple exposures may be performed in any camera operating mode but works well in Aperture-Priority or Shutter-Priority AE with exposure compensation. The latter is essential in most situations when you overlap

images on the same frame, because you are exposing the film to light two or more times. Overexposure will occur (the final image will be far too bright) unless you compensate by reducing exposure from the metered value.

Compensating Exposure for Multiple Exposures
One rule of thumb suggests that you use the camera's ISO dial to "trick" the system into underexposing for multiple exposures—setting ISO 1600 with ISO 100 film when shooting 16 exposures on the same frame of film, for example. However, in many cases, this is an excessive amount of underexposure. And some situations require no exposure compensation at all, e.g., a dark background with the subject located in a different part of the frame for each exposure (no overlap).

There is no magic formula for getting correct exposure in ME. With negative film, exposure errors can often be corrected in the printing process. However, with slide film, the overall exposure should be correct, or reasonably so. As a starting point, consider the following rule of thumb, setting these exposure compensation values in any AE mode:

❏ For 2 exposures on the same film frame: set a -1 EV factor
❏ For 3 exposures: set a -1.5 EV factor
❏ For 4 exposures: set a -2 EV factor
❏ For 5 exposures: set a -2.5 EV factor
❏ For 8 or 9 exposures: set a -3 EV or -4 EV factor

When shooting slide film, experiment. If you plan to shoot nine exposures on a frame of film, for example, try the -3 EV compensation factor suggested above. Then allow the camera to advance to the next frame in C film advance mode and set the camera for multiple exposure operation again. Reshoot the nine exposures on the next frame of film, but this time with a compensation factor of -4 EV.

Focusing the F100

The Autofocus System

The Nikon F100, like the F5, features the powerful Multi-CAM 1300 AF Module. Compared with the F5, autofocus operation is not quite as lightning fast, according to some scientific tests. However, in practice, you are unlikely to notice a difference. The AF system includes complex technology worth understanding for a full appreciation of the practical advantages of the AF system in your photographic pursuits.

❏ The Multi-CAM 1300 AF Module features a very wide working range from low light to high brightness: –1 EV to 19 EV (at ISO 100). The exposure value –1 corresponds approximately to the brightness in a candlelit room. Therefore, the F100's AF system functions perfectly even at light levels so low that manual focusing would be impossible or unreliable.

❏ The system includes wide area coverage ("Wide-Cross-Array"), using five focus detection sensor locations, which are etched in the viewing screen using rectangles. The size and arrangement of the five AF rectangles create a large focus detection area of 16 x 7.1 mm, which allows for quick shooting with off-center subjects and effective tracking of moving objects.

❏ The system works equally well in horizontal and vertical compositions. The three sensors arrayed horizontally on the screen are of the cross-type: capable of focusing on almost any kind of pattern. Within these three focus detection rectangles, there are two types of sensors: The narrow, quick-to-respond AF cross-type sensors are active at normal brightness; and the wide, slightly slower-to-respond cross-type sensors are activated in weak light or with certain long lenses. The combination ensures maximum AF speed in bright light and maximum AF accuracy in low ambient light.

❏ The F100 features two AF modes: Single Servo AF with focus-priority and Continuous Servo AF with shutter-priority (both discussed later). Individual AF sensor areas may be selected

The F100's sophisticated autofocusing system produced a perfectly focused view of the various elements in this dramatic architectural shot. ©Peter K. Burian

manually or automatically. When you select a specific focus detection rectangle it is illuminated in bright red on the viewing screen (by an LED-projected display). You can lock in your selection of focus detection sensor with a lever on the Sensor Selector pad (on the back of the F100 so you do not inadvertently switch to another sensor).

❏ You can select any of the five AF rectangles as the primary focus area in action photography. The selected sensor will find focus, but the other sensors will then take over automatically (in Dynamic Autofocus). If the subject moves to another part of the frame, the system will continue to track its progress with sharp focus. You can change your choice of primary sensor using the AF Sensor Selector pad on the back of the F100.

❏ The system includes Nikon's exclusive overlap servo mechanism. Overlap refers to the fact that the system can detect focus and drive the lens simultaneously. These two steps are not distinct, so autofocus speed and accuracy are maximized.

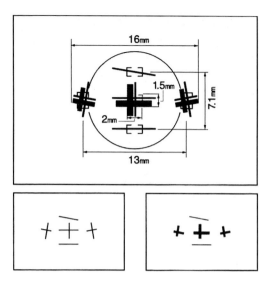

The top diagram shows the arrangement of the F100's autofocus sensors. The bottom left diagram shows the AF sensors used in normal lighting conditions. The bottom right diagram shows the wide sensor pattern active in low light.

When the AF system detects a subject, it drives the lens, focusing not in small jerky steps, but smoothly, simultaneously calculating the changing camera-to-subject distance and making constant focusing updates. Reliable autofocus is assured even for erratically moving subjects that slow down and accelerate as you track their progress.

❏ The High-Speed Focus Tracking system is the "predictive" type. A computer anticipates the direction of the moving subject. It also predicts the exact position the subject will reach at the instant when the shutter curtains open to make the exposure on film. Focus tracking operates at the maximum film advance rate of 4.5 fps, or at 5 fps when the optional MB-15 Battery Pack is used.

❏ Lock-On Autofocus helps to assure that you do not miss a shot when tracking a specific action subject, such as a soccer player with the ball. Even if the subject wanders off the rectangular focus area in the viewfinder or if another player

momentarily blocks the view of the subject, autofocus with lock-on will continue to track it.

❏ Closest Subject-Priority technology allows the system to acquire focus even if a subject is not exactly covered by one of the five focus detection areas. This is helpful in candid photography, because you can concentrate on taking pictures instead of trying to line up the subject with one of the rectangles etched on the viewing screen.

❏ If you decide to change to manual focus with an AF Nikkor lens, the operation will be fully mechanical, not electromechanical as with some brands of camera systems. This provides smooth, sure manual focus and will not cause battery drain.

❏ In manual focus, the electronic rangefinder operates with most Nikkor lenses. This provides focus-assist signals in the viewfinder that confirm accurate focus or supply information as to the direction you should turn the lens' focusing ring to get sharp focus. This system works with lenses with a maximum aperture of f/5.6 or larger, the vast majority of Nikkor lenses.

Autofocus Speed

In addition to the design-influenced performance of AF systems, focus acquisition and autofocus tracking speed are also affected by other factors. Here are three rules of thumb:

❏ The larger the maximum aperture of the lens, e.g., f/2.8 vs. f/5.6, the more reliable autofocus will be, and vice versa.

❏ The shorter the lens focal length, e.g., 50mm vs. 600mm, the faster the AF, and vice versa.

❏ The brighter the ambient light and the greater the subject contrast, the faster the focus acquisition will be, and vice versa (e.g., the system may not be able to set focus on a plain white wall that has no texture or contrast; try focusing on wallpaper with a pattern or roughly textured stucco and you should have no difficulty with autofocus).

Autofocus Modes

Your Nikon F100's autofocus system is switched on when the focus mode selector switch (on the front of the body) is set to "S" or "C." The "S" designates Single Servo AF, which is best for static objects, while Continuous Servo AF ("C") is useful for tracking moving objects. Both AF modes work only with autofocus lenses: AF, AF-D, AF-S, and AF-I series. (However AF will not operate with the few old Nikkor AF lenses designed for use with the F3AF, an early autofocus camera.)

Note: Autofocus operation will be maintained if you use one of the AF-I teleconverters on any of the AF-I or AF-S series of Nikkor lenses. However, AF will not operate unless the effective maximum aperture of the lens/converter combination is f/5.6 or wider. The 1.4x model reduces the effective maximum aperture by 1 stop (from f/4 to f/5.6, for example), while the 2x model reduces it by 2 stops (from f/4 to f/8, for example). Autofocus is not available with other Nikkor teleconverters.

Single Servo AF

Flip the selector switch (marked M, S, C) on the front of the F100 to the S position. Gentle pressure on the shutter release button activates autofocus. You can also activate autofocus by pressing and holding the AF start button [AF-ON].

Focus mode selector set for Single Servo AF

You will probably take most of your pictures using this focus-priority AF mode, whether portraits, landscapes, or still lifes. Generally, autofocusing is started by partially depressing the shutter release button (this also activates exposure metering). You must hold the shutter release button partially depressed until

focusing has been completed and the focus confirmation signal (on the left side of the viewfinder data panel) lights up. The selected AF sensor also appears red in the viewfinder. When you depress the shutter release button all the way to take the picture, the camera will fire only when focus is achieved; you cannot take an out-of-focus picture. This concept is called "focus-priority AF."

In some cases, two inward-pointing arrows will blink in the viewfinder, and the shutter will be locked so you cannot take a picture. This means that the AF system is unable to achieve focus on the intended subject because of lighting, lack of contrast, or other difficulty. However, it is also possible that the subject is too close—closer than the minimum focusing distance of the lens. Try focusing on another subject at the same distance: a door knob, perhaps. Once focus has been acquired, keeping the shutter release button slightly depressed locks focus so you can recompose without shifting focus to some other object.

Note: If your focused subject begins to move, the system will automatically activate tracking AF ("Servo"); it will continue tracking as long as you maintain slight pressure on the shutter release button. Focus locks again when the subject stops moving. Nonetheless, Continuous Servo AF is more reliable for action photography because there is no time delay in activating the Servo tracking feature.

Custom Setting: You may wish to use CSM 4-1 so that the shutter release button activates only the metering system and not autofocus. Then you can set the exposure for one area of a scene while focusing on an entirely different area afterwards.

Continuous Servo AF
Continuous Servo AF with High Speed Tracking is best for tracking focus of moving objects. To select this mode, flip the selector switch (marked M, S, C) on the front of the F100 to the C position. Gentle pressure on the shutter release button activates autofocus. You can also activate autofocus by pressing and holding the AF start button [AF-ON].

With the shutter release button partially pressed (or with the AF start button [AF-ON] fully depressed and held), the camera continuously updates focus data as the object is moving. In

Focus mode selector set for Continuous Servo AF

Dynamic AF mode (to be discussed shortly), the movement of an object is tracked automatically, shifting as required from one AF sensor to the next. The autofocus Lock-On feature also operates. Continuous Servo AF mode uses "shutter-priority AF," which means that the shutter will release to take the picture even if the subject is not yet in perfect focus. Maintain pressure on the shutter release button and focus tracking will continue.

Note: Focus is not locked when the focus confirmation signal appears in the viewfinder data panel. That simply means that focus has been achieved.

Custom Setting: With CSM 4-1, focus is activated only when the [AF-ON] button is depressed and not with the shutter release button.

Tracking AF Evaluation

Theoretically, you should watch the focus confirmation signal and not trip the shutter until focus has been confirmed. However, in our experience with a Nikon F100, we found that the tracking system is highly reliable. We could simply trigger the camera and shoot a series of 10 frames at 4.5 or 5 frames per second. In most cases, the vast majority of these photos would render the subject in sharp focus. Dynamic tracking focus is indeed highly reliable, far more successful with action subjects than using manual follow-focus techniques.

AF System Limitations

The Nikon F100's AF system is based on "passive" autofocus technology. Unlike the "active" systems of most compact point-and-shoot cameras, it does not emit a beam to measure camera-to-subject distance. Therefore, the AF system may fail in the case of extremely bright light, such as reflections from a chrome surface on a sunny day or extreme conditions of backlighting. It may also fail in very low light or with subjects that have little or no contrast. Other sources of potential error sources are flat, monochromatic areas without distinguishable structure or texture. Foreground objects, such as the bars of a cage in a zoo , can also frustrate someone trying to photograph a subject that is behind the foreground objects.

The problem can sometimes be solved with substitute focusing: Focus on an object at the same distance as the desired subject, and lock focus by maintaining pressure on the shutter release button. Then recompose to frame the scene as desired. Naturally, you can also switch to focusing manually. In our experience, that will very rarely be necessary as the F100 contains one of the most successful AF systems on the market today.

Focus Area and Mode Selection

In this section, we will begin discussing some of the basic autofocus options available with the F100. Later we will discuss other options, especially the use of custom settings to modify the operation of the AF system. Because there are many possible combinations of Focus Mode/AF Area Mode, you may want to read this chapter several times, with your F100 in hand.

The Focus Area Selector
You have several options when it comes time to activate the focus detection sensors of the F100's autofocus system. The "command center" for the selection of AF sensors is on the camera back. Its main component is the Focus Area Selector: a large circular thumb pad. To operate the Focus Area Selector, unlock the large circular thumb pad on the back of the F100 with the small tab at the bottom. Press the thumb pad in any direction, guided by the

arrows marked on it. Watch the display change in the top deck LCD panel. Once you reach the desired AF sensor—perhaps the one in the center of the screen—stop. Your selection will be confirmed on the LCD panel and on the viewing screen; the selected sensor lights up in bright red on the screen. Re-lock the thumb pad with the small tab at the bottom so your selection is not changed inadvertently.

Custom Setting: The Focus Area Selection thumb pad switches your selection of focus detection sensor as you press the pad in the desired direction: upward, for example, to select the top focus detection sensor and to the right to select the sensor to the right of center. With CSM 6-1, the operation can be changed. Now you can simply press any edge of the thumb pad and the selected focus detection sensor will keep changing. When you reach the one you want, simply release pressure on the thumb pad. This CSM has no major advantage, but some photographers prefer to access the desired focus detection sensor in this manner.

The Single Area AF mode is most useful when you are shooting stationary subjects.

The AF Area Mode Selector

To the left is the smaller circular AF Area Mode Selector with two options clearly marked: one for Single Area AF ([]) and the other for Dynamic AF ([+]). To select between the two options,

When Dynamic AF is set, you select the primary AF sensor to focus on the subject. If the subject moves, focus shifts to the next sensor that detects the subject.

simply rotate the small circular dial to the autofocus Area Mode that you want. The difference between the two is very significant, so decide carefully. Single Servo (S) or Continuous Servo (C) is selected with the switch on the front of the F100.

Focus Area and AF Mode Options

Single Area AF Mode [] with Single Servo AF (S): When you choose this option, only the single focus detection sensor that you select—using the Focus Area Selector—will be active. The other four will be totally inactive. This is ideal for situations where you want to photograph a relatively stationary subject such as a person posing for a portrait. You can set focus for the most important area, the eyes, in this example, and then recompose with focus locked (with only slight pressure on the shutter release or on the [AE-L/AF-L] button).

Dynamic AF Mode [+] with Single Servo AF (S) with Closest Subject-Priority: This is the "snapshot" mode where you allow the camera to make the decisions as to exactly what will be in focus; you might use this when photographing a group during an activity at a birthday party. To switch to the Dynamic AF mode, set the AF Area Mode Selector on the back of the F100 to the [+] position. Do not designate any AF sensor. With this combination, the system selects a subject—something that is closest to any of the five AF sensor areas—and sets focus on it. Focus will be locked as long as you maintain gentle pressure on the shutter release button.

Note: If the subject moves before focus has been locked, the camera will continue to focus on it by using one of the other focus detection sensors.

Dynamic AF Mode [+] with Single Servo AF (S) without Closest Subject-Priority: If you set custom setting 9-1, the system deactivates the Closest Subject-Priority feature. Now you must select a specific focus detection sensor, and only that sensor will be active. Once focus has been set for the subject covered by the rectangle on the viewing screen, focus will be locked as long as

you maintain gentle pressure on the shutter release button; there is no need to press the focus lock button. This combination is generally used only for stationary subjects.

Single Area AF Mode [] with Continuous Servo AF (C): With this combination, you must specify one AF area—only that one will be active. Because "C" is a continuous focus mode, focus will not be locked. Tracking focus is constantly operating, so if the subject is moving, focus will be continuously readjusted. This combination is suitable for subjects moving straight toward the camera and not moving erratically, such as a car racing toward you or away from you. The subject is adequately large, so there is no need for other AF sensors to be active.

Note: Remember that only the single AF area that you designated will be active, so you must keep that rectangle on the subject at all times; if you fail to do so, the system will set focus for whatever it targets as the new subject. Naturally, you can select another AF area at any time by pressing the large thumb pad on the back of the camera.

Dynamic AF Mode [+] with Continuous Servo AF (S): This is the combination recommended for most action photography. To use this, you must designate a primary AF area. The autofocus system will detect the subject that is covered by the red rectangle on the viewing screen, and it will set focus on that subject. If the subject then moves to another area of the frame, like a football player running across the field, Dynamic AF automatically shifts to the next sensor to maintain tracking focus. (The system will continuously shift sensors in order to maintain focus on the primary subject.) Due to the size and arrangement of the five AF sensors, a large AF area of 16 x 7.1 mm is effectively created, and irregularly moving objects can be tracked very efficiently.

Dynamic AF Mode [+] with Continuous Servo AF (C) with Closest Subject-Priority: In order to activate the Closest Subject-Priority feature, you must set custom setting CSM 10-1. Think twice before doing so, because you are relinquishing control: This is a snapshot mode where the camera will decide what will be in focus. The autofocus system will simply find a subject that is

closest to any of the five AF rectangles and decide that this is the subject of choice. If that subject moves, the system will continue tracking it, using all of the five AF sensors.

Note: This combination, with CSM 10-1, may be useful at sporting events where many players occupy the field and move around quickly and erratically. You may decide that you merely want sharp pictures of the action, without worrying about which player will be selected as the subject to be in sharpest focus. In that case, this snapshot mode will do just fine. However, remember to reset the F100 afterwards to CSM 10-0 (the default setting).

Focus Area Indication

Depending on the autofocus options you have selected, the focus detection area—denoted by a rectangle etched into the viewing screen—may or may not be illuminated in red. This can confuse the Nikon F100 owner who may suspect that the camera is malfunctioning. In fact, this approach was a conscious decision by the designers and does have some logic, which will not be debated here.

However, be aware that the focus area rectangle is illuminated in red only when you designate a specific AF sensor area, as discussed in the previous sections, and not in cases where you allow the system to select sensors automatically. (Nor is the active sensor denoted on the top deck LCD panel.) Note that when the autofocus system begins tracking a moving subject with other sensors, the display on the screen (and on the LCD panel) will not keep changing, i.e., the newly active area rectangle will not suddenly light up in red on the viewing screen.

Reference Guide: Focus Modes and AF Areas

❏ **Single Servo AF** (set the selector switch marked M, S, C on the front of the camera to the S position) with **Single Area AF** (set [] on the rear dial): You must designate a focus detection sensor, and only that sensor will be active. After autofocus is achieved, focus will be locked. (This is fine for stationary subjects where precise focus on an essential subject element, perhaps one large blossom in a flower bed, is your primary goal.)

❏ **Single Servo AF** (set "S") with **Dynamic AF** (set [+]) **with Closest Subject-Priority:** You do not designate a primary AF rectangle. The camera sets focus on the subject closest to any of the five areas. Focus is locked after it is achieved. If the subject moves to another part of the frame before focus is locked, one of the other sensors will focus on it. (This is a snapshot mode in which the camera's AF system decides what subject will appear in sharpest focus.)

❏ **Single Servo AF** (set "S") with **Dynamic AF** (set [+]) **without Closest Subject-Priority:** You must set CSM 9-1 to get this combination. Designate one of the AF sensor areas—all of the others will be inactive. You must keep this rectangle on the subject until autofocus is achieved. You can then recompose, and focus will be locked as long as you maintain light pressure on the shutter release button. (This is suitable for general shooting with stationary subjects.)

❏ **Continuous Servo AF** (set "C") and **Single Area AF** (set []): You designate one AF sensor area as "primary," and the others will be inactive. Focus is achieved on the subject that is covered by the designated area. Focus is not locked, and tracking focus follows the subject but only as long as it remains covered by the designated rectangle. (This is useful for subjects moving in a straight line toward the camera or very large subjects, such as a racing car; it is easy to keep the subject within the single, designated focus detection sensor.)

❏ **Continuous Servo AF** (set "C") and **Dynamic AF** (set [+]): Designate one "primary" AF area that will achieve focus. Should the subject move to another part of the frame, the camera will continue focusing on it using any of the five area sensors with tracking focus. (This is ideal for erratically moving subjects, such as football players, where you want a specific subject to be selected for sharp focus.)

❏ **Continuous Servo AF** (set "C") and **Dynamic AF** (set [+]) **with Closest Subject-Priority:** You must set CSM 10-1 for this combination. You do not designate one AF area. Instead, the camera will find a subject that is closest to any one of the five

areas and set focus on it. Focus will be maintained on that subject if it moves from the first AF sensor area, using all of the AF sensors with focus tracking. (This is a snapshot mode, useful if you want sharp action pictures but are not concerned which subject is selected.)

Maximizing Autofocus Speed

If you want to make the already-fast Nikon F100 even faster, you can use the optional Multi-Power High Speed Battery Pack MB-15 together with the NiMH Battery MN-15. Now the maximum film advance rate increases from 4.5 to 5 frames per second; continuous tracking focus is able to keep up with this higher rate.

For action photography with telephoto lenses, the latest AF-S series of Nikkor lenses, with built-in Silent Wave (ultrasonic) focus drive motor, will offer the fastest/most reliable tracking performance. An earlier series (with conventional focus motor in the lens), the AF-I Nikkor models, also provides high performance but not silently. With old AF Nikkor lenses, such as the AF 300mm f/4ED, tracking autofocus may not be as reliable as with the newer AF Nikkor lenses (look especially for the D-type). With the old lenses, much more mass must be moved, so tracking focus is not as fast.

The AF Assist Illuminator

The Multi-CAM 1300 AF Module is highly sensitive to light. Its response limit is at −1 EV (with ISO 100 and an f/1.4 lens). Consequently, it can function perfectly at dusk or in candlelight. The AF Assist Illuminator (in the Speedlights SB-22s, SB-23, SB-24, SB-25, SB-26, SB-27, and SB-28) allows you to take pictures in complete darkness. The AF Assist of the SB Speedlight is a red lamp located beneath the flash reflector. With the flash unit activated, lightly press the shutter release button of the F100. The AF Assist Illuminator will now project a bright red pattern (with six vertical lines) onto the subject as a reliable target for the autofocus sensors.

The AF Assist Illuminator offered on some of the Nikon Speedlights is an infrared beam that projects a grid pattern for the camera's autofocus system to focus on.

Note: With the F100, the AF Assist Illuminator works only when the central AF rectangle is activated.

The Illuminator is also useful if you want to focus on a subject without pattern or texture, such as a plain wall. It works best in moderate- to low-light conditions when the pattern projected onto the subject is most visible and not overpowered by bright ambient light.

The Illuminator is not intended for very distant subjects. Its reach depends on factors such as the level of ambient light and the brightness of the subject. However, we have found that a distance range of up to 30 feet (10 m) can be achieved indoors.

Even though the AF Assist Illuminator is positioned well above the lens, avoid using it with large telephotos longer than 300mm or with very large lens hoods. Otherwise, the lens barrel or the hood may block some of the light that is being projected, reducing its effectiveness as an autofocusing aid.

Focus Lock

The 16 x 7.1 mm autofocus detection area provided by the five AF sensors covers a rather large portion of the image area, so autofocus on off-center objects is very reliable. However, as discussed earlier, you may prefer to select a single AF area to focus on a specific subject area, such as the eyes in a portrait instead of the subject's nose. Or since an off-center composition is sometimes more pleasing than a centered composition, you may intentionally create a picture in which the subject is remarkably off-center.

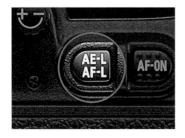

The AE-Lock/AF-Lock button has four possible functions, which can be programmed using custom setting CSM 21.

In situations such as these, you will want to designate a single AF area using Single Servo AF and Single Area AF, achieve focus on the intended area, lock focus, and then recompose. Focus is locked by lightly pressing the shutter release button or by pressing the focus lock [AE-L/AF-L] button. The AF sensor that you selected, e.g., the central rectangle, appears red in the viewfinder. Once focus is locked, recompose and press the shutter release button all the way down.

Occasionally, your subject won't fall within (align with) any of the auto-focus areas. In these types of situations, the autofocus lock feature allows you to achieve focus and then compose the photo as desired.

Custom Settings: By using custom function CSM 21, you can continuously change the function of the [AE-L/AF-L] button as follows:

❏ CSM 21-0 (default setting) = simultaneous focus lock and exposure lock when you press the [AE-L/AF-L] button.

❏ CSM 21-1 = the button now provides AE-Lock only (not AF-Lock).

❏ CSM 21-2 = the button now locks focus only and does not lock the exposure value (no AE-Lock is provided).

❏ CSM 21-3 = both exposure value and focus lock are provided when button is pressed; both remain locked until you again press the [AE-L/AF-L] button.

In Autofocus Mode combinations where light pressure on the shutter release button does not lock focus, you need to use the [AE-L/AF-L] button if you decide to stop AF tracking and lock focus. This lock remains active as long as the button is depressed, i.e., even after the shutter release button has been released.

While it is easy to assess and lock focus with static objects in Single Servo AF mode, it is difficult with moving objects in Continuous Servo AF mode. Should you lock focus, a moving subject probably would not be in focus in the resulting photograph. Should it stop suddenly, the autofocus system would stop tracking and render it sharply. Frankly, we do not recommend using AF-Lock in action photography. However, you may find specific reasons to do so.

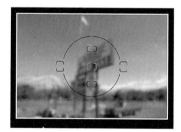

The entire matte field of the focusing screen can be used as a visual indicator of sharp focus.

Manual Focus

The Nikon F100 features excellent AF technology but, as with all automation, with some limitations. There are always lighting and subject situations in which manual focusing makes more sense than automatic focusing. Also, some photographers may prefer to use manual focus with AF lenses' Focus Mode Selector set to "M." Others own non-AF lenses, like the Nikkor AI-P or AI-S

series, which do not provide autofocus or accessories such as bellows and extension tubes; some teleconverters do not allow for AF operation.

Autofocus cameras such as the F100 do not provide focusing-aid devices in the center of the clear matte viewing screen. Consequently, you have two other options for achieving sharp focus manually. Both require that you turn the focusing switch next to the lens mount to the "M" position.

Manual focusing with visual confirmation: By looking at the viewing screen, watch the subject and stop turning the lens' focusing ring when it appears sharp. This technique can be used with practically any lens that can be attached to your F100 and allows you to focus on anything, anywhere on the viewing screen. In low light, however, or with subjects that have little apparent contrast, this technique may be difficult.

Manual focusing with Electronic Rangefinder: Fortunately, Nikon provides an electronic focus assist feature, which works with lenses that have a maximum aperture of f/5.6 or wider. Set the Focus Mode Selector to "M," and depress the shutter release button partway or depress the AF start button [AF-ON]. You'll notice that the indicator—at the left side of the viewfinder data panel—provides an indication as to focus. A large solid dot confirms that the subject is in sharp focus. If a > appears instead, turn the lens focusing ring to the right. If you get a < indication, turn the lens ring to the left. In either case, stop focusing when the large dot appears, confirming that focus has been achieved. If > < blinks in the data panel, the system is unable to confirm focus. You may be trying to focus closer than the lens allows, or the subject is a very poor target for the AF sensor system. In low contrast or low-light conditions, a Speedlight with an AF Illuminator lamp can be used; this will assist the Electronic Rangefinder system.

If you plan to focus manually, make sure that the viewfinder eyepiece is correctly adjusted for your own vision. Rotate the Diopter Correction dial to the left of the eyepiece while looking at the viewing screen. When the markings etched into the screen appear sharp, stop turning the dial. You will also note that manual focusing is easier and more accurate with long lenses and with lenses of wide maximum aperture, such as f/1.4, f/2, or f/2.8.

The combination of a wide-angle lens and a small aperture provides extensive depth of field. Everything in your photo from the foreground out to infinity will seem sharp.

Maximizing Depth of Field

With some subject matter, such as landscapes that extend from the near foreground to infinity, you'll want to decide on the exact point where you should set focus. In order to maximize depth of field (the zone of sharpness in front of the focused point and behind it), do not focus on the foreground or the distant background. Try framing the scene as desired. Now select a point that is about one third of the way up from the bottom of the image area, and set focus for that point, manually, of course. Set a small aperture, such as f/16, because depth of field is greatest at smaller apertures.

This technique should maximize the area of the image rendered acceptably sharp. You can double-check by pressing the depth of field preview button; if necessary, adjust the point of focus slightly to achieve your intended goal.

Lens Compatibility Chart

Lens	Focusing		Exposure Mode				Metering System		
	AF	Electronic Rangefinder	P mode	S mode	A mode	M mode	Matrix	Center-Weighted	Spot
AF-S & D-type AF Nikkors	\times	\times	\times	\times	\times^1	\times^1	\times^2	\times	\times^3
AF-I Teleconverters[4]	\times^5	\times^5	\times	\times	\times^1	\times^1	\times^2	\times	\times^3
Non-D-type AF Nikkors	\times	\times	\times	\times	\times^1	\times^1	\times	\times	\times^3
AI-P-type Nikkor	—	\times	\times	\times	\times^1	\times^1	\times	\times	\times^3
AI-type Nikkors	—	\times^6	—	—	\times	\times	—	\times	\times
Reflex-Nikkors	—	—	—	—	\times^7	\times^7	—	\times	\times
PC-Nikkors	—	\times^8	—	—	\times^9	\times	—	\times^8	\times^8
AI-type Teleconverters	—	\times^5	—	—	\times	\times	—	\times	\times
Bellows Focusing Attachment PB-6[10]	—	\times^5	—	—	\times	\times	—	\times	\times

x Compatible — Incompatible (IX-series Nikkor lenses cannot be used)

1 Aperture can be selected via sub-command dial.
2 3D matrix metering is selected.
3 Metering area corresponds to the selected focus area.
4 Compatible with AF-S and AF-I Nikkor lenses except AF-S 28-70mm f/2.8D ED-IF.
5 With maximum effective aperture of f/5.6 or faster.
6 With maximum aperture of f/5.6 or faster.
7 Aperture cannot be selected.
8 Without shift.
9 Exposure determined by presetting lens aperture. Exposure must also be determined before shifting; use [AE-L/AF-L] button before shifting.
10 Auto Extension Ring PK-11A, 12, or 13 is necessary.

Metering Modes

The Nikon F100 features three exposure metering modes, each with different metering characteristics. Exposure with flash is discussed in the flash chapter, but it is helpful to first review exposure metering concepts in general. The following contains information on basic light-metering principles and offers an introduction to advanced metering techniques.

The following three exposure metering modes were designed by Nikon to meet the critical needs of professional photographers and advanced amateurs: AF-coupled 3D matrix metering with ten metering segments, center-weighted metering (75% of the meter's sensitivity is concentrated in the center of the image area and denoted with the 12 mm diameter circle in the center of the viewing screen), and true spot metering corresponding to 1% of the image area. This exposure technology can handle practically any picture-taking situation, provided the photographer is capable of assessing the drawbacks and benefits of each. Naturally, it helps to understand light-metering technique and to learn to evaluate different types of lighting situations.

This diagram shows the F100's ten-segment matrix metering pattern. The five small square fields correspond to the AF sensor areas.

3D Matrix Metering

3D matrix metering is unique to Nikon, the inventor of "multi-pattern" light metering. (The first camera to introduce this concept was the Nikon FA in 1983; naturally, the current matrix system is far more sophisticated.) Each Nikon camera has a slightly different matrix metering system. The F100 incorporates an entirely new matrix sensor with ten metering segments. It works with the

Multi-CAM 1300 autofocus module to combine information on light intensity and contrast with data on focusing to ensure the best possible results, optimized for the primary subject.

The entire image area is divided into ten metering segments—half of them coupled with the five AF focus detection sensors. A microprocessor evaluates brightness, contrast, subject position within the frame, and subject distance information for the most accurate exposure. Although some cameras on the market (including the F5) have more segments, the ten are sufficient for a meaningful analysis of brightness distribution over the image area. The computer ignores (or reemphasizes) extremely dark or bright peripheral areas, such as the sun in a corner of the frame. This is accomplished by the system's database, which is programmed with more than 30,000 actual scenes—real photographic subjects and exposure situations. By comparing the scene that is being photographed to this accumulated data, the F100 evaluates a complex array of factors. The result is the best exposure value—not necessarily optimal in every situation as we'll see, but with a very high success ratio of pleasing results.

Note: In order to take advantage of 3D matrix metering, you must use a D-type AF Nikkor lens. This provides the microcomputer with "distance data detection" information for the scene evaluation process. An encoder in the D-type lens mount detects and relays camera-to-subject distance information to the metering system, which analyzes this data for more accurate results, even in extremely complex lighting situations. D-type lenses include the AF Nikkor D series, plus the AF-I and AF-S lenses (with built-in autofocus motor), and the AF-I series of teleconverters. When you use AI-P Nikkor, or non-D-type AF Nikkor lenses, the F100 provides matrix metering but not "3D" matrix. (Manual focus lenses without a CPU do not work with matrix metering.)

Benefits of 3D Matrix Metering
By analyzing subject distance in addition to the other data, exposure accuracy is improved with 3D matrix metering. However, this is not dramatic when compared to standard matrix metering, because that system is extremely sophisticated as well. With print films, it is highly unlikely that you will notice any difference between the two results. With slide film, certain high-contrast

situations will be more accurately exposed with 3D matrix metering, because the exposure is optimized for the subject area in sharpest focus.

The 3D matrix system is a plus in situations where the contrast between subject and background is very high, such as with a group of friends on a sandy beach against a bright blue sky. In less difficult situations, the standard matrix meter produces excellent exposures, too. In flash photography, the 3D matrix meter offers advantages and superior results outdoors with multi-sensor balanced fill flash. The five-segment TTL multi-sensor for flash works in conjunction with the matrix system that evaluates ambient light, so distance data detection technology is helpful here, too. The odds are greater that the subject will be nicely exposed in bright conditions thanks to the sophisticated 3D matrix system. Again, in lighting conditions without extreme contrast, fill-flash photos will be beautifully exposed, even if you use a non-D-type AF Nikkor lens for matrix balanced fill flash outdoors.

Frankly, it is optimal to use D-type lenses for full 3D matrix metering with the F100. However, if you already own some non-D-type AF or AI-P Nikkor lenses, you will no doubt be highly satisfied with the conventional matrix metering system. With other types of lenses, such as manual focus AI Nikkors, matrix metering will not operate with the F100. Should you select it, the system automatically switches to center-weighted metering.

Selecting 3D or Matrix Metering
Press the lock release button and rotate the metering system selector on the right side of the camera's pentaprism until it reaches the central position. The lens' aperture ring should be locked on the smallest aperture (largest f/number). The matrix symbol will be displayed in the viewfinder data panel so that the photographer will be continuously informed of the activated metering pattern.

Custom Setting: Custom setting 22-1 allows you to use the aperture ring on the lens to change f/stops, instead of using the command dial on the camera. However, the selected aperture information will not appear in either of the camera's data panels. You must physically check the f/stop that has been set on the lens. Consequently, Nikon recommends this approach for use with

bellows accessories (for extreme close-up work), microscopes, telescopes, and reflex lenses, which have a fixed aperture so f/stops cannot be changed.

3D matrix metering should be the standard with your F100, especially in Program mode unless you intend to apply personal exposure control. The almost symmetrical distribution of the ten metering segments, the "fuzzy logic" artificial intelligence of the camera's CPU, and the distance data information will often produce beautiful exposures with either horizontal or vertical framing. "Fuzzy logic" technology allows the system to make smooth transitions even when making minor changes in exposure. As the brightness of the light changes ever so slightly, or the subject moves into light shade, adjustments in exposure are made in minute increments (in both types of matrix metering). In a nutshell, matrix metering evaluation is like the continuous human thought process.

Limitations of Matrix Metering
No matter how advanced artificial intelligence may be, high subject contrast, particularly with extreme backlighting, may frustrate even the most sophisticated metering system. Also, the contrast range may be far beyond the film's recording ability. Deep shadows will be rendered as solid black or bright highlight areas as pure white, because film cannot record detail on both ends of a tonal scale that is extremely high contrast.

When shooting into the light, for example, when photographing a child against extremely bright sky and water, Nikon recommends the use of fill flash for the most pleasing results—a nicely lit subject and a bright background that is not "burned out." Detail is maintained in the sky and the ocean using this method.

You'll find other scenes where the subject occupies only a small part of the frame with its bright surroundings making up most of the image area. For example, a distant skier on a snow-covered hill or a fisherman against a whitewashed Caribbean building may be underexposed. With a dark scene, like a water buffalo against black volcanic rock, overexposure may occur. The problem will not be severe with color negative film, since its wider exposure latitude often allows good (if not perfect) prints to be made. Switch to slide film, however, and even a minor exposure error will be noticeable.

Overriding the Computer

Nikon recommends that the 3D Matrix metering system be allowed to work without overrides, as the system is already adjusting for unusual conditions, such as snow. If you dial in an exposure compensation factor, it may be excessive, because you do not know what "strategy" the artificial intelligence has taken. If you intend to take control, switch to center-weighted metering and increase exposure by +1.5 stops for a snow-covered scene, for example.

Instead of using exposure compensation, it is better to use exposure bracketing when in matrix metering mode. In tricky lighting, bracketing in 1/3-stop increments usually produces at least one slide that is perfectly exposed.

Exposure Metering Fundamentals

Before moving on to steps you can take to control and override exposure, let's briefly review a few basic concepts. Light meters are calibrated to produce ideal exposures with midtone subjects or with scenes that average out to a middle gray. A landscape with grass, rocks, trees, and a bit of sky, for example, should produce a nicely exposed photo with almost any light meter.

When the subject is very bright or if the scene includes a vast expanse of bright snow, sand, sky, or water, underexposure will occur if you simply shoot at the light meter's recommended settings. The meter attempts to render the subject as a midtone, producing gray snow, for example. A very dark or black subject would be overexposed, since the meter attempts to render it as a midtone, producing a gray instead of black panther, for instance.

With bright subject matter, you need to increase exposure to render it brighter than middle gray. If the subject is a dark tone, you must decrease exposure. Methods to do both will be discussed in detail in this chapter. You can also exclude large expanses of bright areas in a scene, taking a meter reading of only the midtone areas. Then lock in the exposure value as we'll discuss, recompose, and take the picture.

Note: As discussed earlier, matrix metering is an "intelligent" system and will often produce good exposure even with subjects

or scenes that do not average out to a midtone. The concepts discussed here apply primarily to center-weighted and spot metering but should be understood when using matrix metering, since no automatic system is 100% foolproof. If you are testing a situation, use slide film in your F100 to avoid the printmaking step where a lab might override your exposure while attempting to produce a perfect print from a badly exposed negative.

With center-weighted metering, 75% of the meter's sensitivity is concentrated on the shaded area in this diagram.

Center-Weighted Metering

In order to set center-weighted metering, turn the metering system selector on the right of the prism while pressing the lock release. Rotate the switch to the appropriate symbol (o). Once set, the (o) symbol is also displayed in the viewfinder data panel.

In center-weighted metering, the exposure for the entire image area is measured, but 75% of the meter's sensitivity is concentrated in the central area. The rest of it (25%) is feathered out toward the edges of the frame. Center-weighted metering can be used with all Nikkor lenses, except the Medical-Nikkor 200mm f/4. This metering pattern is highly suitable with manual focus AI lenses, because matrix metering is not available.

Center-weighted metering is sometimes used even with AF lenses, because many photographers learned exposure control skills with a similar metering system. They know when to deviate from the meter's recommended value and to what extent. They may increase exposure for white desert sand by +1.5 stops or decrease exposure for a black limousine by -1 stop from a center-weighted reading. (These are rules of thumb only to illustrate the concept.) Such overrides are useful even with negative film if you want a perfectly exposed negative, which is always best to print from. Because the system is calibrated for midtones, exposures

will be incorrect with brighter or darker subjects. Unlike intelligent matrix metering, which will compensate (at least to some extent) for unusual situations, with center-weighted metering, the photographer must make adjustments.

Frankly, this is not a point-and-shoot metering mode, although it will produce good results with average scenes and subjects that are not overly bright or dark. Most photo instructors gear their courses to center-weighted meters, used with overrides, because these are still common in most cameras.

Center-weighted metering produced an excellent exposure of Angkor Wat temple in Cambodia.

Substitute Metering Using a KODAK Gray Card

Exposure meters are calibrated to produce ideal exposure with medium gray, also called a midtone. When using a metering pattern other than matrix or 3D matrix, you should get close to ideal exposures when you take a meter reading from a midtone in the scene. A KODAK Gray Card is frequently used for this purpose, because its tonality is known and is constant from one

card to another. Unlike rocks, tree bark, grass, and other mid-tones, it reflects 18% of the light each time you use it; there is no guesswork.

Use a KODAK Gray Card as follows. Place the card in the scene you plan to photograph in the same light as your primary subject. Tilt the card slightly so it does not reflect glare. Take a meter reading from the card in the camera's Manual mode, making sure not to shade the card with the camera. Then remove the card from the scene, open up by 1/2 stop (aperture or shutter speed), and shoot using these settings for as long as the lighting remains the same.

The F100 matches the 1% area for spot metering to whichever of the five focus detection areas is in use.

Spot Metering

To switch to spot metering, press the metering system selector lock on the right side of the prism and turn the switch until the appropriate symbol (a dot) is opposite the index mark. When spot metering is activated, a dot symbol appears in the left side of the viewfinder data panel as a constant reminder.

Similar in concept to center-weighted metering, spot metering is even more targeted. Instead of reading the brightness in a very large area of a scene, the spot meter ignores all but a very small 1% of the entire area. With it you can measure the reflectance of a single distant face in a crowd or any small subject element. Exposure is set for that point only. If it is a midtone, you should get a good exposure. If it is brighter or darker, under- or overexposure will occur unless you compensate.

Note: Remember, with the F100, the spot metering sensitivity is not always in the center of the image area as with many other cameras. When you select one of the five focus detection areas, meter sensitivity shifts to correspond with the selected focus

point. However, the spot metering sensitivity remains in the center when Dynamic AF is activated or when you use lenses without a CPU—any lens other than AF or AI-P.

After you take a spot meter reading, of a tanned face, for example, you may wish to recompose before taking the picture at the exposure value you have determined to be optimized for that face. In Program or automatic modes, press and hold the [AE-L/AF-L] button to lock in the exposure value as you reframe and shoot. (In Manual mode, this is not necessary since exposure values will not change when you recompose; ignore the meter warning of an "incorrect" exposure.) If you use the [AE-L/AF-L] button while in autofocus, AF will be locked, too. In most circumstances, this will be desirable.

Best results with spot metering are achieved by seasoned photographers with expert judgment of tonal values. It takes experience to be able to make the right adjustment. If the subject is not a midtone, a white bird, for example, you need to know the amount of deviation from the metered value that will produce the desired exposure, whether correct for the subject or your creative intentions. If not used in a thoughtful, knowledgeable manner, spot metering will produce less reliable results than the other two metering methods.

Spot metering is most useful in difficult lighting situations when you want to target an important detail of a scene. Therefore, it is particularly suitable for subjects with a high or extremely high contrast range, extreme backlighting situations, or for objects located in front of a very light or very dark background. For instance, you may be using an archway to frame a city scene, and the arch may be much darker than the distant midtone building that is your preferred subject. You are more likely to achieve the final result you are looking for with spot metering than with center-weighted metering, which may take the dark archway into consideration when calculating the exposure.

Beyond Exposure Metering
Some subjects cannot be measured by any exposure metering system, such as a bolt of lightning or fireworks display. In these unusual cases, it's best to use judgment and ignore the camera's light meter entirely. If you want to take pictures of fireworks in a

By using the "bulb" setting, the shutter stays open so that multiple bursts of fireworks can be recorded against the dark sky. Use a black card to cover the lens between fireworks bursts. ©Peter K. Burian

dark sky, for example, select the camera's Manual exposure mode (M) without autofocus. For the "shutter speed," select "*bulb*"; it appears after the 30 seconds shutter speed as you rotate the rear command dial. In bulb, the shutter will remain open as long as the shutter release button remains pressed. Therefore, it is a good idea to use a tripod and a cable release or remote control to trigger the F100 without jarring the camera. (These accessories were discussed in a previous chapter.)

Trip the shutter when a beautiful burst of fireworks lights the sky, in the area where your lens is pointed, and keep the shutter open for the duration. If you want to include another burst, or several, on the same frame of film, leave the shutter open but cover the lens while waiting for the next display. A small sheet of black cardboard is ideal for this purpose. Simply remove it when the next burst occurs to allow the light to register on the film. After recording the desired number of displays, release the trigger, and the F100 will wind to the next frame of film.

With this technique, you may be surprised at how good most exposures will be. The aperture you select depends on film sensitivity: small aperture (such as f/16) with ISO 400 film and a wider aperture (perhaps f/8) with ISO 100 film. This is a starting point for experimentation. However, correct subject framing, not exposure, will be your biggest problem. When the shutter is open, the camera's reflex mirror remains in the up position, so you cannot see the fireworks through the camera's viewfinder. You must guess when a burst is in the area that your lens includes (50mm to 85mm seems to work well, depending on the size of the displays and their distance to the camera). All too often you will capture just a portion of the display, so you should shoot a lot of frames in order to get a few that are really nice.

If you are shooting negative film and your final result will be color prints, when you turn the film in for processing and printing tell the lab that you want the sky to be dark (if you took the pictures at night). If you don't do this, you may be disappointed with the results, because the printer in the lab will tend to render the backgrounds as middle gray.

Setting Exposure Compensation

Exposure compensation values are selected by rotating the rear dial while pressing the compensation button [+/-]. While you do so, numerical values are displayed on the top deck LCD panel and in the viewfinder. After you select the desired factor, +1 for example, release the [+/-] button.

Only the compensation symbol (+/-) will appear in the top deck LCD panel. You can check the exact value that has been set by pressing the [+/-] button anytime. More specific information is provided in the analog scale in the viewfinder data panel. At +1, for example, note that vertical lines run from the zero on the scale to the left, up to the first major increment.

The ability to set exposure compensation (override) is very important in Program, Aperture-, and Shutter-Priority modes, because this allows you to adjust exposure without sacrificing the convenience of automatic functions. Exposure compensation is possible in Manual operating mode as well, but logically, it makes little sense since there are other methods for varying

exposure, as we'll see. Your Nikon F100 features exposure compensation within a range of ± 5 EV, a very wide range. As mentioned earlier, you will want to set a plus compensation factor for bright or white subjects and a minus factor for dark or black subjects. This technique is most desirable in spot or center-weighted metering, not in matrix or 3D matrix metering as discussed earlier.

If you have set an exposure compensation factor, that value is maintained even after the camera is switched off. To deactivate it, you have two options: Repeat the control procedure until the index mark is at the zero position on the scale, or activate rapid reset by pressing the [CSM] and [MODE] buttons simultaneously for more than 2 seconds. The latter resets other camera functions, too, which may not be desired, as discussed in the previous chapter.

Custom Settings: Generally, exposure compensation is set in 1/3-step increments. This can be changed with custom function 2 as follows: CSM 2-1 = exposure compensation in full-step increments; CSM 2-2 = 1/2-step increments; CSM 2-3 = 1/3-step increments, the default setting.

With another custom function, the F100 can be reprogrammed so you can set exposure compensation more quickly, without pressing the [+/-] button first. Set CSM 13-1 and note the following. In Program and Shutter-Priority modes, use the front dial to set exposure compensation—the rear dial will be used for program shift or for selecting shutter speeds. In Aperture-Priority AE, use the rear dial for setting exposure compensation and the front dial for selecting apertures. This is definitely a faster method but may cause you to inadvertently set an exposure compensation value that you did not want—this would produce serious exposure errors.

If you set CSM 12-1, the opposite applies as to which dial (front or rear) you must use to set exposure compensation , except in Program mode. In (P) mode, you would still use the front dial for setting exposure compensation and the rear dial for program shift (various combinations of shutter speed and f/stop, all providing the equivalent exposure).

Exposure Compensation Considerations

As a rule of thumb, you will probably use compensation when using center-weighted metering with a large subject of unusual

reflectance, such as a snow-covered landscape. You might set a +1 or +1.5 factor and retain that while shooting several different compositions, shooting a few frames each time the light changes, and so on. Spot metering does not lend itself to setting an exposure compensation factor. You are probably better off shooting in the Manual mode of the F100 as the following example illustrates.

Let's say you are photographing a group of colorfully dressed people in a market in some exotic foreign destination. You are shooting from a distance with a telephoto lens, such as the AF 80-200mm f/2.8D Nikkor zoom. You spot meter a man in bright yellow garments and get a combination of f/11 at 1/250 second. You decide you need to increase exposure by 1 stop (+1). In Manual mode, you would simply shift to a wider aperture, f/8, and shoot. This is very quick and convenient.

When you plan to exert this much control over the exposure for every frame, there is no real value to shooting in AE with the exposure compensation option. Yes, you could shoot in Aperture-Priority AE and set a different exposure compensation factor depending on the brightness of the new subject you will photograph in each frame. But unless the light is changing rapidly, as when wind-driven clouds cover the sun from time to time, there is no real value in doing so.

Exposure compensation with matrix metering is a problem, because you do not know what metering strategy the computer has taken. Perhaps it has already increased exposure for the yellow garment; if you set a +1 compensation factor, the photo will be overexposed. Frankly, some autoexposure bracketing would make more sense if you are not confident that the matrix system will get the exposure just right.

Setting exposure compensation in any autoexposure mode is appropriate with extremely high subject contrast: strong backlighting, as well as in situations where you want to capture a particular light ambiance. Scenes at the seaside in bright sunlight, very bright subjects, snowscapes, or extreme backlighting situations may require an exposure compensation of +0.5 to +2. We have rarely found scenes that require more.

A minus compensation factor would be required for very dark subjects, such as the proverbial black cat in a coal bin: Generally, -1.5 is suggested for such a subject. However, if you are photographing a pioneer village with very dark wooden buildings after

sunset, think twice before setting minus exposure compensation during long—5 seconds or longer—exposures. With many films, you lose effective film speed during such long exposures; this is called "reciprocity failure." Theoretically, this example would require exposure compensation of perhaps –1, because the subject (wooden buildings stained dark) is much darker than a midtone. Consequently, you may get better results without any exposure compensation; the reciprocity failure will tend to produce underexposure, counteracting the tendency of the camera's meter to overexpose the darkly stained buildings. In fact, you might shoot a few extra frames with a +0.5 and a +1 exposure compensation factor to be safe.

Note: It is not darkness produced by low light that makes one decide to use minus exposure compensation for a subject. This strategy is necessary only when the subject itself is dark, like a black car.

Exposure Compensation in Manual Mode

The exposure compensation feature of the F100 is not necessary in the Manual (M) operating mode, because there is a simpler/more convenient alternative. In the Manual mode, the camera does not pick an f/stop and shutter speed as it does in Program and automatic modes. You must do so yourself, following the guidance provided in the scale—electronic analog exposure display—in the viewfinder data panel.

Consequently, there is no need to use the exposure compensation feature. If you want to increase exposure by 1.3 EV steps for a landscape including snow, simply set an f/stop/shutter speed combination that will do so, i.e., change settings until the analog scale displays a + value totaling 1.3 steps, displayed by the vertical lines on the scale.

Autoexposure Lock (AE-L)

This is used to lock in an exposure so it will not change when the camera is pointed at a different part of the scene. After taking a meter reading of a subject area in Program, Aperture-, or Shutter-Priority AE, press and hold the [AE-L/AF-L] button; this also locks

focus if you are shooting in autofocus. The symbol (EL) now appears in the viewfinder data panel. Lightly press the shutter release button while recomposing. The exposure value will remain the same, even if the new composition includes a bright sky or a dark object.

Custom Setting: In normal operation, the F100 does not provide AE-lock when you lightly press the shutter release button. You must press the [AE-L/AF-L] button to do so. However, if you do want the exposure value to be locked by the partial depression of shutter release button, too, set CSM 7-1.

You will generally want to use AE-lock when you decide to take a meter reading from a specific element in a scene, then recompose before taking the picture. For example, you may meter only the rocks, trees, and pond in a landscape, and then recompose to include a bright sky. The measured value is stored when you press the AE-L button, so make sure that you do not do so until the lens is pointed toward the area of the scene that you want to meter. As long as you maintain pressure on the button, the exposure value will not be affected by the bright sky, so the exposure used to take the picture should be more accurate, with less risk of underexposure.

Note: Locking in exposure values is useful in spot or center-weighted metering. However, do not use autoexposure lock with matrix metering as a rule. Allow the system to make its "intelligent" exposure analysis, perhaps ignoring the bright sky or setting an exposure that will render both sky and foreground subjects nicely. After gaining extensive experience with your F100 and matrix metering, you may occasionally wish to ignore this recommendation and experiment; however, the results will not always be predictable.

Custom Settings: If you set CSM 21-3, the exposure value remains locked even after you remove your finger from the [AE-L/AF-L] button. To release AE-L, you must press the button again. If you set CSM 21-1, the [AE-L/AF-L] button will only lock the exposure and have no effect on autofocus.

With the exposure value locked, you are not forced to shoot at a single f/stop/shutter speed combination in any of the

automatic modes. As discussed earlier, many combinations of f/stop and shutter speed provide the same exposure; only the depth of field and the depiction of motion change. With AE-L activated, you can shift f/stops or shutter speeds as you wish. The settings will change, but the exposure won't if you switch from f/16 at 1/60 second to f/5.6 at 1/500 second as these are equivalent exposures: The same amount of light exposes the film in either combination.

Note: AE-L has no effect in the Manual operating mode, because the camera does not set the f/stop and aperture required for a "correct" exposure; you do so yourself, with guidance from the analog scale in the viewfinder. Once you have set the desired exposure value by changing f/stop and/or shutter speed, the camera will not override your decision. As you recompose to include a bright sky or a black barn in the frame, it will warn that the exposure will be "incorrect" but will not change the f/stop and shutter speed that you have set. Feel free to ignore the warning; your exposure should be correct if your metering technique followed the advice given earlier (e.g., taking a reading from a midtone or a KODAK Gray Card before recomposing).

High-Key Photographs
High-key shots consist predominantly of light color or gray tones. They may project airiness and cheerfulness, or create a special mood. Bright main subjects (portraits, still lifes, or nudes) in front of a light-toned background with almost no shadows are highly suitable for high-key shots. In order to achieve the desired results, center-weighted metering should be used. You want to intentionally overexpose the image using a plus exposure compensation factor. Depending on subject brightness, a factor of +1 or +2 may be required to produce a bright, high-key effect.

Low-Key Photographs
The exact opposite of high-key shots, low-key shots consist predominantly of dark color and gray tones without any large highlight areas. They have a heavy, almost depressing, effect. Dark main subjects (portraits, still lifes, or nudes) in front of a dark background with only sparse illumination are suitable for low-key shots. Decreasing exposure from the metered value by -1 or

-2 EV—depending on the subject—can intensify this effect. Any small highlight areas in the subject can emphasize the darkness and increase tension in the picture.

Bracketing Exposures

In some difficult lighting conditions, you may decide to shoot several frames of the same scene, varying the exposure slightly from one frame to the next. This technique makes most sense with slide film, where even a 1/3 step of increased or decreased exposure will be noticeable. In order to bring out the best nuances in a subject, you may decide to shoot several frames: one at the metered value, one with 1/3 step more exposure, and the last with 1/3 step less exposure, for example. With print film, the very wide exposure latitude makes increments of less than a full step meaningless—the print exposure will probably be identical if you shoot three frames, varying exposure by only a half step for each one.

As discussed earlier, you can bracket exposures by using exposure compensation in Program or automatic modes—set a different compensation factor for each frame. You can also vary exposure in Manual operating mode by switching to a different f/stop or shutter speed, or both for each frame in a series of images that you shoot. However, the F100 includes an automated bracketing system that can make this process much quicker.

Automatic Exposure Bracketing (AEB)
To set autoexposure bracketing, press and hold the [BKT] button and rotate the rear command dial. "BKT" will appear in the top deck LCD panel. In order to set the number of frames and the exposure deviation for each frame, rotate the front dial while pressing the [BKT] button. When you reach a desired option, *3F0.3*, for example, release the [BKT] button. In this example, the F100 is set to shoot three frames (denoted by 3F) varying the exposure by 0.3 EV or steps for each frame.

When autoexposure bracketing is active, the plus/minus symbol blinks on the LCD panel and in the viewfinder data panel. To cancel the AEB function, rotate the rear command dial while pressing the [BKT] button until "BKT" disappears from the LCD panel.

By using CSM 2-2, exposure bracketing of 0, -.5, and +.5 was automatically set for these three frames.

In the above example, you would shoot three frames of the subject as follows: the first would be at the metered value, the second frame would receive 0.3 EV less exposure, and the final frame would get 0.3 EV more exposure.

This is but one example; your Nikon F100 features the ultimate in automatic bracketing with numerous other setting options:

❏ You can choose either two or three frames for bracketing.
❏ You can bracket to produce only overexposure (with a bright scene) or to only underexpose (for dark-toned subjects).
❏ You can vary the amount of exposure deviation from one frame to the next, up to a maximum of +1 or -1 EV.
❏ You can also select options that will bracket flash exposures, too, if a Speedlight is mounted and activated; AEB for flash is a feature unique to Nikon at the time of this writing.

❏ You can set some exposure compensation before you set AEB; for example, with a snow-covered landscape, you might set a +1 compensation factor, and then set AEB to bracket exposures around that to avoid any extremely underexposed shots.

Many other cameras on the market allow you to select only three frames for bracketing and do not have the option of bracketing only toward over- or underexposure. This feature can save film in situations where you do not need to bracket three frames or in cases where you know that you only want to bracket toward over- or underexposure.

Custom Settings: In the default setting, the increments for bracketing are selected in 1/3 EV steps. Most photographers consider this suitable with slide film. However, custom setting CSM 2 lets you make the following changes: CSM 2-1 = increments selected in 1 EV step, CSM 2-2 = increments selected in 1/2 EV step, and CSM 2-3 = 1/3 EV step (default setting).

For film advance, you may selected single-frame shooting (S) or continuous shooting (C/Cs). In single-frame shooting mode, you must press the camera's shutter release button each time you are ready to shoot the next frame in the bracketed series. In continuous-frame shooting mode, the two or three exposures are made automatically when the shutter release button is pressed. If the camera's self-timer has been set, bracketing is performed one frame at a time.

In Program mode, the system adjusts both aperture and shutter speed for each frame. In Shutter-Priority AE, only the f/stop is changed from one frame to the next. In Aperture-Priority AE and in Manual operating mode, only the shutter speed is adjusted. Note you can set AEB to bracket exposures in Manual mode, not a common feature in most cameras.

Here are some tips to keep in mind if you plan to use autoexposure bracketing:

❏ If you reach the end of the roll of film before the bracketed series has been completed, the remaining shots can be taken on the next roll of film.

❏ AEB remains set even after the camera has been switched off. After you turn the camera back on, you can take the remaining frames in the series. Be sure to cancel AEB unless you

intend to keep using it later on. Otherwise, you will keep shooting bracketed series.

❏ Color negative film benefits from slight increased exposure, which reduces grain and produces richer colors. We do not recommend routinely underexposing color negative film. With color negative film, the "+2F1.0" option makes most sense; you'll get two frames in a series: one at the metered value and the second with +1 EV more exposure. You will first need to set CSM 2-1 in order to be able to bracket in full 1-step increments.

❏ With slide films, the exposure series may consist of three shots with a difference of 0.3 or perhaps 0.5 EV. Slides that are a bit underexposed can have richer color, so our most common bracketing series is the *3F0.3* option or the *3F0.5* option. The latter produces three frames: the first at the metered value, the second at -0.5, and the last at +0.5 EV more exposure.

❏ In situations with strong backlighting, first set a +1 or a +2 exposure compensation factor. Then set AEB to bracket around that setting.

❏ Exposure bracketing must not be confused with the so-called "shotgun" method where the photographer shoots a lot of frames at various exposure, hoping that one will be successful. Even professional photographers frequently take a series of bracketed exposures; all three slides should be usable, but one will most effectively render the subject as desired. This technique can be used even under uncomplicated lighting conditions, when the highest technical and aesthetic image quality is required.

❏ When the shutter speed is adjusted automatically by the camera's computer, you'll get longer exposures for some bracketed frames; sometimes, the shutter speed will be too long for a sharp photo if you are handholding the camera. At the very least, brace your elbows on a solid support.

Custom Setting: CSM 3-1 allows you to change the sequence of bracketed exposures so the underexposed frame will be shot first, then the frame at metered value, and finally the overexposed frame. This is simply a matter of subjective preference and has no particular technical significance.

Autoexposure Bracketing With Flash

We will discuss flash in greater detail in a later chapter, but note that the AEB function is called "autoexposure/flash exposure bracketing" by Nikon. This is logical, because you can set the F100 to bracket exposures with flash only, with both flash and ambient light metering, or for ambient light exposures only. When flash is active, its output level will vary from one frame to the next if AEB is set for flash.

Custom Function: Your F100 is set to vary both flash and ambient light exposure when flash is used. With custom function CSM 11-AS (the default setting), the system provides simultaneous flash and exposure bracketing. If you select CSM 11-AE, only ambient light exposures will be bracketed; flash output will not change from one frame to the next. The other option, CSM 11-Sb, produces only flash exposure bracketing; the ambient light exposure will not change during the bracketed series, only flash output.

In an outdoor situation, for example, you may decide to bracket both ambient light and flash exposures. Flash exposure bracketing controls the brightness of the subject, while ambient light bracketing controls the brightness of the background in the final photograph.

Contrast Determination and Control

Even correct exposure metering can result in a picture that is not pleasing or does not do justice to the subject. The problem is greater in outdoor photography than in studio work, where the light can be controlled much more effectively. When pictures are taken of persons or objects in the studio, we can control the interplay of light and shadow in order to produce the desired scene contrast. Shadows can be lightened with reflector panels. This technique is possible outdoors, too, but requires an assistant or two. Fill-in flash is a less cumbersome technique that achieves a similar effect—reducing contrast by filling in shadow areas so the overall lighting is more balanced or equal. The film will be more likely to handle the contrast and hold detail in both highlight and shadow areas, because neither is excessively bright or dark.

Here is an example of an effective composition that takes advantage of a high-contrast subject.

Excessive Contrast

The primary concern outdoors is that the contrast of the scene often exceeds the recording range of the film, which always occurs in strong backlighting. Exposure at the mean value between the lightest and the darkest image areas may result in burned out highlights and murky, black shadows obliterating all detail. The photographer has a choice between exposing for the highlights or for the shadows if no type of fill-in lighting is to be used, as in landscape photography. (You can use fill flash on a foreground rock or cactus, but how do you fill in a vast scene?)

The decision as to light metering in this type of scenario depends on how the photographer views the scene and on the type of film used. With black-and-white and color negative films, it's best to meter for the shadows. For example, take the meter reading from a KODAK Gray Card in the shadow areas of the scene. When prints are made, some detail can be held in the highlight area, especially when using the services of a custom or pro lab. With slide films, exposure for the highlights is recommended, because "washed out" areas are more unappealing than deep shadows. For example, you might decide to take the meter reading from a gray card in a bright area of the scene, one that includes important subject matter that should be nicely exposed.

An ISO 100 slide film has a contrast recording range of approximately six exposure steps, so it can reproduce a subject contrast of approximately 1:64. An ISO 100 color negative film may have a range of approximately seven exposure steps, so it can reproduce subject contrast of approximately 1:125. With up to an eight- or nine-exposure step range, black-and-white negative films have the greatest contrast recording ability; they can reproduce a subject contrast of 1:250 or 1:500. (Depending on the type of paper used for prints, this exposure range will be reduced more or less during printing.)

When subject contrast is extreme (with both brilliant highlight and deep shadow areas), you have three options: fill in lighting using flash or a reflector panel, use a graduated neutral density filter (if this suits the subject since the filter is dark on one half and clear on the other) with the dark half covering the brighter areas, or when printing take advantage of professional darkroom techniques including pre-flashing the film or the printing paper. These days, computer manipulation of contrast is possible, too, with images that are scanned into a computer and adjusted using the appropriate imaging software programs.

Contrast Measurement

The simplest method for measuring the contrast of a scene is to use your Nikon F100's spot metering capability. Set the camera for Aperture-Priority auto mode and decide on an aperture, say f/16 for this example. First measure the brightness of the area where you must have some subject detail in the final photograph. Let's say this indicates that an exposure of f/16 at 1/125 second would be ideal for this small area. Then meter the darkest spot in the scene where you need to hold detail. Here the recommended exposure might be f/16 at 1/2 second.

When you select the small areas that you will meter, be reasonable; avoid the blackest shadows and the brightest sky area, for example. In this scenario, you can tell that the contrast range is six exposure steps. (Count the shutter speed increments: 1/125 to 1/60 second, 1/60 to 1/30 second, 1/30 to 1/15 second, 1/15 to 1/8 second, 1/8 to 1/4 second, and 1/4 to 1/2 second for a total of six steps.) Even with slide film you should be able to make a photo with subject detail in both the important bright and dark areas without resorting to one of the techniques

To determine if a pleasingly balanced exposure was possible, the shadow and highlight areas of the scene were measured using spot metering.

mentioned earlier. To get a balanced exposure for both in this case, you may decide to shoot at f/16 at 1/15 second or at 1/8 second in the camera's Manual mode, or shoot two frames, one at each of these settings. This is getting into more advanced realms and calls for some willingness to experiment; be sure to keep notes for future reference.

Contrast Control With Graduated Neutral Density Filters

Fill flash and reflectors for bouncing light onto the subject are useful but only with relatively small subjects that are not too far away. For landscape and some cityscape photography in high-contrast lighting, a graduated neutral density filter is more useful. A filter of this type is clear on one half and darker on the other half with a gradual, not abrupt, transition between the two halves gradual, not abrupt. Here is a typical example of a situation where such an accessory can be useful.

You decide to photograph a mountain lake and the peaks behind it. The water is still in shadow, but the early morning sun illuminates the peaks, which are much brighter now. The contrast is high, so your film cannot hold detail in both areas. The following should work well:

Darkening the sky with a Tiffen graduated neutral density filter accentuated detail in the buildings roofline. ©Bob Shell

❏ Set the F100 for the Manual operating mode and take a meter reading of the darker foreground area only, perhaps some rocks and trees on the shore. Let's say the indicated exposure is f/16 at 1/15 second.

❏ Now add the filter and position it so the dark half covers the bright peaks.

❏ Take the picture at the f/16 at 1/15 second settings mentioned above. The shadow area will be well exposed, and the brighter peaks should be reproduced with detail as well, because the dark half of the filter reduced the brightness level. This technique is particularly important when landscape shots are taken with slide film, because the subject contrast is frequently greater than the recording range of the film. Graduated neutral density (ND Grad) filters are also useful for making clouds above a darker landscape stand out better. This accessory can be used for black-and-white as well as color photographic applications.

We recommend that you do not purchase the round screw-in ND Grad filters, because their color transition is exactly centered. This almost forces you to place the horizon line in the center of the image, not an ideal picture composition. The rectangular ND Grad or gray graduated filters that are used in a filter holder allow you to move the filter up and down so the transition line is located wherever you desire. You can also rotate the holder so the transition line can be placed on an angle, useful in some situations such as architectural photography. A medium-size is recommended, because it is large enough for use with almost any lens and allows more room for play.

Tiffen offers Color-Grad® filters, glass graduated filters in different strengths and color gradations. These filters are available in a rainbow array of colors, such as Tropic Blue, Plum, Tangerine, and Tobacco, and neutral densities .3, .6, and .9. In general, ND Grad filters are most useful on wide-angle lenses at moderate apertures, such as f/8 to f/11. The depth-of-field preview button of the F100 is very helpful for checking the effect.

Note: We often use the terms "f/stop" and "aperture" interchangeably in this guide, as in "select an f/stop" or "select an aperture." This is not technically correct, since aperture refers to the opening created in the diaphragm mechanism of a lens, while f/stop refers to the relative size of the opening: f/4 being a wide aperture and f/22 a small aperture. Because this guide is intended as a practical tool and not as a technical treatise, we can use terms that have become accepted as the norm by millions of photographers.

The Value of Contrast

Although we have emphasized techniques for moderating contrast, some contrast is important in most photography. A picture of gray desert sand with dull plants and a gray sky taken on an overcast day with flat lighting will seem "flat," lacking sparkle or visual appeal. While soft, flat light may be suitable for a picture of the vegetation in a rain forest, when detail in all areas is important, the high-contrast lighting at sunset and sunrise can produce beautiful effects, too. And a landscape with both dark shadows and bright highlights can be dramatic; after all, photography can be pictorial as well as documentary.

The key is to be aware of the scenic contrast and the likely

effect it will have on your images. This is an important component in the lighting, as is the color of the light, its direction, and quality. Develop an awareness of all of these factors and use them to your advantage. Modify contrast when required to meet a specific intention, as discussed earlier, perhaps using fill flash for people pictures in backlighting or flash to add some contrast in overcast-day lighting. Learn to measure the contrast range of landscapes so that you'll know when you may need to use contrast controls, such as an ND Grad filter.

F100 Exposure Modes

The Nikon F100's broad choice of exposure modes offers both the sophisticated professional and advanced amateur photographer many useful options. The camera also offers choices suitable for beginners who want to explore the advantages of shooting with an SLR camera.

Press the [MODE] button while turning the rear dial to select exposure modes.

In addition to a fully Manual mode, the F100 features Programmed AE, Shutter-Priority AE, and Aperture-Priority AE modes. (AE is an abbreviation for autoexposure, also called "automatic.") These four AE modes may be used with practically all other camera functions, such as 3D matrix, spot or center-weighted metering modes, single or continuous autofocus, single-frame or continuous-frame shooting, etc. Consequently, it is easy to take pictures that fulfill your expectations—portraits that stand out against the background, landscapes with great depth of field, athletes in fluid motion, or candid pictures taken in quick succession. The most important aspects of how to use these operating modes are described in this chapter.

Programmed Autoexposure Mode (P)

Programmed AE is the point-and-shoot mode of the camera, since a computer sets both f/stop and shutter speed for you. Simply focus, compose, and take the picture. In bright light, Program combines fast shutter speeds and midsize apertures, shifting to wider apertures and longer exposures as the light level drops. In

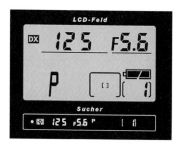

A "P" appears in the viewfinder when in Program mode.

low light, keep an eye on the shutter speed—it may be too long for sharp pictures unless a tripod is used.

With the [MODE] button pressed, use the rear dial to set Programmed AE; the letter P appears on the LCD panel and in the viewfinder. The lens used must be locked in the smallest aperture, the largest number. Otherwise, **FEE** blinks in the data panels, and you cannot trip the shutter.

Note: If you mount a lens other than an autofocus or AI-P series (with the camera set to Program mode), P blinks in the top deck LCD panel and A appears in the viewfinder. The camera automatically switches to Aperture-Priority AE, because Program does not operate with such lenses. You must now set the f/stop using the aperture ring on the lens, and check to see which f/stop has been set; that information does not appear in either data panel.

When your primary goal is to get the picture, the standard Program is fine. However, with variable Program you can shift to other combinations of f/stop and shutter speed: a smaller aperture for more depth of field, higher shutter speed to freeze motion, etc. Naturally, both the shutter speed and aperture shift so the overall exposure remains the same. If the program uses a smaller aperture, like f/16, it will, in turn, select a slower shutter speed. Conversely, a faster shutter speed, like 1/1000 second, will produce a wider aperture. This is essential, of course, to ensure that the correct amount of light reaches the film. The F100's Programmed AE allows you to use all of the control functions and overrides of the camera, such as AE bracketing, exposure compensation, etc. However, in this point-and-shoot mode, we recommend matrix metering, dynamic autofocus, and single-frame

film advance, except for action photography. As your needs and photographic intentions expand, switch to one of the other modes and begin to access other camera functions as well.

The photographer used program shift to select an aperture/shutter speed combination that would give sufficient depth of field to render all of the elements in this scene reasonably sharp.

Program Shift (P*)

To vary the aperture/shutter speed combinations using Program shift, lightly press the shutter release button and rotate the rear dial until the desired combination is indicated in the viewfinder data panel and on the top deck LCD panel. Program shift is indicated on the LCD panel by the symbol (P*). Program shifting is limited when a flash unit is attached and activated. Depending on lighting conditions, shutter speeds can be shifted within the range of 1/250 second to 1/60 second and the appropriate aperture. If you have shifted to some other combination, the camera will automatically shift to a "correct" combination when the flash unit is turned on.

Program shifting allows you to combine the convenience and shooting readiness offered by the automatic exposure system with the ability to control the rendition of the subject. As you

shift, it's almost as if you were shooting in Aperture- or Shutter-Priority AE mode. The Program shift option is canceled by switching off the camera, by utilizing rapid reset ([CSM] and [MODE] buttons pressed simultaneously), or by switching to another operating mode.

Custom Settings: Normally, the aperture and shutter speed shift in very small (1/3-step) increments as you rotate the dial. By setting CSM 2-1, the camera is reprogrammed to shift in full steps; with CSM 2-2, it will shift in half steps. To return to the default setting, set CSM 2-3. Whether you set one of the options depends entirely on personal preference; there is no particular need to do so.

Candid Photography or Snapshots
Natural, spontaneously shot pictures are frequently more impressive than those that are posed or artificial-looking. Snapshots can capture a candid expression, a funny event, or special moment. If you watch a situation unfold, a child opening a birthday gift, for example, you can capture the anticipated facial expressions and other behavior. Capturing the right instant requires a quick reaction and constant shooting readiness. These are the times to use Programmed AE, with or without flash.

Shutter-Priority Autoexposure (S)

Use this mode when it is most important that you select just the right shutter speed from the available range of 30 seconds to 1/8000 second. This is usually the case when you want to control the rendition of motion in the picture. For example, you may

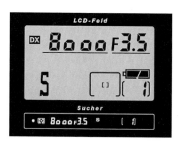

The letter "S" appears on the LCD panel and in the viewfinder to indicate Shutter-Priority mode.

want to render waterfalls as smoothly flowing and fluid instead of as a series of frozen droplets by using a slower shutter speed. Or you may decide to freeze an athlete in mid-jump by choosing a fast shutter speed.

With the [MODE] button pressed, use the rear dial to set Shutter-Priority AE. The letter S appears on the LCD panel and in the viewfinder. As always, the smallest aperture (largest number) on the lens must be locked in. Select the desired shutter speed with the rear dial, and the camera will automatically set the corresponding aperture (f/stop) to ensure correct exposure. This mode is not available if you are using lenses without a CPU, i.e., lenses other than AF or AI-P.

Custom Settings: Normally, the shutter speeds can be adjusted in small (1/3-step) increments as you rotate the dial. By setting CSM 2-1, the camera is reprogrammed to change in full-step increments; with CSM 2-2, it can be set in half steps. To return to the default setting, set CSM 2-3. Whether you set one of the options or not depends entirely on personal preference; there is no particular need to do so.

With CSM 12-1, you can reprogram the camera so that the front dial is used for shutter speed selection instead of the rear dial. Once CSM 12-1 is set, the front dial will also control shutter speed if you switch to the camera's Manual operating mode.

In any event, the shutter speed you select is indicated in the viewfinder and on the top deck LCD panel. The camera automatically controls the f/stop for correct exposure as you shift.

Note: In some cases, you may get a warning *Hi* in the data panels. This is not a greeting, but an indication that the light is too bright for even the smallest aperture offered by the lens in use at the shutter speed you have selected. Switch to a higher shutter speed: 1/1000 second instead of 1/500 second, perhaps. Should you get a *Lo* warning, the scene is too dark with the lens wide open at the shutter speed selected. Switch to a longer shutter speed: 2 seconds instead of 1 second, perhaps, or use a flash unit. In both cases, the analog scale in the data panel will indicate the amount of over- or underexposure that will occur if you do not shift to a different shutter speed. Despite *Hi* or *Lo* warnings, the Nikon F100 allows you to take

pictures at the shutter speed you have selected, but the photo will be over- or underexposed.

There are some circumstances when you may wish to lock in a certain shutter speed: 1/500 second, perhaps, when shooting ski jumping. To do this, press the lock button [L] while you turn the rear dial by one click in the desired direction. The (L) displayed on the LCD monitor and in the viewfinder indicates that the shutter speed has been locked. In order to release this lock, you can use rapid reset or press the lock button while turning the rear dial.

The Shutter-Priority automatic system is ideal whenever choosing the shutter speed is of primary concern, as in shots of moving objects, sports, and action photography. Naturally, the aperture selected by the camera will vary, depending on the lighting and the shutter speed you set. The camera will pick an aperture that gives correct exposure, but depth of field will be quite different when the combination is 1/1000 second at f/4 versus 1/60 second at f/16. The depiction of motion differs as will depth of field.

Depending on what shutter speed has been selected, motion may be frozen (sharply rendered) or blurred in your pictures. Shutter-Priority mode is also useful when shooting with a telephoto lens, and you want to ensure that a shutter speed fast enough for handholding is used.

This mode can be combined with all of the numerous camera functions, such as spot metering, various autofocus options, exposure compensation, bracketing, flash photography, and more. As a basic setting for moving objects, we recommend continuous AF with dynamic AF, 3D matrix metering, high-speed film advance, and AE bracketing, perhaps if you are using slide film.

Shutter Speed and Motion

If the shutter speed you select is not suitable for the speed of a moving subject, you will get some motion blur. The subject will not be sharp. Here is a simple example. A runner is about 15 feet (5 m) from your camera position. You can use the following shutter speeds as reference for freezing motion:

❏ 1/500 second when the direction of motion is transverse to the shooting direction—toward or away from your position

❏ 1/250 second when the direction of motion is diagonal to the shooting direction

❏ 1/125 second when the direction of motion is parallel to the shooting direction

Subjects moving at faster speeds, such as cars racing, require much faster shutter speeds, such as 1/2000 second, if you want to avoid motion blur. In most cases, you would need to use an ISO 400 or ISO 800 film to get such high shutter speeds.

For subjects moving across your view, you may try this: Set a slower shutter speed, such as 1/30 second, and "pan"—point the lens at the subject as it approaches and track its progress by smoothly moving the camera at the same speed. At some point, trip the shutter to take a picture or a series of frames. The subject will be fairly sharply rendered, but the background will be streaked, giving an impression of motion. A monopod can be useful to help prevent blur from camera shake. For success with panning, experiment until you have mastered the technique, and always shoot a lot of frames. Panning is well worth the effort—successful pictures can be very dramatic and rewarding.

Aperture-Priority Autoexposure (A)

This mode is a good choice if you are primarily interested in controlling depth of field—the zone of sharp focus in front of and behind the subject. A small aperture, like f/16, offers more generous depth of field, considering that all other variables are the same. A wide aperture, such as f/4, produces narrow depth of field in a given circumstance. In Aperture-Priority AE, when you set the desired aperture, the camera will automatically set the corresponding shutter speed to maintain correct exposure. Naturally, shutter speeds get longer at small apertures and faster at

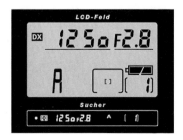

An "A" in the viewfinder indicates Aperture-Priority mode.

Depth of field is critical in close-up photography. A small aperture was selected using Aperture-Priority Autoexposure mode to maximize the zone of acceptable sharp focus. ©Peter K. Burian

wide apertures. Many combinations of aperture (f/stop) and shutter speed provide equivalent exposure.

With the [MODE] button pressed, use the rear dial to set Aperture-Priority AE; the letter A appears on the LCD panel and in the viewfinder data panel. The aperture ring on the lens must be locked at the largest f/number. This mode can be selected if using lenses without a CPU, such as the AI Nikkor series.

Custom Settings: If you prefer to set the f/stop using the aperture ring on the lens (instead of the rear dial), set CSM 22-1. If you do so, the f/stop that has been selected will not be displayed in either data panel on the F100; you'll need to check the aperture ring on the lens. We see no particular need to set this CSM, but some photographers prefer the "old style" of setting f/stops in Manual and Aperture-Priority AE modes. If you switch to Program or Shutter-Priority AE mode, however, you will need to return to the default setting, CSM 22-0; in these modes, f/stops must be selected with the rear dial and not the lens' aperture ring.

Note: In some cases, you may get a *Hi* warning in the data panels. This indicates that the light is too bright for even the highest possible shutter speed with the f/stop you selected. If this occurs, switch to a smaller aperture (larger f/number), such as f/16 instead of f/11. Should you get a *Lo* warning, the scene is too dark for even the longest shutter speed at the f/stop you have selected. Switch to a wider aperture (smaller f/number), such as f/4 instead of f/5.6, or use a flash unit. In both cases, the analog scale in the data panel will indicate the amount of over- or underexposure that will occur if you do not shift to a different shutter speed. Despite *Hi* or *Lo* warnings, the Nikon F100 allows you to take pictures at the aperture you selected. However, the photo will probably be over- or underexposed.

Custom Settings: With the F100, f/stops can be changed in 1/3 steps. CSM 2-2 lets you change f/stops in 1/2 EV step increments, while CSM 2-1 allows you to change them in much larger increments of 1 full step. Naturally, the camera shifts shutter speeds in the same increment, so correct exposure is maintained. The default setting CSM 2-0 (1/3 increments) is fine for most photographers, but some prefer larger increments.

Note: When you set CSM 2-2 or 2-3, the increments of exposure compensation (if that control is used) will also shift in the same increment. With slide film, 1/3 or 1/2 EV step shifts are fine, but full 1-step shifts are probably excessive—you would not be able to set a 1.3 EV or 1.5 EV exposure compensation, for example.

You may wish to lock in a certain f/stop, perhaps f/22 for landscape photography. While pressing the lock button [L], rotate the front dial by one click in the desired direction. The (L) displayed on the LCD monitor and in the viewfinder indicates that the f/stop has been locked. In order to release this lock, you can use rapid reset or press the lock button while turning the front dial. Normally, faulty exposures do not occur, because the shutter speed range is considerably greater than the aperture range.

Although the subject is a statue, the photo is in essence a portrait. Using Aperture-Priority AE mode, the photographer selected f/5.6 so that the sharp subject would be set off from an out-of-focus background.

Aperture-Priority AE is an ideal shooting mode whenever controlling depth of field is a primary concern. For example, you can select a wider aperture to isolate the subject and blur a busy background in portrait or wildlife photography, or you can maximize the zone of sharpness in a cityscape by using a small aperture. When choosing an aperture with depth-of-field considerations, be aware that when the camera sets the right shutter speed, it does not consider subject motion. During a long exposure, camera shake and/or subject movement will produce a blurred image. If this occurs and you want to continue to use the aperture you desire, you may need to switch to a faster film, ISO 400 or 800, for example.

Aperture-Priority AE mode can be combined with numerous F100 functions. With print film, matrix metering will produce excellent exposures in the vast majority of lighting conditions. In strong backlighting, use flash or a plus exposure compensation factor. However, if you are shooting slide film, you may wish to switch to center-weighted metering and use exposure compensation and/or AE bracketing. For portraits taken in front of very light or very dark backgrounds or with other very unusual subject/lighting combinations, spot metering can be very useful.

In some cases, you may want to control the point of focus, so use an autofocus mode where you select a specific focus detection point. Single-frame film advance will generally be fine, unless you want to shoot a series of the same subject, a model taking many different poses, for example.

What is Depth of Field?
Imaging laws dictate that only one plane of a three-dimensional object can be in razor-sharp focus in any photo. However, an area in front of that plane and an area behind it may appear acceptably sharp in a photo. This phenomenon is referred to as depth of field. The term "depth of focus" is sometimes used but is incorrect when describing the zone of apparent sharp focus in a photo.

Entire books have been written about depth of field, a technical phenomenon. However, for practical purposes, simply remember the following points:

❑ In general photography, the zone of apparent sharpness extends 1/3 in front of the subject and 2/3 behind it. In

extremely high-magnification photography (higher than 1x), depth of field is more evenly distributed.

❏ The zone of apparent sharpness is greatest at small apertures (large f/numbers, like f/22) and smallest at wide apertures (small f/numbers, like f/1.4).

❏ Wide-angle lenses offer more expansive depth of field, while telephoto lenses offer shallow depth of field.

❏ Depth of field increases with subject distance. The closer the focused subject to the camera, the smaller the zone of apparent sharpness. With subjects at a distance, the greater the size of the zone.

❏ Do not rely on depth of field to mask focusing errors, especially with telephoto lenses or whenever shooting at wide apertures from f/1.4 to f/5.6. If you use an ultra wide-angle lens, like 20mm, at a very small aperture, like f/22, the exact point of focus is less critical. This combination can be useful for street photography, in manual focus, when you want candid, unposed photographs.

Manual Exposure Mode (M)

Even with a high-tech camera like the Nikon F100, manual metering is an essential option for the serious photographer. It provides control over aperture and shutter speed, the rendering of depth of field and motion, and the exposure of the photograph. Photographers use Manual mode whenever they prefer to control creativity or take advantage of the shortcuts available to Manual-mode shooters.

With the [MODE] button pressed, use the rear dial to set Manual exposure mode (M); the letter M appears on the LCD panel and in the viewfinder. The lens aperture ring must be locked on

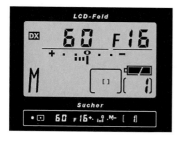

In Manual exposure mode, the letter "M" appears on the LCD panel and in the viewfinder.

the smallest aperture (largest number). Shutter speeds are selected with the rear dial and f/stops with the front dial. The camera's metering system only provides recommendations; correct exposure is not set automatically.

Custom Settings: If you prefer to control the f/stops with the aperture ring of the lens, CSM 22-1 allows you to do so. Shutter speeds and f/stops are shifted in 1/3-step increments, unless you select custom setting CSM 2-2 for 1/2-step increments or CSM 2-1 for full 1-step increments. Frankly, in Manual mode, we suggest leaving the camera at the default setting, CSM 2-3, if you shoot slide film. That's because you are controlling the exposure—not just depth of field and the depiction of motion—and will want to do so in small increments. With print film, the larger increments are fine. You can also set CSM 12-1 to reverse the functions of the rear and front dials.

Note: With an AF Micro Nikkor lens, there may be some loss of light with close-focusing due to the amount of lens extension. If you are basing your exposure on readings from an external light meter, Nikon recommends setting the aperture with the camera's command dial. If you use the aperture ring on the lens, the effective aperture may be different than the selected f/number.

In Manual mode, you can select from all available shutter speeds and "bulb." With the bulb setting, the shutter remains open as long as you press the shutter release button on the camera or remote control accessory. Turn the rear dial until ***bulb*** appears in the data panels. The camera will provide no metering guidance. You must use your own judgment, advice from published materials, or an external accessory light meter to decide how long the shutter should remain open.

When shooting in Manual mode, there is no automatic assist (only guidance) provided by the F100. Neither f/stops nor shutter speeds will change unless you change them. The camera provides guidance as to a suitable combination, depending on the lighting, subject brightness, etc. Simply check the analog scale in the viewfinder or top deck LCD panel, and change f/stops and/or shutter speeds until the pointer is at the zero position, indicating "correct" exposure according to the metering pattern you had

selected: matrix, spot or center-weighted. Of course, since you are in Manual mode, you will probably wish to use a slightly different combination in order to achieve a creative effect. If so, use the camera's recommendation as a reference and proceed as you think best.

Watch the lines on the analog scale as you adjust the shutter speed and/or aperture. These will move toward the plus or minus side of the scale as you increase or decrease exposure from the meter-recommended settings. The exact increments are displayed so you know exactly how far you have deviated. After you have taken the photos, don't forget that your Nikon F100 is set to Manual mode and not one of the automatic modes. Every time you shoot, you must set the exposure or switch back to one of the AE modes to allow the camera to set the exposure. If you wish to lock in a specific f/stop and/or aperture, you can do so using the lock option [L] as described in the sections on AE modes.

Electronic Analog Exposure Display

In 1/3 EV steps	In 1/2 EV steps	In 1 EV steps
Correct exposure	Correct exposure	Correct exposure
-2/3 EV	-1/2 EV	-1 EV
Over +2 EV	Over +3 EV	Over +3 EV

Examples of electronic analog exposure display indications.

Aperture and f/Number

The use of f/numbers to designate aperture size is a logical progression. Each f/number denotes a ratio or a fraction of the focal length. For example, think of f/4 as meaning 1:4. When you shoot at f/4, the actual size of the opening (aperture) that admits light is 1/4 of the focal length. With a 100mm lens, the actual opening is 25 mm in diameter (1/4 of 100). Switch to an 800mm lens, and the size of the opening is 200 mm (1/4 of 800). In both cases, exactly the same amount of light is transmitted to the film as long as the same f/number is set and the same shutter speed is used. Thus, there is no need for calculations as you change lenses. Full consistency is assured. We often use the term "aperture" when we mean "f/stop." Although this is not technically correct, the expression has become very common. In truth, aperture means the opening in the diaphragm mechanism of a lens, while an f/number is used to denote the relative size of the opening. Today, the terms are commonly used interchangeably, though rarely in textbooks and other technical materials. Because this *Magic Lantern Guide* is intended as a practical tool and not as a technical treatise, we can use the informal terminology that has become accepted as the norm among millions of photographers.

Nikkor Lenses

As important as the camera is in photography, it is the lens that has the greatest direct effect on the quality of the picture. As you would expect, Nikon offers a vast range of lenses for the F100, both autofocus and manual focus. As well, many Nikkor lenses that are no longer manufactured can be used with the camera (although not necessarily with all modes and features). This "backward compatibility" was an important priority when Nikon first designed autofocus SLR cameras and remains significant even today. In this chapter, you will learn about lenses in general and then read about Nikkor lenses specifically, including information on the level of compatibility of each Nikkor series with the F100. For more detailed information on Nikkor lenses, consult *Magic Lantern Guide to Nikon Lenses* by B. Moose Peterson.

A photographic lens is generally identified by two factors: its focal length and its maximum aperture (or "speed"). A lens' angle of view (the amount of scene coverage) is also of great importance as it is related directly to the focal length. In this chapter, you'll read about optical components and characteristics that will help you make informed decisions in determining which lenses are best to meet your photographic needs.

Focal Length

A lens' focal length is probably its most important specification. The focal length is engraved on the lens along with its maximum aperture (e.g., 85mm f/1.8 or 28-200mm f/3.5-5.6). Focal length determines a lens' reproduction ratio, extension, and angle of view. Combined with the camera-to-subject distance, the focal length determines how large an object will appear in the image.

Reproduction ratio is related to the focal length. If the lens-to-subject distance remains the same, doubling the focal length doubles the reproduction ratio. So, if a 50mm lens records a certain object at a height of 1/2 inch (12.5 mm) on the film frame, a 100mm lens will record the same object at a height of 1 inch (25 mm), while the object shot with a 25mm lens will measure only 1/4 inch (6.5 mm). If you change from a 50mm lens to a 100mm,

you double both the width and the height of the object's size on the film, quadrupling its size.

Despite common belief, perspective (the relative size of objects within an image) is not determined by the focal length in any way; perspective is changed by changing the lens-to-subject distance. However, "apparent perspective" does seem to change. A long lens seems to compress objects at various distances from the lens, making them all appear to be stacked, very close to each other. A short focal length, however, seems to expand perspective; objects very close to the lens appear unusually large in a photo, while those that are further back seem to recede into the distance.

Generally speaking, a normal lens' focal length is approximately equal to the diagonal measurement of the film frame. That's 43.3 mm in the 35mm format. Therefore, a 40mm to 60mm lens is generally considered "normal" in 35mm photography, while focal lengths of 35mm or less are considered wide-angles, and focal lengths longer than 70mm are called telephotos.

Angle of View

A lens' angle of view, or picture angle, is a function of its focal length and the film format. In 35mm photography, a lens with a focal length of 21mm has a picture angle of 92°, while a 135mm lens has a picture angle of only 18°. Lenses with an angle of view wider than about 50° are called wide-angles; those with an angle of view narrower than about 40° are called telephotos.

Lens Speed

Photographers often refer to a lens as "fast" or "slow." Those with a wide maximum aperture, such as f/1.4 to f/2.8, are considered "fast," because the large opening allows a great deal of light to expose a film in a short time duration. They allow us to use faster shutter speeds than the "slow" lenses that have a small maximum aperture, such as f/5.6. (A lens' aperture is the opening in the diaphragm that allows light to pass in order to expose the film.)

Apertures are quantified by f/numbers, which represent the ratio between the focal length of the lens and the diameter of the

opening. If a lens with a focal length of 90mm has a maximum diaphragm diameter of 45 mm, the aperture ratio is 90:45 or 2:1, hence the aperture is usually expressed as f/2. A small f/number means a wide aperture: the lens is capable of letting more light pass through to the film plane. A 50mm f/1.4 lens, for example, is "faster" than a 50mm f/1.7 by 1/2 stop.

Effective Aperture

Loss of light caused by absorption and reflection as light travels through the lens to the film plane inevitably reduces the effective aperture. In high-quality lenses, these losses are minimized by advanced optical design, so the maximum aperture marked on the lens is also a good indication of its effective maximum aperture. However, some lower-quality lenses can show a significant deviation between the marked aperture and the effective aperture. This may be as great as a full stop, so an f/1.4 lens may actually have an effective aperture of f/1.9 or f/2. Cameras such as the F100—with through-the-lens metering systems—automatically compensate for these variations in light transmission.

Lens Components

Manufacturers' brochures usually contain technical data that can be helpful in evaluating a lens, such as number of elements, minimum focusing distance, minimum aperture, and filter size. Depending on the lens' intended use, some specifications may be of great importance, while others are of little significance to the photographer.

Don't necessarily judge the quality of a lens by the number of elements and groups it contains. A lens designed with 16 elements in 12 groups may seem quite impressive, but the number of elements and groups actually gives little indication of potential image quality. The quality of the glass and the optical design make a difference.

The minimum focusing distance and maximum reproduction ratio are important to know if you are shooting close-ups. Just because a lens is capable of rendering an image at a ratio of 1:4 (1/4 life-size on the film frame), its optical performance at close distances may be poor or excellent. With the exception of true

macro lenses, most lenses are designed to produce the best image quality when focused at a greater distance: anywhere from 10 feet (about 3 meters) to infinity. Some zoom lenses include "macro" in their designation, but this merely indicates close-focusing ability is better than average. However, very few zoom lenses focus as close as true macro (or micro in Nikon terminology) lenses.

The minimum aperture (largest f/number, such as f/22) indicates how far the diaphragm can be closed down to gain maximum depth of field. This is important to know if you are taking landscapes, close-ups, and other subjects that require an extensive range of apparent sharp focus. There is, however, one caveat to this: At apertures smaller than about f/16, image sharpness begins to suffer. Everything may appear sharp in a photo taken at f/32, for example, but under close scrutiny, you may find that nothing is critically sharp. This effect is caused by refraction—the bending of light rays by the edges of the diaphragm blades as they enter an extremely small aperture.

Knowing the lens' filter size is helpful in purchasing filters with correct diameters. Ideally, all of your lenses should have the same thread size so that your filters are interchangeable on any lens, but this is not always possible. Other factors are far more important in choosing a lens, and filter size is seldom the deciding factor. Besides, "step-down ring" accessories are readily available; these allow you to use a large filter on a lens with a smaller diameter, for example, a "62 to 52" ring allows you to mount a 62mm filter on a lens that calls for 52mm filters.

Other lens features include close-range correction or floating elements (which improve image quality at close-range focusing), internal focusing or IF (which keeps the lens barrel length constant while focusing), and a non-rotating front element (which maintains a fixed filter orientation during focusing). This information is sometimes omitted from the technical data, but it can be very relevant to evaluating a lens. Other specifications such as lens length, diameter, and weight are important, especially to travel, landscape, and nature photographers who have limited space and/or must carry equipment for extended periods.

Modern lenses for 35mm cameras are small masterpieces of precision optics, mechanics, and electronics. Built from hundreds of complex parts, they are designed with computer assistance

then produced and assembled to precise specifications. What follows are descriptions of the most important components, which will help you make wise choices in selecting and handling your own lenses.

Bayonet mount: The bayonet mount is the link between a lens and the camera body. Both the bayonet on the lens and its mount on the camera must be machined to high accuracy in order to ensure that the lens axis is exactly perpendicular to the film plane. Perfect fit also ensures that both the camera's and lens' mechanical and electrical operations are supported by a properly functioning signal-transfer system.

Lens barrel: The lens barrel is a hollow cylinder made of metal or plastic in which the glass elements are precisely mounted, centered, and locked in the proper positions. The more accurate the centering, the higher the image quality should be.

The barrel and the helicoid (focusing mechanism) should both be constructed of materials that are insensitive to temperature variations. If both are made of materials with similar expansion coefficients, smooth and easy focusing will be ensured. The interior of the barrel, and every other internal structure, should be designed to absorb as much stray light as possible and coated with matte-black paint to minimize internal flare.

The torque required for manual focusing is important, too. With some autofocus lenses, the focusing ring rotates with very little friction; this makes manual focus less comfortable and less precise. Zooming control is another consideration. A straight in-and-out, push-pull movement of the lens barrel with a non-rotating front end facilitates the use of filters, such as polarizers, that require a specific orientation on the lens. Once set, their position and effect is unchanged while the lens is focused and zoomed. However, some photographers prefer the feel and action of a rotary zoom design, where focal lengths are changed by rotating the zoom ring.

Diaphragm: The lens diaphragm is a mechanical device inside the barrel, consisting of multiple crescent-shaped blades that produce a symmetrical opening (aperture) centered on the optical axis of the lens. Varying the size of the opening controls the

amount of light entering the camera during any given time. Nikkor diaphragms are designed and built to close accurately and repeatedly to the predetermined diameter, thousands of times, at any temperature. The blades are designed to close quickly and arrive at each designated position with a minimum of bounce. Like the interior of the lens barrel, the diaphragm blades are black to suppress reflections and stray light.

The aperture is created by the diaphragm blades.

Distance and Depth-of-Field Scales

To achieve sharp pictures, the image must be focused accurately on the film plane. Whether set manually or by the AF system, the focusing distance, indicated in feet and in meters, can be read off a scale on the focusing ring. The distance position for infinity is represented by a symbol (∞), also marking the end of the helicoid's rear travel. (To allow for temperature-related variations, some telephoto lenses can be rotated beyond the infinity mark.)

The distance scale's most useful function is to allow the photographer to determine depth of field. Many lenses have a second scale engraved on their barrels, consisting of pairs of f/numbers situated symmetrically around an index mark. With the help of this scale, the photographer can discover the zone of sharpness resulting from a particular distance setting and aperture value.

The same scale also permits you to set the hyperfocal distance, which gives the greatest possible depth of field for any given lens aperture. To do so, align the infinity mark on the focusing ring to the number on the depth-of-field scale corresponding to the desired f/stop. The total depth of field, as displayed on the focusing ring, extends from infinity to the distance shown by the corresponding f/number on the other side of the index mark.

Also found on some depth-of-field scales is an infrared focusing mark. Because infrared radiation focuses at a different distance than visible light, images shot with infrared film would be blurry if a focus adjustment were not made. To focus when shooting with infrared film, set focus visually on the focusing screen. Then align the focusing distance with the infrared focusing mark (usually a short line or dot) on the lens. This should be considered only as a general reference point for infrared photography.

ED and Aspherical Elements

Many Nikkor telephoto lenses are designated as ED, indicating that they incorporate one or more elements of extra-low-dispersion glass to correct chromatic aberration. By forcing all wavelengths of light to focus on a common point (the film plane), ED glass produces images of superb quality—razor-sharp, without color fringing and with high contrast for an impression of extreme sharpness. This measure is necessary especially with long focal lengths of wide aperture; with other lens types, conventional optics can be used. However, even some of the more modest Nikkor lenses incorporate ED glass to help ensure optimum image quality.

In a few Nikkor lenses, one or more aspherical elements—with a non-spherical surface—are used to compensate spherical aberrations (for higher edge-to-edge sharpness) and to minimize distortion near the edges of the frame. The AF-S zoom Nikkor 17-35mm f/2.8 IF-ED, for example, uses both ED and aspherical elements to correct for all types of aberrations at all focal lengths. (Aspherical elements are most often used in wide-angle lenses and in zooms that include wide-angle focal lengths.)

Unfortunately, Nikon does not designate lenses with aspherical elements in any way. (Some other manufacturers do so, often with the letters "AL.") However, the lens specifications on Nikon's web site and in their literature clearly state which lenses have aspherical elements. Determining if a Nikkor lens has aspherical elements wouldn't require extensive research.

Autofocus Components

Regardless of the operating system, any autofocus (AF) system requires a motor to drive the helicoid in the lens. This AF motor can be situated in the camera body (common with most Nikkor AF lenses) or inside the lens barrel (as with F-I and AF-S series Nikkor AF lenses). Many newly designed Nikkor AF lenses (D-type) are also fitted with a microcomputer chip responsible for the exchange of distance data between the camera and lens. This information is employed by the exposure metering computer and helps to assure more accurate exposures, especially with scenes of very high contrast including extreme highlight and dark shadow areas.

The Rules of Perspective

The spatial illusion of three dimensions in a two-dimensional photograph is created according to the rules of central projection. This springs from two important concepts: foreshortening and convergence.

Foreshortening means that identically sized objects are pictured smaller as their distance from the camera increases—identical objects closer to the camera seem large, while more distant objects appear small. Another commonly used term for this effect is "expanded spatial perspective."

The effect is especially obvious at short camera-to-subject distances and is much less noticeable when the subject is far from the camera. That's why foreshortening is strongest in wide-angle shots that include clearly identifiable objects in the foreground and in the background. A small rock, for instance, photographed with a 21mm wide-angle lens from 8 inches (20 cm) away may look like a boulder; likewise, a massive boulder in the distance will look like a pebble. This effect is very apparent in a full-face portrait made with a wide-angle lens, creating a caricature of the person, with a huge nose and distorted features.

The rules of central projection also determine the appearance of converging or vanishing lines, creating the illusion that parallel lines running along the lens axis meet at a single point. In effect, the lens becomes the center of perspective, equivalent to the

0mm 24mm 35mm

0mm 70mm 100mm

35mm 200mm 300mm

These nine photographs illustrate the different views that various focal lengths achieve when shot from the same location.

human eye. This impression occurs when you photograph, for example, a set of railroad tracks. If the tracks run nearly vertical to the image (along the lens axis, straight away from your eye point), they seem to converge in the distance. All parallel straight lines join at a single vanishing point created by perspective projection onto the flat image. This vanishing point, located exactly

Parallel lines that run diagonally through an image into the distance converge at a vanishing point outside of the image area.

on the center of perspective, also determines the location of the horizon line.

Imagine a photo of railroad tracks receding into the distance. The cross-ties on the tracks, aligned parallel to the image plane (and perpendicular to the lens axis), are depicted as parallel. In fact, straight lines running parallel to the image plane always remain parallel in photographs, because their vanishing points lie at infinity. This is true for vertical, horizontal, and inclined straight lines, as long as they are aligned parallel to the image

Parallel lines that run straight through an image into the distance converge at a vanishing point within the image area.

plane—a characteristic that's vital to achieving a natural look in architectural photography.

Picture Angle and Perspective Distortion

One of the most important features of central projection is the faithful depiction of straight lines. Any well-corrected lens will reproduce a straight line straight, regardless of the focal length. (An exception is the fisheye lens, which is intentionally uncorrected for linear distortion. Except for lines running directly through the center of the frame, all lines exhibit an outward bowing, called "barrel distortion.")

A classic example of perspective distortion concerns the converging lines that occur when the image plane is tilted upward, for instance to capture a tall building. This effect is called "keystoning"—when you tilt the lens upward to include an entire building, without including a lot of foreground clutter—the building appears to be falling over backward in the photo.

The same effect occurs when you photograph a building from a higher position shooting downward—the walls appear to converge toward the base of the building. Such converging lines are

The distortion evident in this image is caused by the extreme angle of view of the ultra wide-angle lens.

nothing more than the familiar vanishing lines, transposed to the vertical plane. Imagine a set of railroad tracks running up the side of the building, and you'll get the idea.

Perspective distortion should not be confused with an optical defect that causes straight lines to be depicted as curving inward ("pincushioning") or curving outward ("barreling"). These problems are caused by poor optical design and are most common in inexpensive zoom lenses. Perspective or linear distortion, on the

other hand, is not an image defect and cannot be corrected by improving the lens design. In order to prevent it, you must set up the camera so the film plane is perfectly parallel to the subject plane, to the walls of a building, for example.

With ultra wide-angle lenses, such as an 18mm, you may notice that objects at the edges and corners of the image frame seem distorted. Round objects situated at the image's edge, especially in the corner, are subject to elliptical distortion; they are rendered closer to oval than circular. This becomes more pronounced at increasing angles of view (as the focal length becomes shorter) near the edges and the corners of the image. This is an optical fact and not a sign of poor design in extremely wide-angle lenses.

Focal Length and Perspective

20mm 35mm 50mm

70mm 100mm 200mm

These six photos illustrate how the perspective changes with alterations to the camera-to-subject distance. The photographer changed his location to depict the subject the same in every shot, however the change in perspective can clearly be seen.

Contrary to common wisdom, perspective is determined by the camera-to-subject distance and not by the focal length or the angle of view of a particular lens. In order to appreciate this concept, try an experiment using negative film.

Photograph the same subject, perhaps a person in a landscape, from the same distance with a 20mm lens and a 200mm lens. Order an enlargement from a tiny portion of the wide-angle shot and then compare it to the 200mm shot. You'll see that the perspective is actually the same, when the subject is the same size in the final image.

As a second experiment, try this: Photograph a subject with a 20mm lens and then with a 200mm lens, but change your shooting position to keep the subject's size constant within the frame. (You'll need to move close with the short lens and far back with the longer lens.) Order an 8 x 12″ print of both frames, and observe how very different the perspective is in each image. This

0mm focal length at 1 foot

20mm focal length at 1 foot

20mm focal length at 1.3 feet

00mm focal length at 3.3 feet **100mm focal length at 4.3 feet** **100mm focal length at 8 feet**

Here you can compare how a change in focal length from wide-angle to telephoto affected the depiction of the objects as well as how a change in distance affected perspective. Also note the difference in how round and angular objects were affected by those variables.

confirms that changes in camera-to-subject distance alter perspective, especially in terms of how the background is rendered.

A natural-looking, undistorted picture is best achieved with a normal or medium telephoto lens that is not positioned very close to the subject. The main subject and its surroundings are rendered with correct shapes and relative sizes, and the vanishing point is back far enough so that perspective is not exaggerated. An eye-level camera position and film placement parallel to the subject also contribute to a natural appearance.

Conversely, the best way to achieve a strikingly dramatic depiction of a subject is to use a short focal length at close range. With a short focusing distance, the vanishing point is shifted toward the front, and the converging lines are quite steep. Everything near the camera is presented at an exaggerated size, while distant objects appear far smaller than the eye perceives. This unusual view can be further exaggerated by tilting the camera upward, so the bottom of a building is closer to the optical axis than the top of the building.

When choosing focal length and focusing distance, the shape of the subject is an important consideration. If you photograph an assortment of round and rectangular objects with a 20mm wide-angle lens from a short distance and from a high angle, the objects will appear grossly distorted. The short focusing distance and high viewpoint cause an exaggerated depiction of perspective slightly stretching, but not disfiguring, the objects.

If you were to take photographs of the same objects from a greater distance, without tilting the camera, the photo would depict a more accurate image of the objects. Frankly, there are no mandatory rules for making use of perspective. The aim is to achieve a visual effect that suits your concept of the image. Camera position and lens focal length should be chosen to create the desired perspective, not merely to crop out distracting details. You can always crop a print or a transparency, but perspective can only be created at the moment of exposure.

Interchangeable Lenses

Many photographers think of interchangeable lenses in very simple terms: If you can't move far enough away from a subject, use

This photo taken in Monument Valley with a 24mm focal length gives strong emphasis to the foreground subject while including some visual texture in the background. This serves to draw the viewer into the picture.

This image, taken with a 300mm telephoto, spans the distance effortlessly, rendering the eroded stone with sharpness and clarity.

a wide-angle; if you're unable to get close enough, use a telephoto. This approach is a good starting point, but it is somewhat limited. It ignores the most important reason for choosing a focal

length: to achieve the composition that you want. A telephoto lens is helpful in recording an object, animal, person, or group from a discreet distance. Its more limited depth of field tends to isolate the subject from its surroundings. A moderate wide-angle lens allows a subject to be shown in relation to his or her surroundings or environment.

Lenses, Vision, and Composition

Photographic lenses "see" differently than the human eye. Our vision is three-dimensional, with a sense of depth that is actually created in the brain. A photograph, however, is only a two-dimensional image. The impression of depth must be created by the lighting effects, composition, depth of field, and perhaps by emphasizing the relationship between the foreground and the background.

To produce expressive images and fully exploit the opportunities that interchangeable lenses afford, you need to become familiar with how each lens "sees" and its role in composing a picture. Longer focal lengths, with narrower picture angles, tend to isolate the subject from its surroundings and force the viewer to concentrate on the selected object. Such isolation can also emphasize a subject's details. On the other hand, an object that seems isolated to the human eye can be visually connected to its surroundings by employing a short focal length lens with a very wide angle of view. A 50mm lens used from a medium distance will usually make an object seem as natural and as similar to human vision as possible.

Wide-angle photos can have a dynamic appearance. The images tend to show a large surrounding area, which accentuates the sense of depth. The main subject in the foreground is emphasized, and its proportions may be distorted. Meanwhile, objects in the background rapidly diminish in size, providing an impression of depth in a two-dimensional image.

With longer focal lengths, the visible area behind the main subject is compressed, and the appearance of depth is less pronounced. Changing the camera position and the focal length results in varying impressions of depth and space in a picture. You can make the foreground appear to move closer to the background. Space seems to be compressed as near and far subject

These five views illustrate the variety of effects you can achieve shooting with various focal lengths from various points of view. Each image has its own strength, demonstrating the versatility of 35mm SLR photography.

elements appear to be almost on the same plane; this effect is increased as you use longer and longer lenses from a distance.

It makes good sense to experiment with different focal lengths until you are thoroughly familiar with every lens you own. Try a variety of shooting positions and distances. Also, look for vertically oriented subjects, and become familiar with holding and using your camera in the vertical position.

Taking just one lens on a short photographic excursion can be a great help in getting to know its point of view. Try changing your distance to the subject, as well as the camera's position (by tilting the camera, crouching down, shooting from an elevated position, etc.). By concentrating on a single focal length, you learn how the lens affects composition and the sense of perspective, and how and when to use it so it is most effective.

It's also interesting to shoot the same subject with various focal lengths. When switching to a telephoto, try picking out details within a vast landscape or city panorama to create different pictorial effects. This exercise will illustrate the relationship between focal length, camera position, perspective, and reproduction ratio. Work on it for some time, and you may discover a favorite focal length, which should yield some great photographs.

Choosing the Right Lens

Manufacturers offer hundreds of lenses for the 35mm format, making it difficult for the SLR photographer to select the right ones for his or her needs. To simplify the process, consider a few basic questions:

❏ Do you prefer fixed focal length lenses or zooms?
❏ How important is a wide maximum aperture in the types of photographs you take?
❏ Which focal lengths would you use most frequently?
❏ Are there special lenses that can help to expand your picture-taking horizons?
❏ For infrequently used focal lengths, such as 18mm or 600mm, can you rent a lens locally?

Naturally, there is no universal answer to these questions, because each photographer's situation and demands are different.

However, pondering the basic issues in relation to your own favorite subjects and style of shooting will help narrow your potential choices.

Zoom or Fixed Focal Length?

From year to year, zoom lenses continue to gain in popularity. The most obvious advantage of zooms is their added flexibility. While a prime (or fixed focal length) lens has only a single focal length, a zoom model covers a range of focal lengths (such as 80-200mm, 24-120mm, etc.), replacing several lenses with one. This allows a stepless choice of focal lengths, so you need only to zoom the lens to change the subject's framing.

It is not by chance that zoom lenses are so popular, and their practical advantages cannot be overlooked. With a zoom, there is less need to change lenses and fewer lenses to carry around. In addition, while a zoom lens may cost more than a prime lens, it is considerably cheaper to purchase one zoom than the several fixed focal length lenses it replaces.

Zoom lenses in the 28-80mm or 28-105mm range are well suited for landscape and travel photography and serve as good general-purpose optics. Normal-to-telephoto zooms, such as 70-210mm or 75-300mm, are also useful for landscape and travel work, as well as portraits, sports, and animal pictures taken from a moderate distance.

Some photographers carry only one wide-range "all-purpose" zoom, such as a 28-200mm. This is certainly convenient, because you avoid the hassle of carrying and changing several lenses, and you are always ready for unexpected photo opportunities. On the other hand, wide-range zooms are generally larger and heavier than conventional short zooms, such as a 28-80mm. Even the new ultracompact and ultralight models tend to weigh over a pound, considerably more than the typical normal or wide-angle lens.

Perhaps the biggest question still asked by countless photographers concerning zoom lenses is, "How does their image quality compare to that of fixed focal lengths?" Today's best zooms are comparable in optical quality to their prime focal length counterparts thanks to technical advances: new types of glass, aspherical or low-dispersion elements, computer-assisted lens designs, and robotics-aided lens construction.

If you compare a zoom lens in the mid-range of focal lengths, perhaps a 28-70mm, to its counterparts in a fixed focal length, you may find little difference in image quality. Exceptional zoom lenses of this type are easy to design and manufacture with conventional optical methods. However, in the ultrawide and super-telephoto range, the single focal length lenses are often superior in terms of image quality, unless you consider the most expensive zooms with aspherical or low-dispersion glass elements. With the broad-range zooms, covering numerous focal lengths from wide-angle to telephoto, the designers face a greater challenge: correcting the different optical aberrations which occur at short and long focal lengths. With such zoom lenses, the best image quality is produced in the mid-range of apertures, such as f/8 or f/11, in the mid-range of focal lengths.

When used at their widest aperture, many zooms are inferior to fixed focal lengths due to optical aberrations. Stop down to f/8, however, and image quality usually improves noticeably. Or consider one of the highly corrected zoom lenses, such as wide-angle zooms with aspherical elements or telephoto zooms with ED (extra-low-dispersion) elements. These are highly corrected and provide exceptional sharpness, resolution, and freedom from distortion, even at the maximum apertures.

Available-light photographers should note that zooms tend to be slower than comparable prime lenses. They have smaller maximum apertures, such as f/4 instead of f/1.8, for example. Note, too, that some zooms have variable maximum apertures. For instance, the Nikkor AF 28-200mm f/3.5-5.6D IF offers a maximum aperture of f/3.5 only at the short end. As you zoom toward longer focal lengths, the size of the maximum aperture diminishes, and becomes f/5.6. This strategy is employed by lens designers in order to keep zoom lenses as small and light-weight as possible. The reducing aperture size does not mean that exposures will be incorrect, because the camera's TTL metering system measures the amount of light that will actually strike the film. However, the smaller maximum aperture can be a problem: The shutter speeds become longer, especially at telephoto focal lengths where the least camera shake is amplified.

While you may be able to use a slow film, such as ISO 50, with a fast zoom, like the AF 80-200mm f/2.8D ED, in handheld

photography, you may need to switch to a faster film, such as ISO 200, with a slow zoom, such as the 28-200mm model.

The close-focusing ability of a lens may also be an important consideration. Wide-angle to telephoto zooms often have rather limited close-focusing abilities. For example, the AF 28-200mm f/3.5-5.6D IF zoom has a variable close-focusing ability: It ranges from 2.8 feet (0.85 m) at the 28mm end to 4.9 feet (1.5 m) at the 200mm end. By comparison, the Nikkor AF 28mm f/2.8D will focus as close as 0.85 feet (0.25 m). The minimum focusing ability of the 28-200mm zoom is quite respectable, however. For example, the AF 180mm f/2.8D ED-IF will focus only as close as 5 feet (1.5 m). Our concern is about the minimum focusing distance of the 28-200mm zoom (and many others) at wide-angle settings.

Each photographer must decide what features in a lens are important to his or her style of photography. Replacing several prime lenses with one zoom lens is appealing for any photographer wanting to travel light. Any slight loss of image quality may be irrelevant. Before deciding upon any lens, zoom or prime, look at the individual lens' advantages or disadvantages in view of your own needs: image quality, minimum focusing distance, maximum aperture, convenience, favorite subject matter, and your own photographic techniques.

Variable Effective Apertures
As previously mentioned, many zoom lenses are designed with variable maximum apertures, such as the AF 28-200mm f/3.5-5.6D IF. Light transmission reduces as you shift to longer focal lengths where the maximum aperture is smaller.

When you use a lens of this type with your Nikon F100, the effective aperture reduces only when you are shooting at the widest aperture. If you set a smaller aperture, such as f/8, the effective aperture will be f/8 throughout the entire focal length. It will not get smaller as you zoom.

Note: The above applies only if you are setting f/stops with the command dial of the F100. If you have set a custom setting that allows you to do so with the aperture ring of the lens, the above does not hold true. Instead, the effective aperture will diminish as you zoom to longer focal lengths, no matter what f/stop you are using. If you set f/8 at the short end of the zoom and shift to

longer focal lengths, the effective aperture will diminish. By the 200mm end, it will be smaller than f/11.

Custom Settings: CSM 19 should be considered when using a lens of either type. CSM 19-0 is the default setting. When you use a Micro Nikkor lens, or a variable-aperture zoom, the f/stop selected with the camera's command dial remains constant as focus is changed or the lens is zoomed. This assumes that you have set an aperture smaller than the maximum aperture, f/8 perhaps. Throughout the entire zoom range, the effective shooting aperture will be f/8. The effective aperture will diminish only when shooting at the maximum aperture of the lens.

CSM 19-1 can be set. When a Micro Nikkor lens is close-focused, or a variable-aperture zoom is zoomed, the actual aperture size will always vary. For example, f/8 may change to f/11 in extreme close-focusing and when you are shifting to longer focal lengths with a zoom. This effect is similar to what you would get if you were using the lens' aperture ring to set desired f/stops.

Frankly, we do not recommend either strategy with Micro Nikkor and variable-aperture zoom lenses. In our experience, changing f/stops with a command dial—without setting CSM 19-1—is the most logical way to use such lenses. As your experience with the F100 increases, you may decide to ignore this advice for specific reasons.

Compatibility With Various Nikkor Lenses

In order to take full advantage of all of the capabilities of your Nikon F100, it is best to use D-type AF Nikkor lenses. However, you can also use the earlier AF series of lenses, and even the older manual focus AI or AI-S Nikkors (without CPU contact points), but with limitations.

When non-D-type AF Nikkor lenses are used, you may not notice any difference at all in comparison to operation with AF-D lenses. Matrix metering (with and without flash) will be slightly less reliable, especially in scenes with extremely high contrast or unusually dark or light subjects. All other camera functions will operate perfectly.

When you mount a manual focus Nikkor lens, matrix metering

is not available; set the camera for center-weighted or spot metering. Program and Shutter-Priority modes are also not available, so select Aperture-Priority or Manual operating mode on the F100. (Matrix metering and all operating modes are available with the few AI-P series lenses.) Autofocus will not operate either, of course, but the electronic rangefinder's focus assist signals in the viewfinder will operate as long as you use lenses with f/5.6 or wider maximum aperture. Remember that teleconverters and extension tubes reduce the amount of light transmitted to the camera's computer; the focus assist system will not respond if the effective maximum aperture is smaller than f/5.6.

Only one current series of teleconverters, the AF-I series, maintains autofocus, P and S modes, and matrix metering. With all others, none of these capabilities are available. However, the AF-I teleconverters are only compatible with the AF-I series and the AF-S series Nikkor lenses, though not with the AF-S 28-70mm f/2.8D IF-ED zoom.

Note: When you use a manual focus lens with the F100, f/stops must be selected using the aperture ring on the lens. (The only exception to this rule is with the few AI-P series lenses that do have a CPU.) The command dials cannot be used to do so. As well, no indication will be given in either of the camera's data panels as to which f/stop has been selected; the symbol ***F- -*** will appear instead. In order to check which f/stop has been set, take a look at the setting on the aperture ring of the lens.

Note that the following lenses must not be used on your Nikon F100:

❏ The IX-series of Nikkor lenses (made for Nikon Advanced Photo System cameras, such as the Pronea)
❏ Non-AI lenses (unless modified to the AI standard)
❏ AF teleconverter TC-16A (an obsolete accessory that provided some autofocus capabilities with manual focus lenses on some older Nikon AF cameras)
❏ K2-Ring
❏ 400mm f/4.5, 600mm f/5.6, 800mm f/8, and 1200mm f/11 lenses with Focusing Unit AU-1
❏ 8mm f/8 fisheye lens
❏ Old-type 21mm f/4 lens
❏ ED 180-600mm f/8 lens (serial number 174180 and smaller)

- ❏ ED 360-1200mm f/11 lens (serial number 174127 and smaller)
- ❏ 200-600mm f/9.5 lens (serial number 300490 and smaller)
- ❏ 80mm f/2.8, 200mm f/3.5, and TC-16 teleconverter for the Nikon F3AF camera
- ❏ PC 28mm f/4 perspective control lens (serial number 180900 and smaller)
- ❏ PC 35mm f/2.8 lens (serial number 906200 and smaller)
- ❏ Old-type PC 35mm f/3.5 lens
- ❏ Old-type reflex 1000mm f/6.3 mirror lens
- ❏ Reflex 1000mm f/11 mirror lens (serial number 142361 to 143000)
- ❏ Reflex 2000mm f/11 mirror lens (serial number 200310 and smaller)

Note: The Medical Nikkor 120mm f/4 lens can be used only in Manual mode and only with shutter speeds of 1/125 second or slower. When AI or AI-S teleconverters—or the auto extension rings PK-11A, PK-12, PK-13, and PN-11—are used, exposure will be inaccurate with some lenses. Some exposure compensation is necessary for correct exposure.

While the above list may seem long, remember that Nikon made a multitude of lenses that are compatible with the F100. If you include the non-AI lenses that must first be converted to the AI standard, the number of lenses that can be used with the F100 totals several hundred.

Focal Lengths

Focal length is the most important attribute of any lens. Therefore, each of the following sections deals with a specific focal length group, discussing the common characteristics of its members. Where necessary, the points of differentiation between individual lenses within a group are mentioned. Although Nikon offers a wide selection of manual focus lenses, only the Nikkor AF lenses are discussed here.

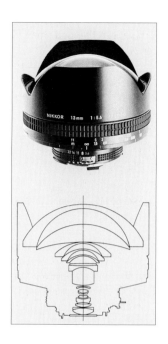

Nikon has a wide range of manual lenses that can be used with the F100, such as the Nikkor 13mm f/5.6. This lens' wide angle of view can open the door to infinite creative compositions.

Ultra Wide-Angle Lenses

The lenses in this category (13mm to 21mm) have extremely wide angles of coverage, ranging from 118° (13mm) to 92° (21mm). Nikon offers two ultra wide-angle lenses: AF 18mm f/2.8D and AF 20mm f/2.8D, with 100° and 94° angles of view, respectively. In addition, Nikon offers two zooms within this focal

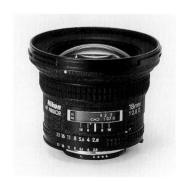

Nikkor AF 18mm f/2.8D

Nikkor AF 20-35mm f/2.8D

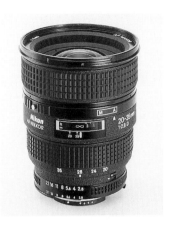

length range, the Nikkor AF 20-35mm f/2.8D and the newer AF-S 17-35mm f/2.8D IF-ED.

The latter is one of the best zooms of its type on the market, competitive with the best fixed focal length lenses in terms of image quality, close-focusing ability (0.9 feet or 0.28 m), premium-grade optics (both aspheric and low-dispersion), internal focusing, plus the extremely fast Silent Wave (ultrasonic) focus motor.

The 18mm focal length emphasizes the converging lines, which give this image great depth.

This photo, taken with an 18mm lens, demonstrates how ultra wide-angle lenses are well suited for architectural photography.

Originally used only for practical reasons inside very small rooms, helicopters, boats, etc., ultrawides have become popular for creative purposes. Extreme wide-angle lenses produce dramatic impressions with expanded spatial perspective. The foreground tends to dominate the picture, especially if the lens is close to the main subject, while the background appears to drift into the distance.

Ultra wide-angle lenses offer extensive depth of field, even at their maximum aperture. Stopping down extends it even further, allowing everything from foreground to background to be sharply rendered.

Ultra wide-angle lenses are particularly well suited for architectural photography. Their wide angle of coverage can allow multi-storied buildings to be depicted in their entirety, without converging lines, even from relatively short distances. Architectural pictures taken from a comparatively low position may include a lot of foreground, perhaps a street with pedestrians and vehicles. These features can often be made part of the composition. Also, converging lines can be used to create a dynamic sense of composition. Tilting the lens upward from the base of the building can emphasize perspective and exaggerate it for an unconventional effect.

Ultra wide-angle lenses, however, pose specific challenges. In photos with dominant foregrounds, strongly tapering backgrounds, and wide expansive horizons, composition can be difficult. The main subject must be carefully positioned, often in ways not dictated by the classic Rule of Thirds approach. And as the angle of view becomes wider (at shorter focal lengths), a wealth of details may be included in the frame; sometimes this can be a problem as the numerous elements compete for viewer attention. Often this goes unnoticed until the image is projected or enlarged. So the viewfinder image should be thoroughly examined before shooting; move in closer to the primary subjects to exclude unrelated subject matter.

Simply trying to align the camera properly can be difficult as well. When shooting in small rooms, be sure not to accidentally tilt the camera. Also, direct flash is not likely to provide even illumination across the wide picture angle, so bouncing the flash light from a ceiling may be necessary. (Some Speedlights allow for coverage for focal lengths as short as 18mm.)

The varying levels of brightness and contrast you are likely to encounter with an extremely wide angle of view can often create a challenge for the camera's metering system. Careful light metering is particularly important in landscape shots made with ultra wide-angle lenses, especially when the sky is included in the frame. Due to the extreme angle of coverage, the sky often occupies large parts of the image area and may produce an

underexposed foreground if it is quite bright, even with 3D matrix metering. Depending on the contrast and the amount of sky included, an exposure compensation factor of +1 to +2 EV steps may be necessary.

Vignetting and distortion are two of the ultrawide's less-endearing properties. Vignetting—the darkening at the corners of the frame—is most pronounced at wide apertures, especially with zoom lenses. Closing down 2 stops usually reduces or even eliminates it. However, advanced design methods have minimized vignetting in today's better lenses. Linear distortion also increases with the picture angle, causing straight lines near the edges of the frame to be rendered as slightly curved. In high-end ultra wide-angle lenses and zooms, distortion is usually well corrected and almost unnoticeable.

Fisheye Lenses

Although they fall in the same range of focal lengths, fisheye lenses are quite different than the rectilinear lenses described so far. (A rectilinear lens reproduces straight lines accurately.) These unique lenses offer an incredibly wide angle of view: 180° with the AF fisheye 16mm f/2.8D, for example, as compared to 104° at the short end of the 17-35mm zoom. However, this is achieved only because straight lines are rendered as curved due to severe barrel distortion. All horizontal and vertical lines—except those that pass through the image center—are severely curved, especially those near the edges of the frame. These lenses are especially suitable for creating unique effects in landscape and architectural photography, as well as certain scientific applications.

At the time of this writing, Nikon offered only one fisheye lens in the AF series, the AF 16mm f/2.8D. This is a full-frame fisheye, which produces a rectangular image. (Some other lenses, such as the manual focus 8mm f/2.8 fisheye, produce a circular image on a rectangular frame of film.) The effect is similar to a panorama, if there are no obvious straight lines to be distorted in the image. Great care should be taken not to include the tips of your shoes or tripod legs in fisheye pictures (this happens more easily than you might think). And remember to dial in some + exposure compensation factor when bright sky or water fills much of the frame.

Note that fisheye lenses are not necessarily shorter in focal length than the well-corrected (rectilinear) ultrawide lenses. For

This traditional view was taken with a 13mm focal length.

Here is the same view, photographed using a Nikkor 8mm f/2.8 fisheye lens.

An even more unusual perspective was achieved by the author lying on the ground, shooting upwards with the 8mm fisheye lens.

This photo is an example of the relatively wide angle of view captured with a 28mm moderate wide-angle lens.

example, Nikon offers a manual focus Nikkor 15mm f/2.5 that does not bend lines but has an angle of view of only 110°.

Moderate Wide-Angle Lenses

The moderate wide-angle range, from 24mm to 28mm, is a favorite of many photographers because their relatively wide angle of view (84° for the 24mm and 74° for the 28mm) gives pictures wide-angle coverage without unduly exaggerating perspective. If the camera is aligned carefully, images have a well-balanced almost natural look, even though their angle of coverage is greater than that of concentrated human vision. However, if you tilt the camera or shoot from a low angle, perspective will be exaggerated.

Nikon has three prime moderate wide-angle lenses: AF 24mm f/2.8D, AF 28mm f/1.4D, and AF 28mm f/2.8D. It also offers a number of zooms that cover this range: AF 24-50mm f/3.3-4.5D, AF 24-120mm f/3.5-5.6D, AF 28-70mm f/3.5-4.5D, AF 28-80mm f/3.5-5.6D, AF 28-200mm f/3.5-5.6D IF, the *non-D* AF 28-85mm f/3.5-4.5, and the newer AF-S 28-70mm f/2.8D with Silent Wave focus motor.

Moderate wide-angle lenses provide wide-angle coverage without unduly exaggerating perspective.

Expansive depth of field and relatively fast apertures render the 24mm and 28mm lenses ideal for photojournalism. Landscapes, cityscapes, candids, and group portraits are other strong applications. They are also appropriate for indoor assignments in available light with ISO 200 or 400 film.

Wide-Angle Lenses

For decades, 35mm lenses were the most popular wide-angles, mostly because they were the only ones sufficiently corrected for high optical quality. More recently, improvements in lens technology have made it possible to design well-corrected wide-angle lenses with broader angles of coverage.

With a picture angle of 62°, the 35mm lens covers a considerably larger area than a 50mm normal lens with its 46° angle of view. Still, the 35mm lens tends to provide a relatively normal rendition of perspective. The depth of field is also greater than with a normal lens, and the shorter, lighter lens reduces the risk of blur from camera shake. These characteristics lend themselves to candid photography, photojournalism, landscapes, group portraits, and environmental portraits of individuals. In addition, still

Nikkor AF 35-70mm f/2.8D

lifes of larger objects and nearby architectural details are the 35mm focal length's natural domain.

Nikon offers one 35mm AF lens, the AF 35mm f/2D and many zooms that include the 35mm focal length: all zooms mentioned in the ultra and moderate wide-angle lens sections as well as the AF 35-70mm f/2.8D, 35-80mm f/4-5.6D, 35-105mm f/3.5-4.5D, AF 35-135mm f/3.5-4.5 (non-D lens), and the newer AF-S 28-70mm f/2.8D with Silent Wave focus motor.

Normal Lenses

Lenses with a focal length around 50mm are considered "normal." The 46° angle of view is comparable to what we can see with one eye; a 28mm lens provides an angle of view comparable to what we see with two eyes, without scanning a scene. However, a 50mm lens tends to produce a more "normal" rendition of a scene that most viewers consider the most accurate. At this time, Nikon offers two normal lenses: AF 50mm f/1.4D and AF 50mm f/1.8 (non-D lens).

Nikkor AF 50mm f/1.4D

Normal lenses can be used in almost any area: journalism, candids, travel, still lifes of large objects, architectural details, posed portraits, and group shots. As a rule, normal lenses are compact, lightweight, and modestly priced. Nikon's fast normal lens (f/1.4) is perfect for available-light photography at night or indoors without the need for superfast film.

Numerous zoom lenses include this focal length. Many photo dealers even offer a camera body packaged with a normal zoom, such as a 28-70mm, 28-80mm, 28-85mm, 35-70mm, or 35-105mm. If you don't purchase a kit, it's a good idea to start with a 50mm lens and branch out later when you discover which lenses you want to add.

Moderate Telephoto Lenses

The focal lengths between 70mm and 135mm are the most popular in the telephoto range. Nikon has two conventional lenses in this category, the AF 85mm f/1.8D and AF 85mm f/1.4D. Some of the many zooms that cover this focal length range include: AF 35-135mm f/3.5-4.5, AF 70-210mm f/4-5.6D, AF 70-300mm f/4-5.6D ED, AF 75-300mm f/4.5-5.6, AF 80-200mm f/4-5.6D, AF 80-200mm f/2.8D ED-IF, and the newer AF-S model with Silent Wave focus motor.

Prime lenses or zooms of this type are easy to handle and very versatile. In fact, moderate telephotos are comparatively simple to design and often display excellent overall image quality. Their relatively narrow picture angle simplifies composition by concentrating on the main subject and eliminating extraneous

The Nikkor AF 85mm f/1.4D is an ideal portrait lens.

Nikkor AF 80-200mm f/2.8D

surroundings. Compared to wide-angle and normal lenses (assuming the same camera-to-subject distance), moderate telephotos include less subject matter in the scene at a larger reproduction ratio. Their shallow depth of field at wide apertures can be used to render the subject sharply against a soft background.

Another advantage of moderate telephotos is their tendency to slightly compress the space within the object area. The effect is not as distinct as with longer focal lengths and thus appears more natural to the viewer. Also contributing to the natural impression is the fact that these lenses produce very little distortion; they create tight head-and-shoulder portraits from a comfortable working distance to the subject. These properties have made 80-100mm optics so popular for photos of people that they are often called portrait lenses.

Not yet mentioned are two portrait lenses with Defocus Image Control technology, the AF DC 105mm f/2D and the AF 135mm f/2D. These lenses allow the photographer to control the degree of spherical aberration in the background or foreground by rotating the lens' DC ring. Any bright out-of-focus areas can be rendered as rounded, a very pleasing effect.

The moderate telephoto lens' characteristics also make such focal lengths ideal for still lifes and for details of landscapes or buildings. Because they tend to be relatively compact and fast, handheld shooting is easy. Appropriate uses include journalism, travel, fashion, and candids taken from a discreet distance.

A telephoto zoom set at a focal length between 80mm and 105mm is
excellent for head-and-shoulders pictures of people.

Photos taken from long distances are best made with a telephoto lens.

Telephoto Lenses

Lenses with focal lengths between 180mm and 300mm are used from even greater distances and display distinct telephoto characteristics: compression of spatial perspective, narrow angles of coverage, and shallow depth of field. In photographs taken from intermediate distances, relatively small objects will fill the frame. On the other hand, these focal lengths are not quite long enough to span great distances. Zoo animals, for instance, may fill the picture area, while those in the wild may not.

Telephotos are fine lenses for frame-filling landscape details, such as a single mountain peak or a rock face. In architectural photography, distant details, for instance, a gable, can be captured, or a row of houses can be compressed so the buildings appear to be stacked. Candid portraits or concert shots are also possible from considerable distances. Sports and wildlife photography often

This photo demonstrates a typical characteristic of telephoto lenses— the compression of distance.

requires still longer lenses, unless you want to include the surroundings as well for an environmental portrait.

The classic telephoto range includes focal lengths from 180mm (angle of view, 14°) to 300mm (angle of view, 8°). Nikon makes a number of zoom lenses as well that fall into this focal length range. Prime lenses offered by Nikon include: AF 180mm f/2.8D ED-IF, two AF-S 300mm lenses both with Silent Wave focus

Nikkor AF 70-300mm f/4-5.6D ED

Nikkor 300mm f/2.8D EDIF AF-S

motor, and AF 300mm f/4 ED-IF. At these focal lengths, handheld shots are best made at 1/350 second or higher if maximum image quality is required.

With the additional power of these lenses, great care should be taken to focus accurately and to release the shutter without causing any vibration. Whenever possible, mount a 300mm telephoto on a sturdy professional tripod and use a remote shutter release accessory. For sports and wildlife photography, a monopod is a good compromise.

Extreme Telephoto Lenses

The most powerful lenses of all, super-telephotos with focal lengths between 400mm and 600mm (angle of view from 6° to 4°), are ideal for spanning long distances. They offer magnifications of 7x to 24x (compared with 50mm lenses) and are well suited for wildlife, sports, and other action photography. Because of the great shooting distances, perspective is extremely compressed, creating striking visual effects. The very shallow depth of field is also useful for blurring a cluttered background into a soft wash of color, so the viewer's eye is drawn immediately to the subject.

Nikon offers three extreme telephotos, all with Silent Wave focus motor: AF-S 400mm f/2.8D ED-IF, AF-S 500mm f/4D ED-IF, and AF-S 600mm f/4D ED-IF. Thanks to an internal-focusing design, they offer smooth manual focusing and autofocus.

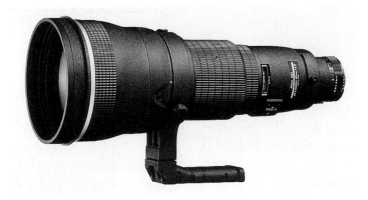

Nikkor 600mm f/4D EDIF AF-S

We don't recommend handholding such long lenses, because even the slightest movement impedes their sharpness. Shoot from a sturdy, professional tripod and trip the shutter with a remote accessory. And at high magnifications, even a tripod-mounted camera and lens may be affected by a strong breeze or by the movement of the reflex mirror, which creates internal vibration. (Avoid shooting at shutter speeds slower than 1/60 second to avoid the risk of slight image blur from reflex mirror action.) Some sports photographers use these very long/heavy super-tele-photos with a monopod, but sharpness is unlikely at shutter speeds longer than 1/250 second unless the monopod is braced against a very solid object.

Rather than using the tripod mount on the camera, be sure to use the one on the lens; this increases stability and makes it easy to rotate the camera/lens from a horizontal to a vertical orienta-tion. Also, using the built-in lens hood protects the large front ele-ment from stray light, which causes image-degrading flare.

Special-Purpose Lenses

Macro Lenses

Macro lenses—called micro by Nikon—are very versatile; they can either be used exactly like conventional models or as high-quality close-up lenses. Depending on the lens design and focal

The AF Micro 105mm f/2.8D was used to capture the precise detail of this butterfly.

length, reproduction ratios up to 1:2 (half-size) or 1:1 (life-size) can be achieved without accessories. Special close-up equipment, such as a bellows unit, T-series supplementary close-up

lens, or extension tube, enables you to achieve even greater magnifications.

The AF Micro Nikkor series includes: AF Micro 60mm f/2.8D with a minimum focusing distance of 8-3/4 inches (21.9 cm) and a possible reproduction ratio of 1:1, AF Micro 105mm f/2.8D with a minimum focusing distance of 1 foot (31.4 cm) and a possible reproduction ratio of 1:1, AF Micro 200mm f/4D ED-IF with

Nikkor AF Micro 105mm f/2.8D

a minimum focusing distance of 1.7 feet (0.5 meter) and a possible reproduction ratio of 1:1, and a true macro zoom, AF Micro 70-180mm f/4.5-5.6D ED with a minimum focusing distance of 1.4 feet (1 meter) and a possible reproduction ratio of 1:1.32 (slightly less than life-size). Nikon also offers an 85mm f/2.8D micro lens with full perspective control capabilities discussed in the PC lens category; it will focus as close as 1.3 feet (0.39 m) for a maximum reproduction ratio of 1:2.

Perspective Control (PC) Lenses

This shot exhibits converging lines that result from the film plane and the building's face not being parallel.

Shift lenses are specially designed to correct perspective distortion that is evident with subjects prone to converging lines, such as architecture. To achieve parallel perspective, you have to shift the lens' optical axis, which is easily accomplished with a perspective control (PC) lens. Nikon makes two shift lenses, the 28mm f/3.5 PC and the 35mm f/2.8 PC.

When using optics of this type, you can position the camera so the film plane is perfectly parallel to the subject and shift the lens axis instead. To achieve parallel perspective, you first align the film plane with the front surface (the building's facade) then, if possible, shift the lens axis to include the second surface (the building's side).

In an uncorrected photo, central projection causes the building's front and side to be depicted with distinct vanishing lines. In a corrected photo, the film plane is first aligned parallel to the facade, correcting the vertical perspective lines. Then the lens is shifted (if it offers this feature) to correct the horizontal perspective lines. In this way, the building takes on a more natural appearance.

Parallel perspective is not helpful just for outdoor shots. For studio photographs of rectangular objects, such as packages,

This was taken from the same location, but it has no converging lines because the lens was shifted 10mm, allowing the film plane to be parallel with the building's face.

books, or appliances, it creates a more natural look. These lenses make it possible for you to render a three-dimensional object on a two-dimensional surface just as you perceive it.

Nikon offers the two manual focus lenses with shift capability only and an entirely new lens that offers both shift and tilt capability: the PC Micro Nikkor 85mm f/2.8D. The tilt feature—a first in a Nikkor PC lens—helps to achieve sharp focus of an entire subject even when it is not parallel to the film plane. As well, it can be used to narrow the plane of sharp focus to a single area for a unique effect favored by advertising photographers. The ability to both tilt and shift the lens off-axis makes this a highly versatile tool for correcting image distortion and ensuring just the right amount of sharp focus in subjects that are not parallel to the film plane, even when shooting from an inclined position.

Note: The camera's exposure metering and flash control systems do not work properly when shifting or tilting the 85mm PC lens or when using any aperture other than f/2.8. Use a handheld accessory light meter or flash meter instead.

Nikkor 500mm f/8 Reflex

Mirror Lenses

Catadioptric or "mirror" (also called "reflex") lenses are a special type of telephoto that uses a "folded" light path: The light is bent back and forth from mirror to mirror. The advantage of this type is compact size and length. A 500mm f/8 mirror lens is roughly the same size as a 135mm f/2.8 lens.

The light rays enter through a large, ring-shaped lens element and are reflected by the ring-shaped primary mirror onto a smaller, secondary mirror. This mirror then reflects the light back through the other lens elements onto the film.

Due to its unique construction, a mirror lens cannot accommodate a variable diaphragm. The f/number noted on the lens is the only possible aperture setting. And because of the folding of the light path, mirror lenses are typically very slow, with f/8 common in the 500mm reflex lenses. Because the f/stop cannot be adjusted, exposure is controlled by changing the shutter speed in the camera's Manual mode or by setting some exposure compensation in the Aperture-Priority AE mode.

The circular highlights in the background of this image are caused by the ring-shaped mirrors in the reflex lens.

Nikon does not make AF mirror lenses but offers three in manual focus mount: 500mm f/8, 1000mm f/11, and 2000mm f/11; the latter is available only by special order, with advance payment. While the slow speed may be problematic in some instances, these lenses are usually mounted on a tripod, which allows for the use of long shutter speeds. The most limiting feature of a mirror lens is that the fixed aperture gives the photographer no way to control depth of field.

Optical correction of these powerful telephotos is greatest at moderate-to-long distances, although some are capable of close-focusing as well. For example, the Nikkor 500mm f/8 focuses to about 5 feet (1.5 m) with a reproduction ratio of 1:2.5. The 1000mm f/11 focuses to about 25 feet (8 m), and the 2000mm f/11 focuses to about 60 feet (18 m).

Like all telephoto lenses used at long camera-to-subject distances, mirror optics give a distinct sense of compressed spatial perspective. Also unique to this design are "doughnut-shaped" out-of-focus highlights in the foreground or background, caused by the ring-shaped mirror and front element. Natural subjects for mirror lenses include sports and wildlife photography as well as photography of the stars with the longer lenses.

Note: The relatively compact size of the 500mm f/8 reflex lens makes it suitable for handheld photography. However, it is almost impossible to get sharp images with any 500mm lens at shutter speeds longer than 1/500 second unless a tripod or monopod is used. If you must shoot hand-held, use a faster film, ISO 400 and perhaps ISO 800 in lower light.

Nikon AF-I 1.4x Teleconverter
TC-14-E

Teleconverters

Teleconverters extend the focal length of a lens but also reduce the effective maximum aperture. A 1.4x teleconverter reduces effective aperture by 1 stop, making a 300mm f/4 telephoto into a 420mm f/5.6 combination. A 2x converter turns that lens into a 600mm f/8 combination due to a 2-stop loss of light transmission.

At this time, Nikon offers only two autofocus teleconverters, the AF-I series: TC-14E and TC-20E. These can be used only with the AF-I and AF-S series of lenses that incorporate a focus motor in the lens barrel. (The AF-I lenses are no longer current but may still be available, especially used.) However, they are not compatible with the short AF-S zoom, the 28-70mm f/2.8D.

The conventional Nikkor teleconverters include the following: TC-14A, TC-14B, and TC-14E (increasing focal length by 1.4x), and the TC-201, TC-301, and TC-20E (doubling focal length).

Each teleconverter is designed to be used with a specific family of lenses. The TC-14A is for use with short lenses whose rear element is flush, and the TC-14B is for use with lenses whose rear element is inset. The TC-201 is for use with lenses whose rear element protrudes, and the TC-301 is for use with long lenses whose rear element is recessed.

Aperture numbers and depth-of-field scales engraved on the lens are not valid with a teleconverter in place. If, for instance, a 85mm f/1.4 lens is turned into a 170mm f/2.8 by a 2x converter, the marked aperture of f/1.4 represents an effective opening of f/2.8 at the new focal length.

A teleconverter not only increases the power of a telephoto lens, but its close-up capabilities as well. While the focal length with a 2x is doubled, the minimum focusing distance of the lens remains the same, resulting in a doubling of the reproduction ratio at a given distance. Converters are a good compromise for

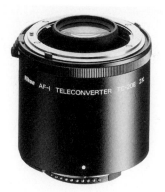

Nikon AF-I 2x Teleconverter TC-20E

photographers who occasionally need longer focal lengths. They offer a less-expensive alternative to purchasing a more powerful lens, for instance by converting a 300mm f/2.8 telephoto lens into a 420mm f/4 lens or a 600mm f/5.6 lens.

Nikkor teleconverters are expensive but incorporate premium-grade optics to help retain the high quality potential of the lens to which they are attached. With a few exceptions (such as the 80-200mm f/2.8 models), they are not recommended for use with zoom lenses. Some independent lens manufacturers also make teleconverters, and some models are said to be fully compatible with AF Nikkor lenses and the Nikon F100. If you are considering one of these, shop at a store that is also a Nikon Advanced Systems Dealer. Ask the staff to check the accessory manufacturers' technical manual to confirm compatibility.

Buyer Beware: The Nikon warranty does not cover damage caused by any lens or accessory made by any manufacturer other than Nikon. While some of the most reputable accessory manufacturers' teleconverters may be fully compatible, shop wisely—your local Nikon Advanced System dealer is a good place to start. Take their advice seriously and check the manufacturer's warranty closely.

Subject-Oriented Photography

The Nikon F100 has been designed for the serious amateur and professional photographer, offering all of the advanced capabilities required for taking excellent pictures of any subject type. If are a typical F100 photographer, you will strive to make compelling photographs. While some photographers are extremely versatile, most find that specializing in a few areas allows them to excel. While some may shoot wildlife photography, underwater photography, or candid scenes in exotic locations, most of us tend to channel our interests into smaller categories, such as people photography, studio photography, or travel photography.

Concentration on a few broad subject types makes sense, even for sophisticated amateurs. Instead of attempting to become an expert in every area—and buying every single lens and accessory made by Nikon—it may be preferable to focus on certain subject matter and equipment. In this chapter, we offer a few recommendations as to effective techniques and equipment. They are intended to introduce you to different topics while offering some helpful tips for subject-specific situations. Suggestions for equipment are general recommendations and will include the use of older Nikkor lenses and those from independent lens manufacturers.

Portraits

Portrait photography holds great potential for good creative photography as well. Sophisticated portrait photography is targeted, composed, and compelling. It reflects the character and persona of the individual depicted, whether realistically or in line with the photographer's perceptions. For example, a football

◁ A 28mm lens was used in this environmental portrait of a couple that includes their surroundings to help tell the story. ©Peter K. Burian

player might be depicted as rugged and tough, while a ballet dancer appears lithe and graciously athletic—or exactly the opposite if that is the photographic intention. The pose, the costume, the lighting, and the background should complement the theme of the image and must be well thought-out in advance.

Classic focal lengths for portraits are in the 90-135mm range, generally of wide aperture from f/1.4 to f/2.8, necessary to blur a distracting background. The new Nikkor DC series, with Defocus Control, would be an ideal choice for foreground and background control. By using a would be an ideal choice for foreground and background control. By using a shallow depth of field, the viewer's attention will be drawn to the subject instead of conflicting background elements. Some photographers will use much longer focal lengths and shoot from much greater distances. The 180mm or 200mm f/2.8 lenses are common, while the 300mm f/2.8 is used by some for an unusual effect. Focal lengths between 28mm and 50mm are generally used for group portraits.

The primary factor to consider when selecting focal lengths is the distance from the camera to the subject. With a 28mm lens, you will need to move in very close, and the perspective will appear distorted. With a 300mm lens, however, you will need to move very far back, and the "compressed" perspective will be obvious. Neither effect is wrong but should be a conscious decision based on planned intentions. As a starting point, however, the 80-200mm range should be considered, maybe with one of the Nikkor f/2.8 zooms.

The Rule of Thirds applies to indoor and outdoor portraiture, whether taken in natural or artificial light (i.e., try to place the subject off center). Spot metering makes outdoor portraits easy, even with backlighting. And thanks to the F100's sophisticated TTL flash control, portraits can be taken with success with flash mixed with ambient light. Off-camera flash is generally more pleasing, however, unless you are adding only a hint of extra light on bright days, for example, to fill in the shadow cast by the bill of a cap. When shooting indoors, off-camera flash is the most appropriate; at the very least, try bouncing flash from a nearby white surface, such as a wall or ceiling. Direct frontal illumination should be avoided, because this type of light is the least effective in people photography.

Equipment Suggestions for Portraits
Basic equipment: 1 camera plus 35-105mm or 24-120mm zoom
Standard equipment: 1 or 2 cameras plus 35mm, 50mm, 85mm or 28-70mm and 80-200mm zoom
Advanced equipment: 2 cameras plus 35mm, 50mm, 85mm, 180mm or 28-70mm, 80-200mm zoom; and 105 or 135mm DC

Lens tip: In order to minimize depth of field in portraits, you should acquire lenses with the widest possible maximum aperture: f/1.4, f/1.8, f/2, or f/2.8. Or consider the DC series with Defocus Control for blurring the foreground or background, even at smaller apertures.

Film tip: The natural depiction of skin tones is very important in nudes, as well as portraits. Try portrait films of ISO 160 or 400. Some films are specifically labeled as portrait films, while others are not; read film test reports in photographic magazines to help narrow your choice.

Camera tip: If you have two Nikon camera bodies, mount a different lens on each: a 28-70mm zoom on the first and an 80-200mm on the second, for example. Now you have most of the focal lengths covered and can quickly change cameras to try new effects. You may also wish to load entirely different film types: color in one camera and black and white in the other, for example.

Travel Photography

Just about everyone who travels on vacation carries a camera to record the people and places encountered along the way. The resulting snapshots are great for reliving the sights of a trip but may not be photographically excellent. Dedicated travel and action photography is a highly complex topic, because it covers so many diverse subject areas and requires great photographic versatility.

Good travel photographers should be experienced in photographing landscapes, cityscapes, architectural details, people interacting, and still lifes of icons that one encounters. You can plan both the trip and the subjects you intend to photograph,

Travel photography isn't just pictures of scenes or buildings—interesting details capture the essence of a place and add variety to slide shows or albums. A versatile mid-range zoom lens is useful for both overviews and details—a great choice for a day of sightseeing.

especially in assignment work, and then strictly follow a checklist of specific subjects and general concepts.

Competent travel photographers also have the ability to be spontaneous, ready to respond to an unexpected situation. They study the region in advance, reading guide books on the area's culture, ethnic and religious mix, events with photographic potential, geography, particular points of interests, etc. They proceed with sensitivity, in particular in Muslim countries or among

native populations when taking pictures of people, aware of the local taboos and what is and is not acceptable behavior. Because people define any location, it's worth developing a high comfort level with strangers; a smile and a friendly gesture can quickly break the ice, even if you do not speak much of the language. This approach is definitely preferable to shooting with long lenses while hiding behind a tree. When it is clear that a potential subject prefers not to be photographed—and you will know from his or her reaction—smile and move on, looking for a more cooperative subject.

Before starting a trip, careful consideration should be given to the choice of film. Pictures should have the same color characteristics and similar resolution. In most instances, it is better to use only slow (ISO 50 or 100) film of the same brand for consistency and for maximum sharpness. A tripod can be used in poor lighting situations, when long focal lengths are used, or when small apertures are required for the greatest possible depth of field. Faster films may be required in situations where flash and/or a tripod are prohibited or impractical; in that case, you may need to switch to a higher ISO film of the same brand. Tripods are not allowed in most museums, and trying to light Notre Dame cathedral with an SB-28 flash is a sign of wishful thinking. Switch to an ISO 400 film and brace your elbows on some firm support, or try a tabletop tripod for an extra measure of stability.

Equipment Suggestions for Travel

A top professional travel photographer who frequently shoots assignments for prestigious magazines offered the following recommendations as a basic kit for travel photography:

❏ Two camera bodies, perhaps an F100 and a smaller N60/F60 as a backup, each with a different lens

❏ A Nikkor 20-70mm and 80-200mm (or similar focal lengths) zoom lens, plus a fast 50mm lens for low-light situations. A 1.4x teleconverter can also be useful if you carry the 80-200mm f/2.8 zoom.

❏ A very rigid tabletop tripod. A larger tripod, left in the car or hotel when not needed, is essential for night shots of a city.

❏ A flash unit, such as the SB-28, with a smaller unit as a backup; a TTL remote cord for off-camera flash, such as the SC-17

❏ Warming filter, such as a Tiffen 812, circular polarizer, and a pale amber filter (gel) to be taped onto the flash head in warm light, as at sunset. If shooting black-and-white film, then red, orange, and yellow filters should be added.

❏ A rugged camera bag, such as the Domke F2 bag, which is water-resistant, soft-sided, and compartmentalized

The above kit is certainly manageable and should be adequate for 90% of the potential subjects one encounters in amateur or professional travel photography. When sporting events, such as bullfighting, are to be included, a 300mm lens plus a 1.4x converter will be required as well. Longer focal lengths might be useful but may not be practical to carry around.

Landscape Photography

Sophisticated landscape and nature photography is not the by-product of a hiking tour but comes from a serious dedication to making exceptional images. When you visit an area, spend as much time as possible scouting for locations and great subject matter; the hours from 11am to 3pm are ideal for this task, as the lighting conditions are rarely optimum. Have your camera equipment with you at all times, however, in case some great lighting situation occurs: the minutes before a thunderstorm, for example, when the sky is already black but a ray of sunlight illuminates an area of the scene. In most cases, however, patience will be essential as you wait for just the right light to complement the subject.

In addition to a heightened awareness of light (its color, direction, and quality), it is important to develop a sense for composition. In a formal landscape photo, for example, you may want to include a visually interesting foreground element, a complementary mid-ground subject, and a striking background. Or switch to a telephoto lens to make intimate landscapes, isolating the most interesting segments of a vast scene.

From wide-angle to short telephoto lenses, depth of field is an important consideration. You generally expect landscapes to be sharp from foreground to background, and this calls for a small aperture, perhaps f/22 in some cases. (The new 85mm Micro PC Nikkor lens, with both tilt and shift capability, can be extremely

useful for maximizing depth of field even at wider apertures.) Check the effect using the depth of field preview, and try different points of focus to see which offers the widest range of acceptable sharpness throughout the scene. You will rarely want to focus on infinity; with a 28mm lens at f/16, for example, focusing at a point that is 7 feet from the lens provides a range of acceptable sharpness from 3.5 feet to infinity. At shorter focal lengths, focus on an even closer point, such as 3.5 feet with a 20mm lens at f/16.

At times, the shutter speed you use will be just as important as the f/stop. For example, shutter speeds between 2 seconds and 1/2 second (depending on the speed of flow) can render flowing water as fluid. On windy days, you may need to shoot at fast shutter speeds, such as 1/250 second to freeze the motion of flowers, grasses, and foliage. Or take the opposite approach and set a long shutter speed, such as 1 second for intentional blur of the moving elements for an interesting effect. Naturally, long shutter speeds will require you to use a small aperture for correct exposure, unless you use an ISO 50 film and perhaps a polarizer. Fast shutter speeds will call for a wide aperture unless you load a fast film, such as ISO 400.

In landscape photography, the contrast between sky and earth is often excessive—greater than the contrast recording range of film, particularly slide film. If you meter for the sky, the land will be rendered as very dark; meter for the foreground instead, and the sky will be rendered as white. The solution is to use a graduated neutral density filter. When the sky is a dark shade of blue, you should use a polarizing filter. This will increase the color contrast between clouds and sky, useful in both color and black-and-white photography. With black-and-white film, an orange or red filter can be used instead, but that will have a side effect—reds, oranges, and earth tones will be lightened by the filter.

Equipment Suggestions for Landscapes
Basic equipment: 1 or 2 cameras plus 28-200mm or 24-120mm zoom; tripod
Standard equipment: 1 or 2 cameras plus 24 or 28mm, 50mm, 105mm or 20-35mm, 28-80mm, 80-200mm zoom; tripod
Advanced equipment: 2 cameras plus 20mm, 28mm, 50mm or 20-35mm, 28-80mm, 80-300mm zoom; 85mm Micro PC (Perspective Control); tripod

This still life was shot using a simple tabletop setup. The backdrop was smooth and unwrinkled, creating a smooth transition from vertical to horizontal.

Still-Life Photography

Artistic still-life photography is one of the most fascinating, and at the same time most difficult, topics of photography. Whether discovered or arranged in natural light or specially lit, still lifes tend to challenge all of the skills of the photographer. This type of photography demands a distinct sense of form, color, and space, paired with substantial knowledge of image composition and lighting. Studio shots require an eye for aesthetic arrangement as well as lighting control to make the illumination appear natural and complementary to the subject.

The selection and placement of objects should create tension without disturbing a harmonious and sensitive balance. Form, structures, and colors should be enhanced with lighting to reflect the original idea. When the interplay of all of these factors is successful, the result is a balanced and expressive still-life image. Generally, the objects to be included will be small and photographed from a moderately close position. Hence, there will be no need for a huge studio, and the subjects can be set up quickly in any room. The centerpiece of the home studio is a foldable table with mounting devices for background panels, which must be smooth and not wrinkled or creased in the transition from the vertical to the horizontal. The basic kit for the sophisticated still-life photographer should include a flash unit setup with studio umbrella or reflector for bounce flash, a snoot to narrow the light beam from flash, and light stands for mounting the flash units.

Equipment Suggestions for Still Lifes
Basic equipment: 1 camera plus 28-80mm zoom with close-focusing ability; (optionally, also 105mm Micro Nikkor lens); tripod; flash unit; and TTL connecting cord (SC-17) for off-camera flash
Standard equipment: 1 camera plus 24, 28, or 35mm, 60mm macro, 105 macro or 70-180mm micro zoom; tripod; connecting cord system for two or more off-camera flash units; backdrops; umbrella for bouncing flash light onto the subject
Advanced equipment: 2 cameras plus 20mm, 35mm, 50mm and 105mm Micro Nikkor or 200mm Micro Nikkor or 70-180mm Micro Nikkor zoom; tripod; studio lighting equipment with light modifiers and professional background sheets; light reflector panels

Animal and Sports Photography

Considering the subjects, these two topics appear to have nothing in common. The equipment, however, is identical for both, or at least very similar. You must be able to shoot with long focal lengths and not miss the right moment. Wide-angle and standard lenses are rarely used, except for the first overview shot of a stadium or habitat, for example. As wildlife photographers know, shooting conditions in the field are far more difficult and varied

than at a sporting event. Uneven ground, thick brush, heavy foliage, and shy subjects are a few of the challenges that must be overcome. Even in an area known to be inhabited by deer, for example, finding a subject (and getting close enough for a good photo) can seem almost impossible. A thorough knowledge of the habits and behavior patterns of your subject is essential in the planning stage.

You will want to research the area in advance. Once you have set up, patience becomes a virtue. Yes, you can stalk some species, although this takes a great deal of experience for success. Setting up a blind or shade can be more productive; the animals may come to you once they become accustomed to the new structure in their habitat. Portable blinds are often advertised in magazines that specialize in outdoor photography. You will also find ads for taped animal calls that attract certain species, sprays that mask your natural scent, camouflage clothing, etc.

Your presence must not disrupt the animals' natural behavior, as it might if you set up too close to a bird nest or fox den. Be fully informed as to any local rules that apply. You may not be allowed to approach animals (per specific distance limits) or get so close as to alter natural behavior in any way. However, animals may approach you, especially in parks where they are accustomed to people; an automobile makes the ideal shooting position in such locations. In general, however, long lenses and patience are often rewarded with extraordinary images.

Sports photography may be less difficult in that your subjects are readily available. The biggest challenge is access; it's very difficult to get high-impact images at a pro event if you are confined to a seat that is far from the field. At amateur events, arrive early and speak to the coaches or the organizer. In return for a promise of some free prints, you may be granted access to the side of the field; this is preferable to shooting from a fixed position. Before shooting a certain sport, develop some familiarity for the types of action that typically occur and the locations on the field where these are most common. Try to position yourself accordingly. If you must shoot from a seat at a pro event, pay extra for the best seat you can afford. You are likely to need a 300mm telephoto and at least a 1.4x teleconverter if shooting from the sidelines; a 70-300mm zoom is an ideal backup for moments when the action is nearby.

Under favorable lighting conditions and with fast (f/2.8 or f/4) telephoto lenses, you can use slow- to medium-sensitivity film (ISO 100 to ISO 200) for both sports and wildlife photography. Otherwise, especially with slower lenses or when using a tele-converter, ISO 400 film may be required. This will allow for faster shutter speeds to freeze any subject motion or minimize any camera/tripod shake. Monopods offer support as well as increased mobility, so they are often used by sports photographers. Whenever possible, brace the monopod against something solid—a rock or railing, for example, for greater stability.

Equipment Suggestions for Animals and Sports

Basic equipment: 1 camera plus 70-300mm zoom, 400mm tele-photo and 1.4x teleconverter; tripod or monopod for sports
Standard equipment: 2 cameras plus 28-80mm zoom, 300mm and 1.4x and 2x teleconverters; tripod or monopod
Advanced equipment: 2 cameras plus 28-70mm and 80-200mm zooms, 500mm or 600mm and teleconverters

Lens tip: Telephoto lenses with wide maximum apertures (f/2.8 or f/4) permit faster shutter speeds. These are important for freezing subject motion and minimizing the effect of any camera shake or vibration that would be amplified under high magnification. If you are unable to afford such lenses, a faster film such as ISO 200 (ISO 400 if you are also using a teleconverter) may be necessary. (In most major cities, you can also rent Nikkor lenses; check the telephone directory for stores catering to professional photographers.)

With 500mm and 600mm lenses, the very large/heavy tripods and heads are necessary for sharp images at shutter speeds longer than 1/125 second. Monopods can be used as well but only at faster shutter speeds, at least 1/250 second unless the monopod is firmly braced against a very solid support.

Nudes

Since the beginning of the nineteenth century, the photography of nude figure studies has had a special appeal, for obvious reasons, for photographers and viewers alike. However, the photographic aspects are often given only secondary attention as photographers

and viewers direct their attention mainly to the depiction of nude bodies. Figure studies with high visual impact are aesthetically pleasing and may include glamour, erotic in nature. The social acceptability of nude photography varies from one country to another; keep your own local customs and tolerance in mind.

In order to avoid straining your modeling fee budget, you should know exactly what you want to shoot and take preparatory steps (set up props, lighting, etc.). This applies to indoor as well as outdoor shoots. Before the photo session, you should explain your intended use of the photos to the model. If the photos are to be sold, a legally binding model release must be obtained from the model, specifying that nude photos of the individual may be published or otherwise displayed. Naturally, you must take care to act in a professional manner.

There are no specific rules with regard to lenses, but a pleasing perspective often calls for a medium-power telephoto lens. Of course, you should not use a 20mm lens to get close to a beginning model during the first shooting session nor should you expect conventional perspective with such an approach. Some highly successful nude photographers use short focal lengths in the photography of nudes. Before shooting your own nude photography, you may wish to browse thorough books on the subject at your local library or bookstore. You will see many different but successful approaches to the subject and technique of nude photography. For more specific information, read *The Nude: Complete Photography Course*, published by Silver Pixel Press.

Close-Up and Macro Photography

Extreme close-up photography is quite popular among nature photographers whose subjects typically include butterflies, insects, and blossoms. However, there are other potential subjects for a Micro Nikkor lens, including the mechanisms of watches, jewelry, stamps, and coins. The term "macro" refers to very high magnification photography, at least 1x magnification: The subject is at least life-size on the film frame. (A penny would be exactly penny-sized in a 35mm slide, for example, at 1x magnification.) Any extreme close-focus photography is sometimes referred to as macro photography. Nikon uses the term "micro lens" to denote

This monarch butterfly was photographed using a 105mm Nikkor lens and a tripod. Many photographers prefer a macro lens in the 105mm range, because it allows them to move back from the subject, making it less likely that the lens will cast a shadow on the subject. ©Peter K. Burian

its lenses with extreme focusing ability, while other manufacturers use the term "macro lens"; the two are interchangeable.

Note: Some zoom lenses are labeled with the "macro" designation, but this usually refers only to moderate close-focusing ability, up to a magnification of 0.25x or perhaps 0.33x.

In any event, taking pictures in the extreme close-focus range can pose significant technical problems, even for experienced photographers. The first problem is shallow depth of field due to high magnification as you get closer to the subject. The zone of acceptable sharpness is miniscule, sometimes only a few millimeters; if you focus on the stamen of a flower, for example, the petals will not be sharply rendered, even at f/22. The primary solution: Set up the camera so the film plane is parallel to the most

important subject element, such as the wings of a butterfly. Or shoot with shallow depth of field where only one important subject plane, the eye of an insect, perhaps, is sharp while the rest is softly blurred.

Another problem outdoors is motion blur from camera movement, even when a tripod is used. The smallest vibration is amplified in high-magnification photography, making a large/heavy tripod and remote shutter release accessory necessary. In nature photography outdoors, the wind-induced motion of your subjects can also be frustrating. Try to shoot when there is a lull in the breeze; use fill flash to help freeze minor motion.

In addition to the Micro Nikkor lenses, you have a few other options for extreme close-up photography. The two most popular accessories used to allow the lens to focus much closer than usual are:

❏ an auto extension tube or "ring," which mounts between the camera and lens and allows the lens to focus closer
❏ a close-up attachment lens (Nikon 3T, 4T, 5T, and 6T), which screws into the front filter thread of the lens and resembles a filter with magnifying glass

Note that extension tubes reduce light transmission, so shutter speeds will become longer when such accessories are used. In-camera TTL light metering compensates for this light loss, so exposures should still be accurate. However, as mentioned earlier, the F100 can only be used in center-weighted or spot metering with the Nikkor PK and PN accessories, and metering errors may occur. Some exposure compensation may be necessary. The use of older PK or PN accessories is not recommended with this camera.

Note: Some independent-brand lens manufacturers offer high-tech extension tubes. Some of these accessories are said to be fully compatible with Nikkor AF lenses and the F100 but may or may not allow for autofocus operation. (AF is rarely used in extreme close-up photography, in any event.) Shop wisely, preferably at a store that is also a Nikon Advanced Systems Dealer. Ask the staff to confirm compatibility via the accessory manufacturer's technical manual, and ask for return privileges in case you find less-than-full compatibility after shooting a roll of slide film.

Check the accessory manufacturer's warranty regarding coverage for any damage the product may cause to your camera or lens. The Nikon warranty does not cover damage caused by any lenses, flash units, or accessories made by other manufacturers.

At present, our primary recommendation is to use the Nikon T-series of front-mounted attachment lens accessories. These are optically excellent and do not cause any loss of light transmission. They work very well, especially with zoom lenses in the 70-300mm or 70-210mm range; optimum image quality is produced at around f/11 or f/16, apertures often used in close-focus work.

Technique Tips: In extreme close-up work, on-camera flash with a hot-shoe-mounted Speedlight is not practical, because the lens barrel blocks some of the light. Also, much of the light will be directed above the subject. We generally use off-camera fill flash for nature close-ups, with an SC-17 TL Remote Cord, as discussed in the chapter on flash. This allows for ideal placement of the Speedlight, generally above the subject and at a 45° angle to it. Wireless TTL off-camera flash is also possible, as discussed in the chapter on flash.

A TTL Macro Speedlight SB-21B (not the SB-21A!) is another option for the F100. This unit (with a circular dual, rotatable flash tube system) mounts on the front of the lens and is intended specifically for extreme close-up photography. The lighting is soft and even but rather "flat"; try shooting with only one of the two tubes, instead of both.

Instead of or in addition to flash, a reflector panel can be used to bounce natural light onto important subject areas. These are commercially available from several manufacturers, in white, gold, silver, etc. Most of them collapse to a much smaller size for portability. You can also make one by taping wrinkled aluminum foil onto a sheet of cardboard or by simply using a white board or shaving mirror. When using such accessories, remember this: Do not take the meter reading until after the accessory is in place; otherwise, overexposure will occur.

In macro photography, it is best to set an approximate focus (manually, not with AF) with the camera placed at the right location for the desired magnification. Then move the camera back and forth until the desired point of focus is achieved. Since you

will be working with a tripod, this means moving the entire tripod, usually only a millimeter or so. That is not really practical, so we recommend the use of accessories such as the Nikon Focusing Stage PG-2. This device allows you to move the camera toward the subject and away from it in miniscule increments, without moving the tripod.

Lens Tip: In extreme close-up nature photography, the longer Micro Nikkor lenses, such as the AF 200mm f/4D or the AF 70-180mm f/4.5-5.6D are more useful than the shorter micro lenses. The primary value of longer focal lengths is as follows: You do not need to get as close to the subject for high magnification, so you are less likely to trample flowers, scare away an insect, or cast a shadow on the subject; the narrower angle of view includes less of the surroundings, so it is easier to frame a subject against a narrow patch of greenery while excluding any clutter. With inanimate subjects, such as coins or stamps, the shorter micro lenses are preferable; mount the camera on a copy stand, such as the Nikon Repro Copy Outfit PF-4.

Develop an Awareness for Light

With the sophisticated Nikon F100, AF-D lenses, and high-tech Speedlights, most anyone can produce sharply focused, well-exposed photos that are technically excellent. This is an impressive achievement if you want technically perfect shots of a place, object, or person, but such pictures may not have much viewer appeal.

The finest sable brush, the most expensive canvas, and the most brilliant pigments do not make a painter an "old master." He must develop a feel for the brush strokes, the play of light and shadow, the use of perspective, complementary colors, and so on. All too often we see well-equipped photographers burning film at high noon, with motor drives whirring, without any apparent care for the harsh, overhead light. It is possible to get good pictures any time of day if you use advanced techniques, such as fill flash, reflectors, various filters, light diffusion panels, etc. But for landscapes and cityscapes, it is generally preferable to shoot early or late in the day, with warm, directional lighting. For

people pictures, it's easy to ask your subject to move to a better location or to wait a few minutes until a cloud covers the sun for softer illumination.

In addition to the use of effective composition, color harmony, appropriate focal lengths, and the "right" viewpoint, an awareness for light is a key ingredient to making visually appealing photographic images. Study the work of well-known photographers and painters to learn how light affects the mood or the message of their images. Change your shooting position to take advantage of side- or backlighting, wait until the light is more suitable, look for light that enhances certain subject types, learn to modify the light with accessories, and bracket your exposures when using slide film. This is all part of controlling the situation and the entire process. It's an important step toward creating images with high visual impact instead of merely recording pictures on light-sensitive material.

Flash Photography With the F100

When combined with the latest generation of Nikon Speedlights, the Nikon F100 offers advanced flash technology with sophisticated automation plus a full range of user-controlled overrides. Whether to fill in shadows in outdoor photography, to light a dark location with one or more Speedlights, or to alter the mood of a photo, flash can add new dimensions to your creative and technical photography.

Nikon's intelligent flash metering system analyzes scene brightness, contrast, and even reflectivity in order to accurately calculate the flash output required to produce a photo that is beautifully exposed with a balance of flash and ambient light. Both the subject and the background should be nicely illuminated. Nikon's exclusive five-segment TTL multi-sensor meters the entire frame. It does not heavily emphasize the subject area, as some of its competitors do. This helps to ensure better flash exposures for a broad variety of situations and compositions. Before we explain the use of flash with the Nikon F100, we will give a brief overview of basic flash control concepts.

Guide Numbers
While the F100's sophisticated flash system determines exposure automatically, it is helpful to understand what guide numbers are. A guide number is a numerical value assigned to a flash unit by the manufacturer to quantify its maximum output. It is based on a mathematical formula involving the aperture and the flash distance:

$$\text{Guide Number} = \text{Aperture} \times \text{Distance}$$

Guide numbers are usually determined using ISO 100 film as the standard. Since distance is part of the formula, guide numbers differ depending on whether they are expressed in meters or feet. Guide numbers used in the United States are expressed in feet (and therefore are 3.3 times larger than the corresponding metric guide numbers), unless otherwise indicated. The flash unit's guide

number can be used to calculate exposure for a given distance by using the same formula in a different way:

Guide Number ÷ Distance = Recommended Aperture

The higher the guide number, the more powerful the unit. Flash units are given a guide number by the manufacturer. When comparing two flash units' features, note the guide numbers in the flash unit's specification listing and they will instantly tell you which is the more powerful unit.

The guide number depends on the film sensitivity and the reflector's angle of illumination. Remember, as the flash unit's zoom head position changes, so does its guide number.

Synchronization

The Nikon F100 is equipped with an electromagnetically controlled, vertically traveling focal plane shutter. A focal plane shutter has one characteristic that is critical in flash photography—during very short exposures the entire film frame is not exposed at once. This is because the slit that is formed by the two curtains traveling over the film frame is smaller than the film frame, and it sweeps over the film area exposing the frame in portions. If flash is used with a short exposure time, the flash will illuminate only that part of the film that is uncovered by the slit at the instant the flash goes off. The fastest shutter speed at which the entire frame is uncovered by the shutter curtains is called the "flash synchronization speed," which for the F100 is 1/250 second. Any shutter speed slower than that will also expose the full film frame as the shutter blades expose the entire frame at once. However, using flash with shutter speeds faster than 1/250 second will not result in proper flash exposure of the entire film frame unless you are taking advantage of the F100's FP high-speed sync feature, which is available only with Speedlights SB-28, 26, and 25.

Primary Flash Modes

Multi-Sensor Balanced Fill Flash Mode

With this mode, a pleasant balance of ambient light and flash light can be achieved. Multi-sensor balanced fill flash can be used outdoors to fill in shadows and reduce contrast in bright sunlight. However, it performs well indoors, too, when mixing available light with flash. This mode requires a lens with a CPU (AF Nikkor or AI-P Nikkor). When you use a D-type AF Nikkor lens, distance information is also considered in the flash exposure calculations, giving you 3D multi-sensor balanced fill flash.

After you press the shutter release button, monitor preflash is activated (when using the SB-28, SB-27, SB-26, and SB-25 only). The flash unit fires a series of brief bursts that reflect off the scene and are analyzed by the five-segment TTL multi-sensor that calculates scene brightness and contrast. This occurs in an instant, just after the reflex mirror is raised to its upward position but before the shutter curtain opens. The camera's microcomputer determines the location of the primary subject and evaluates other data as well; it considers and ignores a very dark background so overexposure of the subject will not occur. When an extremely bright area is detected—the sun, reflections from a mirror, etc.—this segment is ignored to reduce the risk of overall underexposure. It also assesses the reflectance of the subject, whether a bride in a white gown or a groom in a black tuxedo. The flash output level is automatically set so that flash and ambient light are balanced. The end result is a very high percentage of beautifully exposed flash photographs, automatically.

Note: The SB-24 and other Speedlights older than the SB-25 do not have monitor preflash capability.

Center-Weighted Fill Flash Mode

When you are using a Nikkor lens without a CPU (like the AI or AI-S series), matrix metering does not operate. Therefore,

This crisp example of good travel photography was shot at noon on a ➪ **sunny day. A Tiffen® circular polarizing filter was used to eliminate glare, and matrix-balanced fill flash reduced the contrast for a pleasing natural result. ©Peter K. Burian**

ambient light is measured with center-weighted metering, rather than matrix metering. When a TTL AF Speedlight is activated, flash output and the ambient light are balanced, but not as effectively. In some cases, correct exposure is unlikely, e.g., when there is some very bright object in the frame or when the subject is off-center.

Standard TTL Flash Mode
Standard TTL mode is generally not recommended, since matrix-balanced fill flash is a superior method of determining flash exposure. With Standard TTL, a sensor in the camera reads the flash light reflected off the film. The duration of the flash is adjusted to provide proper exposure for a subject of average reflectance. You need only be certain that your subject is within the distance range indicated on the Speedlight's LCD panel. Standard TTL Flash mode can be used with any metering mode, but when you set spot metering on the F100, it is the mode that is automatically selected.

The system does not attempt to balance the flash light with the ambient light. An obvious flash effect may be visible in the photos. For example, the subject may be well lit, but the background may appear very dark in the photos. You can access Standard TTL Flash mode with any lens. With Speedlights other than the SB-28, SB-27, SB-26, SB-25, and SB-24, you must set the camera to Manual operating mode.

Note: For TTL flash, films in the ISO 25 to 1000 range can be used. Do not use faster films.

Non-TTL Auto Flash Mode
This is a far less sophisticated method of determining flash exposure than TTL flash metering that is emphasized in this chapter. It is generally not recommended unless you are using a flash unit that only offers this type of exposure automation. The duration of the flash is controlled by a sensor on the flash unit that measures light reflected off the subject while the exposure is being made. Any aperture can be selected in "A" mode, but camera-to-subject distance becomes a critical factor. After you set an aperture on the camera, check the distance scale on the Speedlight to make sure that the subject is within the range suggested by the scale. If

necessary, switch to a different aperture until you get the desired distance range. The flash unit will adjust the exposure within the distance range. Most Nikon Speedlights offer Non-TTL Auto Flash mode, but the SB-23 and SB-21B are exceptions.

Manual Flash Mode

The basic principle of Manual Flash mode is that the flash unit will output a set amount of light. Exposure is controlled by selecting different apertures for different subject distances as in the guide number formula. Thus, the photographer determines the flash-to-subject distance and chooses an appropriate aperture setting. So that you do not have to make GN computations, aperture choice is determined by the distance scale on the LCD panel of the flash unit and will be affected by film speed, position of the Speedlight's zoom head, and the power setting. Great care must now be taken to shoot at the right camera-to-subject distance.

If the subject is distant, you'll need to set a wide aperture (small f/number); if it is quite close, you must set a small aperture (large f/number). You are very restricted in the choice of aperture, based on distance. For close-up photography, however, you do have a method for using wider apertures than would normally be required. Simply adjust flash output on the Speedlight from full to 1/2 power, 1/8 power, and so on to 1/64 power—the latter only for extreme close-ups. As you do so, you'll be able to change to a wider aperture, guided by the distance data on the back of the Speedlight.

Note: In Non-TTL Auto Flash and Manual Flash modes, the distance from the camera to the subject is an essential bit of information. It is easy to find. Simply focus—with AF or manually—on the subject and then check the focus distance scale on the lens.

Using Multi-Sensor TTL Flash
With Camera Exposure Modes

With Program AE Mode

With the F100 set to P mode, activate a Speedlight, such as the SB-28. The camera automatically sets a correct sync speed (between 1/60 second and 1/250 second) and aperture. Program

This nicely lit photograph was made with the camera in Program AE mode with the SB-28 set for multi-sensor TTL flash.

shift operation will be limited when a flash unit is activated because of the limited shutter speed/sync speed range.

The widest aperture that will be selected depends on the film speed: f/4 with ISO 100 film, f/4.8 with ISO 200 film, f/5.6 with ISO 400 film, f/6.7 with ISO 800 film, and so on. This is a point-and-shoot mode, ideal for candid photography.

With Aperture-Priority AE Mode
With the camera set to A mode, activate the attached Speedlight. You can select the desired aperture using the camera's command dial, just as if you were shooting without flash. The corresponding shutter speed will be set automatically by the camera in the 1/60 second to 1/250 second range.

Operation is now similar to Program mode, except you have great versatility in the choice of f/stop selected. You can set a wide aperture for shallow depth of field or a small aperture for extensive depth of field. At small apertures, such as f/16, the distance range covered by the flash may be unacceptably short.

Since the highest sync speed is 1/250 second, you may not be able to set very wide apertures in bright light and get correct exposure. If desired, you can use an SB-28, SB-26, or SB-25 in the FP High-Speed Sync mode (non-TTL). You can now shoot at very wide apertures, and the camera will respond with a corresponding fast sync speed. However, be sure to check the flash distance scale on the back of the Speedlight; position yourself at the indicated distance from the subject.

With Shutter-Priority AE Mode

Select S mode on the camera and activate an attached Speedlight. All shutter speeds between 30 seconds and 1/250 second can be selected on the camera using the command dial. The camera will automatically respond with the corresponding aperture.

Select this camera operating mode when your primary concern is about the length of exposure times, as in night photography or to "freeze" or blur the motion of a cyclist, for example. When you set long exposure times at night, a dark background will have time to register on film, while the primary subject is illuminated by a burst of light from the flash unit. Because this is an Automatic mode, you can shoot quickly. Watch for any *Hi* or *Lo* warning provided in the viewfinder data panel, of course, and also watch for a warning that underexposure may have occurred (blinking flash symbol).

With Manual Mode

Select M mode on the camera and activate a Speedlight. TTL flash control and all flash automation will be maintained. You can set any aperture and any shutter speed from 30 seconds to 1/250 second (also *BULB*) using the camera's command dial.

Now you can control both depth of field and the depiction of motion, without loss of full TTL automation. (The manual non-TTL FP high-speed sync can be used, too, as discussed elsewhere.) You can set any shutter speed from 30 seconds to 1/250 second with full TTL flash control when shooting in the camera's

Manual mode. As long as the subject is within the broad distance range indicated on the back of the Nikon Speedlight, depth of field and the depiction of motion are controlled completely by the photographer. Flash output is controlled by the TTL flash meter in the camera for more accurate flash exposures.

By controlling the aperture, the photographer can choose shallow or extensive depth of field. Adjusting the aperture also changes the distance range of the flash, so the photographer has some control over whether or not the background will be illuminated by flash.

The shutter speed controls how motion is depicted and also whether or not ambient light is included in the exposure. To experiment with motion blur, try using flash with a slow shutter speed or use the BULB setting to keep the shutter open for as long as the shutter release button is depressed. The quick burst of flash freezes motion and the ambient light exposure will have an interesting, soft blur if your subject moves or if you hand hold the camera.

Special Flash Modes

Synchronization Modes

As mentioned earlier in the chapter, the fastest shutter speed at which the entire frame is uncovered by the shutter curtains is called the flash synchronization speed, which in the F100 is 1/250 second. If flash is used with a faster shutter speed, the flash will reach only that part of the film that is uncovered at the instant the flash fires. Slower shutter speeds are not a problem.

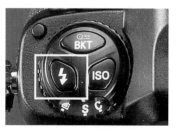

The flash mode selector button, indicated by the lightning bolt symbol, is located on the top left of the camera.

Manual exposure control with TTL fill flash was used for this photo of an owl in captivity. ©Peter K. Burian

With the exception of FP high-speed sync, the synchroniza-tion modes are set by rotating the rear dial of the camera while depressing the flash mode selector button on the top left shoulder of the camera (marked with a lightning bolt symbol). Symbols for the various options appear on the LCD panel; stop when you reach the desired flash sync mode. The modes appear in the fol-lowing order:

Front Curtain Sync

This mode is the most commonly used type of flash synchroniza-tion. All it means is that the flash fires as soon as the first shutter curtain is completely open. (If you are using an SB-26, SB-25, or SB-24, set the Speedlight's mode selector to NORMAL. With other Speedlights, this is not necessary.) In normal photography, the camera sets a sync speed of 1/60 second to 1/250 second in Aperture-Priority or Program AE mode.

Slow Sync

In some situations, especially at night, you may wish to shoot at a slower shutter speed; slow sync will set a speed as long as 30 sec-onds. During the long exposure, the darker background, city lights, perhaps, will have enough time to expose the film. The foreground subject will be exposed by the brief burst of flash that occurs at the start of the exposure. During the long exposure, the camera should be mounted on a tripod to prevent blur from cam-era shake.

Rear Curtain Sync

This mode should be used to create dynamic flash photographs of moving subjects. The flash fires at the end of the exposure just before the second shutter curtain starts to close. The resulting effect is a flash-illuminated subject followed by natural-looking trails of light. (If you are using an SB-26, SB-25, or SB-24, set the Speedlight's sync mode to REAR. With the SB-27 or 28, this is not necessary.) If the camera is set for Aperture-Priority or Program AE operation, slow sync is automatically set if you select rear curtain sync. In Shutter-Priority AE or Manual modes, setting a slow shut-ter speed is recommended; if the exposure time is brief, ambient light may not have time to register on film, and the trails of light may not be visible.

This photo, with its trailing motion blur, was made using flash in the rear synchronization mode.

Note: Rear curtain sync cannot be used with studio flash systems, because the synchronization will not be correct.

Red-Eye Reduction

A bright lamp on the Speedlight lights up for about a second before the flash fires in order to reduce the red-eye effect by forcing the subject's pupils to contract. This mode is available only with Speedlights that incorporate this lamp: SB-28, SB-27, and SB-26. Frankly, the lamp may reduce red-eye but does not totally eliminate it in very dark conditions. As well, the one-second delay is less than ideal for candid shooting.

Controlling Red-Eye

The red-eye effect is the result of light being reflected off the blood vessels in the retina of the eye. The probability of this effect increases when the flash unit is close to the lens or "optical axis." The level of ambient light also affects red-eye. When it is dark, the pupils dilate, which increases the effect and makes it very obvious. Some steps you can take to reduce the effect of red-eye with on-camera flash include turning on room lights, asking the

This lamp on the front of the Nikon SB-28 Speedlight lights for about one second before the flash fires. This causes the subject's pupils to contract, reducing the possibility of red-eye.

This direct flash photo was taken with the SB-28's red-eye reduction feature.

subject to look to the side, and switching to a shorter lens. For better results, move an accessory Speedlight off-camera. The red-eye effect is reduced or eliminated. At the very least, consider bouncing flash from a ceiling or wall, and brighten the room as much as possible.

In red-eye reduction mode, the Nikon F100 sends out a beam of light prior to the exposure (as discussed earlier) that is intended to close the pupils somewhat. This reduces the amount of reflection from the blood vessels at the back of the eye. However, there is a danger that the subjects' facial expressions can change in response to the bright light burst. To reduce this risk, warn your subjects that the red-eye reduction lamp will be going off so that it does not catch them by surprise.

FP High-Speed Sync
Traditional flash photography requires appropriate synchronization of the shutter with the burst of light from the flash unit. In

spite of this, the F100 can be used at higher sync speeds—up to 1/4000 second, but only with the SB-28, SB-26, and SB-25 Speedlights. This allows you to shoot at very wide apertures even in brilliant sunlight with fast film. Now you can blur away a busy background even while using fill flash. This is possible because the flash unit generates numerous flash bursts during the exposure so all parts of the film frame are exposed by flash during FP high-speed sync operation.

First set FP High-Speed Sync mode on the flash unit, then set the F100 for Manual exposure mode. Now you can select any shutter speed on the camera, using the front dial. Then set an appropriate aperture with the camera's rear dial.

Note: This is a Manual flash operating mode without TTL flash control. You must maintain the exact distance from the main subject, as provided on the distance scale on the LCD panel on the back of the Speedlight. The shooting distance can be changed by changing the shutter speed or the f/stop on the camera; check the distance scale on the back of the Speedlight again. The distance can also be changed by zooming the flash head to another position or by setting FP2 on some Speedlights, to vary flash output.

When you set high shutter speeds such as 1/2000 second, you will only be able to shoot extreme close-ups, even at wide apertures such as f/2.8. Except in brilliant lighting conditions, the effective reach of the flash is very short. Switching to a faster film—ISO 400 or 800 vs. ISO 100—may be necessary if your subject is at a greater distance. You will note that the distance recommendation on the back of the Speedlight is now different, a greater distance than with slower film.

Flash Exposure Compensation

Although the F100 automatically provides fill flash—balancing flash output with the ambient light—in some situations you may want to further reduce flash output. If you feel that you would prefer just a gentle hint of extra light to softly fill in shadows, consider the following:

Some Speedlights (SB-24, SB-25, SB-26, SB-28) incorporate a flash exposure compensation feature. If you have a Speedlight with this capability, you can set a plus or minus factor on the flash unit no matter what camera exposure mode you are using. You can set a minus compensation factor to reduce flash output. (Of course, a plus factor can also be set to increase flash output, as in extreme backlighting where some underexposure may otherwise occur.) As a reminder that flash exposure compensation has been set, a [+/-] symbol appears in the viewfinder data panel, but the compensation value does not. If you own one of the appropriate Speedlights, try setting a −1 EV flash exposure compensation factor as a starting point on sunny days.

With any compatible Speedlight, you can bracket flash exposures instead for two or three frames. In order to establish the amount of flash exposure compensation that you prefer, shoot several frames, each with a different compensation factor: 0, -1/3, -2/3, -1, and so on, keeping notes as to your strategy. Use slide film for your experiment; with negative film, the lab may adjust exposure when making prints.

With flash exposure compensation (set on the Speedlight) and exposure compensation (set on the camera), you can control the exposure for both the primary subject and the background. You can increase or reduce flash output so the subject will be brighter or darker by using the Speedlight's flash exposure compensation control. You can increase or decrease exposure for the background with the exposure compensation control on the F100.

For more information, see the section on autoexposure bracketing/flash exposure bracketing in the chapter on metering modes. Also review the information provided there about custom setting 11, which allows you to bracket only the ambient light exposure (for the background) or only the flash exposure (for the primary subject). You'll probably prefer to bracket flash exposures only, and only toward the minus side except in strong backlighting where more flash output may be required.

Note: You can combine flash exposure bracketing with flash exposure compensation that has been set on an appropriate Speedlight. For example, you might set a -1 factor on an SB-28 and then set flash exposure bracketing on the F100. The exposures will be bracketed around that −1 EV factor you set on the flash unit.

Flash Displays

The flash symbol in the viewfinder and LCD data panels indicates that flash is ready by remaining lit. The top deck LCD panel also indicates the flash mode and flash sync mode that have been set. Other data displayed in the LCD panel of most Speedlights includes the distance range, the set aperture, and the zoom head setting.

After you take a picture, the ready light may blink for 3 seconds, warning that underexposure may have occurred. (If it does not blink, the flash exposure was adequate.) Should this warning occur, reshoot the subject after moving closer to it or after setting a wider aperture (e.g., f/5.6 instead of f/11). You might also consider switching to a film with a higher ISO number.

PC Cord Terminal

Unlike many cameras today, the Nikon F100 is equipped with a terminal for attaching a flash sync cord from a studio strobe system (for non-TTL flash, with exposure determined by an accessory flash meter). However, you must not attach a sync cord to the camera when a Speedlight is in the hot shoe and Rear Curtain Sync Flash mode has been selected.

Bounce Flash

Most Speedlights can be tilted upward to bounce light from a ceiling, and some can be rotated so the tube faces sideways to bounce flash off a wall. If not, an off-camera TTL connecting cord such as an SC-17 can be used, attached to the camera's hot shoe to maintain full automation. With TTL flash metering, the additional distance—from flash to bounce surface and then to the subject—is taken into consideration in the final exposure calculation. However, in low light, the flash range may not be adequate, and you may get a warning that underexposure has occurred. Try shooting with a wider aperture or switch to a film with a higher ISO number.

Bounce flash provides soft, even light but with low contrast. If bounced from the ceiling, dark shadows may occur in the eye

sockets. Bouncing flash from a nearby wall may be more appropriate. To avoid a color cast, bounce flash only off white (or other neutral color) surfaces.

Flash Accessories

Particularly with on-camera flash in low-light conditions, the light may be somewhat harsh; dark shadows will appear on any wall behind the subject. Many accessory manufacturers offer diffuser accessories that fit over the flash tube to spread/diffuse the light for a softer effect. Some also include a bounce surface, sometimes available in various colors like white, silver, and gold. The larger the diffuser and/or the bounce surface, the more effective it will be. Remember, too, that these accessories are most useful in close-up work, especially for portraits and still lifes when the subject is 6 feet or less from the camera.

TTL flash metering is maintained when an accessory of this type is used with a Speedlight, so exposures should be correct. However, some diffusers substantially reduce light transmission (by 2 to 3 stops in some cases), so the effective reach of flash will be much shorter. You may need to use a faster film, like ISO 400.

Nikon does not offer diffuser accessories but does make various devices for flash photography. The SC-17 is a 4.9-foot (1.5-meter) coiled TTL cable with a flash connector on one end and a flash shoe with two multiflash sockets on the other. The flash connector slides into the camera's hot shoe to relay information between the F100 and flash. The remote Speedlight attaches to the shoe on the other end of the cord. Additional Nikon system flash units can be attached to the shoe by plugging TTL cables (SC-18 or SC-19) into the flash units and shoe sockets. These TTL remote cords transmit all Nikon system flash commands, assuring full TTL compatibility between camera and flash unit.

The SC-18 and SC-19 are TTL extension cables with connectors on both ends for attaching Nikon multiflash system components (such as the SC-17 remote cord, multiflash adapter AS-10, and Nikon system flash units). The two cords are identical except in length: the SC-18 is 5 feet (1.5 meters) long and the SC-19 is 10 feet (3 meters) long. TTL multiflash adapter AS-10 allows you

to operate three off-camera flash units, one on the hot shoe and two by using SC-18 or SC-19 multiflash cords. It has a 1/4"-20 socket on the base for mounting it to a tripod or light stand.

The Wireless Remote Control Unit SU-4 is intended for use with most recent Speedlights (SB-15, 16B, 21B, 22, 22s, 23, 24, 25, 26, 27, and 28). Its infrared beam is used to trigger one, two, or more accessory flash units. The number of remote flash units and their positions (relative distances to the subject) determine the lighting effect. The SU-4 has a range of up to 23 feet (7 meters) in TTL Automatic flash mode and 131 feet (40 meters) in Manual flash mode.

Nikon also offers the Power Bracket SK-6, which holds four AA batteries. This is intended for off-camera flash, with its adjustable handle; flash recycle time is reduced while the number of available flashes is increased. High-power battery packs (SD-7 and SD-8A) are also available for certain Speedlights for much greater flash capacity and shorter recycle times. For additional information on Nikon accessories, visit a well-stocked Nikon dealer.

Wireless TTL Off-Camera Flash

With some Speedlights, cordless off-camera TTL multiflash is possible with the F100. You will need the optional Wireless Remote Flash Control Unit SU-4 and at least two Speedlights: one on the camera and the other attached to an SU-4. If you use more remote Speedlights, one SU-4 must be attached to each unit. All Speedlights will fire simultaneously, with the on-camera flash acting as the master unit to trigger the others.

The Wireless Remote Control Unit SU-4

Frankly, for most off-camera flash photography, we find that using a cable such as the optional SC-17 TTL remote cord is just as convenient. The cable is used to connect off-camera Speedlights to the hot shoe of the F100; all camera and flash capabilities are maintained.

Nikon Speedlight Models

Nikon offers a variety of shoe-mount flash units, with the SB-28 being the most recent. These units come in various sizes, weights, prices, and with various capabilities. As discussed earlier, these can be used off-camera, too, with the appropriate accessories. We will briefly discuss the current Speedlight models and their primary capabilities (when used with the F100 camera) as well as limitations. For additional information and full specifications for all of the models, visit a Nikon dealer or the Nikon Web site, www.nikon.com.

Information on Using a Nikon Speedlight

After the Speedlight has been turned on, do not shoot until the flash ready symbol appears in the viewfinder data panel of the F100. After you take a picture with flash, check the flash ready symbol (lightning bolt) in the viewfinder data panel. If it blinks for about 3 seconds, underexposure may have occurred. Take the picture again, but this time try one or more of the following: move closer to the subject, set a wider aperture (larger f/number) on the camera, do not bounce flash off of a distant surface, switch to a film with a higher ISO number. If the symbol does not flash after you take the picture, the exposure should be correct.

Most Speedlights provide a flash distance range scale on the LCD panel of the flash unit. This can be set for feet or meters and provides an indication as to the effective range of flash at any camera settings. You should check this scale before shooting, especially with a subject that is very close or very far from the camera. Use the focus distance scale on the lens to determine the subject distance.

You can use any of the flash sync modes of the Nikon F100 as discussed in the previous sections. Some Speedlights (SB-26, SB-25) have a Flash Sync mode selector, too. If you set a mode on

the flash unit and a different mode on the camera, the setting on the Speedlight will be the one that is effective. The newer SB-27 and SB-28 do not have a Flash Sync mode selector, so that must be set on the camera.

If your Speedlight has an autofocus assist illuminator (to project a pattern that helps the AF system achieve focus in low light), you must set the central focus detection sensor on the F100. (See the chapter on autofocus.) If any other sensor has been selected, the illuminator will not operate.

Nikon SB-28/SB-28DX
This high performance model offers every possible capability with the F100. With a guide number (GN) of 164 in feet (42 in meters) at ISO 100, at the 85mm position, this is a very powerful model. Its power zoom head adjusts for focal lengths from 24mm to 85mm, and a built-in accessory allows for flash coverage for lenses from 18mm to 20mm. A built-in bounce card is included for use when flash is bounced from a ceiling; a bit of light is directed toward the subject to help fill in the eye socket areas.

Repeating flash can be selected for a strobe effect, and the frequency (number of flashes per second, up to 50 Hz) can be set as well as the number of flashes per exposure (up to 90). This technique—intended for motion studies such as a golfer's swing—is quite complicated and should be attempted in a dark room in

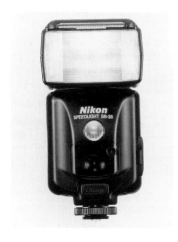

The Nikon Speedlight SB-28

front of a black background. As well, all of the capabilities discussed in this guide are available, including tilting and rotating flash head for bounce flash.

Nikon also offers the SB-28DX, a newer version of the SB-28. It is essentially identical to the SB-28 and can be used with the F100 in the same manner. The DX model was developed for full compatibility with the Nikon D-1 digital SLR camera and has no advantages over the conventional SB-28 when used with the F100.

For more information, read the *Magic Lantern Guide to Nikon SB-28 AF Speedlight*, published by Silver Pixel Press.

Nikon SB-27

This is a smaller/lighter/less expensive flash unit, with lower power output. The GN is 112 in feet (34 in meters) at ISO 100 when the zoom head is set to the 50mm position. The zoom head adjusts for lenses from 24mm to 50mm in the horizontal position and for 35mm to 70mm when set for the vertical position. The unit can be pivoted to the right or left through a 180° arc. It has the bounce reflector card mentioned in the SB-28 section. Neither high-speed sync, repeating flash, nor flash exposure compensation is available, but most F100 capabilities are maintained.

The Nikon Speedlight SB-27

Nikon SB-26

This precursor to the SB-28 is not a current model but is owned by many Nikon system users. Its power output (GN) is the same as that of the SB-28, as is the power zoom head, etc. The SB-26 supports monitor preflash, allows for repeating flash, high-speed sync, etc. The SB-26 has some controls that are not included on the SB-28, because the same functions can be set on the F100 body.

The SB-26 is the only Speedlight that allows for wireless off-camera flash without accessories; the remote SB-26 units are

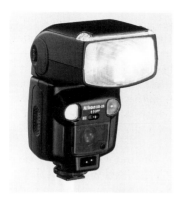

triggered by an on-camera flash unit. However, flash control is non-TTL, so it is far more difficult to make correct and predictable exposures. We recommend the use of the SC- TTL cables or the SU-4 controller accessory instead for off-camera TTL flash photography.

Nikon SB-25

This model is highly compatible with the F100, but it does not support the camera's red-eye reduction capability. The SB-25 supports monitor preflash and allows for repeating flash, high-speed sync, etc., like the SB-26. Very much like the SB-26, this unit has a similar GN (power output) and power zoom head to match lenses from 24mm to 85mm. A built-in wide-angle flash adapter can be used for focal lengths as short as 20mm. The SB-25 has some controls that are not included on the SB-28, because the same functions can be set on the F100 body.

Nikon SB-24

This was the original pro Speedlight, first available in 1988, and is compatible with the F100. However, as mentioned earlier, it does not support all F100 capabilities, for example, red-eye reduction and 3D multi-sensor balanced fill flash (only non-3D, even with D-type lenses). Its guide number is similar to that of the SB-28, and it is also a powerful unit.

Nikon SB-11

This is a large handle-mounted flash unit, sometimes called a "potato masher" style. It is intended for off-camera flash photography using a TTL connecting cable SC-23 attached to the hot shoe. Its power output and GN are slightly higher than that of the SB-24, 25, 26, and 28 Speedlights, but flash recycle is no faster. The primary advantage of an SB-11 is convenience in off-camera flash thanks to the large handle (attached to the base of the F100 with a bracket).

If that feature appeals to you, in spite of the excessive weight/size/cost, note that the SB-11 supports multi-sensor balanced fill flash (not 3D), but it does not offer an AF illuminator, red-eye reduction lamp, or repeating flash. Instead of an SB-11, we recommend a more versatile SB-28 used with an SC-17 TTL remote cable, mounted on a flash bracket accessory. Several manufacturers, including Stroboframe, make these brackets.

Nikon TTL Macro SB-21B

This is the ring-light intended for extreme close-up photography. The circular flash tube system mounts on the front of the lens, while the control unit mounts in the camera's hot shoe; the two components are connected with a cable. The circular head contains two separate flash tubes; either or both can be used. Autofocus is possible only with the AF Micro Nikkor lenses, but AF is very rarely used in extreme close-up photography. An illuminator lamp aids manual focus. The GN is 43 in feet, at ISO 100, adequate for close-up work. (SB-21A is for F3 series cameras.)

Compatibility with the F100 is similar to that of the SB-11 (except for the lack of a non-TTL Auto mode), adequate for most of the intended applications of this TTL macro flash unit. However, a flash exposure compensation control (not included) would be very useful for varying flash output in nature photography.

Notes

Notes